D0454705

THE ASIAN ART MUSEUM
OF SAN FRANCISCO

✤

SELECTED WORKS

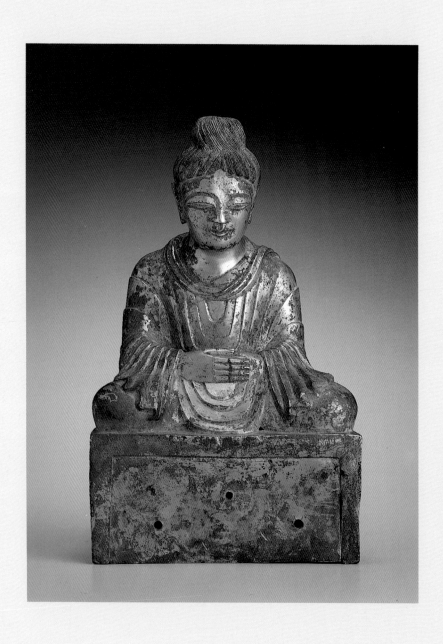

THE ASIAN ART MUSEUM
OF SAN FRANCISCO

❧

SELECTED WORKS

❧

in association with

UNIVERSITY OF WASHINGTON PRESS
SEATTLE AND LONDON

Published by the Asian Art Museum of San Francisco
Distributed by the University of Washington Press,
Seattle and London

Copyright © 1994 by the Asian Art Museum of San Francisco.
All rights reserved. No part of this publication may be reproduced or
transmitted in any form or by any means, electronic or mechanical,
without permission from the publisher.

Produced by Marquand Books, Inc., Seattle
Production supervision for AAM by Richard L. Mellott
Edited by Lorna Price
Photography by Kaz Tsuruta
Designed by Ed Marquand and Bret Granato
Printed and bound in Hong Kong by
C & C Offset Printing Co., Ltd.

Note to reader: Measurements for screens, scrolls, and paintings are
for image only (not mounts) unless otherwise noted.

Cover: *Chaogua* (lady's court overvest; p. 144)
Back cover: Seated Ganesha (p. 33)
Frontispiece: Seated Buddha (p. 91)
Page 9: Bowl with floral decoration (p. 20)
Page 21: Samantabhadra (p. 47)
Page 53: Uma (p. 58)
Page 79: Rhinoceros-shaped *zun* (p. 84)
Page 145: Ewer with lid (p. 151)
Page 161: Ogata Kōrin, *Morning Glories* (p. 195)

Library of Congress Cataloging-in-Publication Data
Asian Art Museum of San Francisco.
Selected works / the Asian Art Museum of San Francisco.
 p. cm.
 ISBN 0-295-97414-1 (paper)
 1. Art, Asian—Catalogs. 2. Art—California—San Francisco—
Catalogs. 3. Asian Art Museum of San Francisco—Catalogs. I. Title.
 N7262.A882 1994
709'.5'07479461—dc20 94-32735

THE ASIAN ART MUSEUM OF SAN FRANCISCO is located
in Golden Gate Park, San Francisco CA 94118.
Public information: 415/668-7855

CONTENTS

The Commissioners of
The Asian Art Museum of San Francisco
and
The Trustees of the Asian Art Museum Foundation
dedicate this book to

Rand Castile
Director of the Asian Art Museum, 1985–1994

Donors to this publication

The City and County of San Francisco
The Society for Asian Art
A Generous Anonymous Donor

Among American government agencies supporting
the Asian Art Museum of San Francisco:

The City and County of San Francisco
The California Arts Council
The National Endowment for the Arts
The National Endowment for the Humanities
The Institute for Museum Services

FOREWORD AND
ACKNOWLEDGMENTS

To travel Europe is to assume foreseen inheritance. . . . But to travel in
. . . Asia is to discover a novelty previously unsuspected and unimaginable. . . .
Suddenly, as it were, in the opening of an eye, the potential world—the field of
man and his environment—is doubly extended. The stimulus is inconceivable
to those who have not experienced it.
—Robert Byron, *First Russia, Then Tibet,* 1933

The character of the art in this book is
broad, inventive, original, and stunning
in its compass. For the arts of Asia are
as vast as mankind, and as complex and
remarkable. Yet, while they conform to
little of what Western artists know or
knew, these arts are born of grand tradi-
tions, nurtured talents, and splendid
ideas. The arts of Asia originate in the
largest of Earth's continents and repre-
sent the oldest continuum of civilized
activity in this world.

Asian arts arise from perspectives
magnificently different from those of
Western concepts and attitudes of ex-
pression toward landscapes, peoples,
and the accoutrements of everyday life.
It is appropriate to begin this volume
with the wisdom of Asia's ages—with,
in fact, a citation from Confucius, the
great teacher and instiller of values by
whose words many have charted their
lives:

> The gentleman behaves in har-
> mony, but never conforms; the
> man of small character conforms,
> but never behaves in harmony.

Asian artists represented in this book
epitomize this dictum, for the best art-
ists always extended the sights and
insights of their audience by original
and profound reflection upon their times
and the world around them. The artists
did not conform to established ways.
Instead, they sought new harmonies.

An art museum's handbook is a
guide to its collections, for collections
are the key to the museum's qualities,
purposes, and programs. Handbooks,
once meant to be carried as one moved
about the galleries—and this is still
done—more and more have become
standard references as well. This publi-
cation, long in the making, represents
the first comprehensive treatment of the
large and important holdings given to
us by Avery and Elizabeth Brundage and
by many other and subsequent donors.

Museums in the United States go
back to the mid-nineteenth century,
a time of America's great industrial
and intellectual expansion. Americans
of means traveled, and in their travels
acquired works of art, much as the En-
glish had done a century earlier. The
accumulation of these objects and pic-
tures formed many of the great art
museums of this country.

With few exceptions, museums
west of the Mississippi are relatively
recent in establishment, not often pos-
sessed of vast treasures gathered over
long years of local patronage, nor have
they necessarily benefitted from large
endowments, like those accumulated
over time by many eastern institutions.
The Asian Art Museum, however, stands
upon the extraordinary foundation laid
by one dedicated and accomplished col-
lector: Avery Brundage. His gift to San
Francisco of some ten thousand objects

represents one of the great American benefactions. Avery Brundage's single vision was to build a comprehensive museum devoted exclusively to Asian art. Like Mr. Charles Freer of the Freer Gallery of Art, Washington D.C., Brundage succeeded admirably.

The objects presented in this handbook are mostly from Mr. Brundage, but others have joined us and extended his vision with gifts of important Asian art in fields where the Olympian was not able to finish his work. Our task now is to continue a harmonious expansion of the Brundage collections, attempting through acquisition and gift to complete what he began so well.

This handbook presents a selection by our curators of the highlights of the Asian Art Museum collections. It is, therefore, simply an introduction to the subject, but it is also an invitation for the reader to investigate further, to visit the museum, and to see at first hand the arrayed masterworks of Asian art installed in the galleries.

We are grateful to the curators who authored this book. Their scholarship, specific knowledge of the collection, and dedication to the museum are important to the success of our collecting and to our programs. Dr. Patricia Berger, Curator of Chinese Art, Ms. So Kam Ng, former Associate Curator, Department of Education, and Mr. Clarence Shangraw, Chief Curator Emeritus, and Manni Liu, Acting Director, Chinese Culture Center, San Francisco, contributed to the handbook on subjects relating to Chinese art. Ms. Terese Tse Bartholomew, Curator of Indian and Himalayan Art, wrote entries in her fields, and Richard Kohn, independent scholar and adjunct associate curator for the exhibition *Wisdom and Compassion: The Sacred Art of Tibet* (1991),

co-authored two entries in this area. Dr. Kumja Paik Kim, Associate Curator of Korean Art, completed the citations for Korea. Dr. Nancy Tingley, Paul L. and Phyllis Wattis Foundation Curator of Southeast Asian Art, wrote the sections covering her area of expertise. Ms. Yoshiko Kakudo, Curator of Japanese Art, and Dr. Yoko Woodson, Associate Curator of Japanese art, wrote the sections treating our second largest collection. Dr. Terry Allen, noted historian of Islamic art, wrote the essays for objects in this area. Curator of Education Richard Mellott supervised the entire project, assisted by Michael Morrison and Kathleen Scott. Mrs. Hanni Forrester, head of the museum's photographic services department, coordinated the taking of photographs for the book. Museum photographer Kaz Tsuruta increases still further his high reputation with the images in this publication. Our registration department provided information about the collection and coordinated the movement of art works in their usual efficient manner. Ms. Lorna Price served most capably as its editor and editorial coordinator.

I thank as well the good volunteers who lead the museum, especially Mr. Ian Wilson, Chairman, The Asian Art Commission, and Mr. Johnson Bogart, Chairman, The Asian Art Museum Foundation. They inspire and encourage us with their outstanding leadership.

All of us at the Asian Art Museum are here to serve the art entrusted to us, and in that service we trust this handbook of the collections will help us reach out to new as well as familiar audiences through the great arts of Asia.

RAND CASTILE, Director
The Asian Art Museum of San Francisco

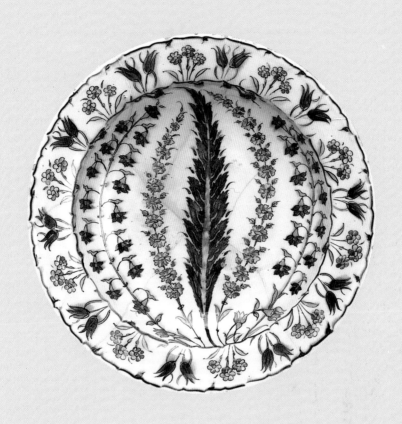

NEAR EAST

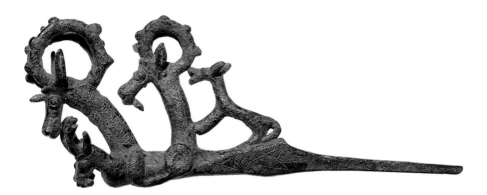

PIN WITH CERVIDAE

Iran, Luristan; 8th–7th century B.C.
Bronze
L: 7¾ in. (20.9 cm)
The Avery Brundage Collection
B62 B132

Engaging abstract bronzes like this pin found a responsive audience when they came onto the world art market following World War I. Their fantastic metamorphoses and economy of detail appealed to eyes familiar with the art of the new century, and they became fixtures in collections of non-Western art.

This pin is one of a group of bronzes from the mountainous region of Luristan in western Iran, roughly halfway between Baghdad and Isfahan; they are attributed to the ninth to seventh centuries B.C. They were cast by the lost-wax technique, a very ancient process. Similar pins offered as votives were found at a shrine excavated in 1938 at Dum Surkh. Most pieces are identified as horse-trappings; the shape of this pin, however, is suitable for a finial or a protome.

The art of the Luristan bronze-founders lay in their irrepressible inclination to turn hardware into animals. These deerlike animals grow as if from one common body or stem, their long necks attached to bumps that suggest shoulders. They thrust forward from the pointed end, where a dog jumps up the erect neck of a bearded goat or antelope, to the short, doubled heads at the front, which are bent forward radically. The forward thrust of the composition is heightened by hatched arrows engraved along the shaft. This complex, open form attracts maximum attention to a small object and makes economic use of material. T.A.

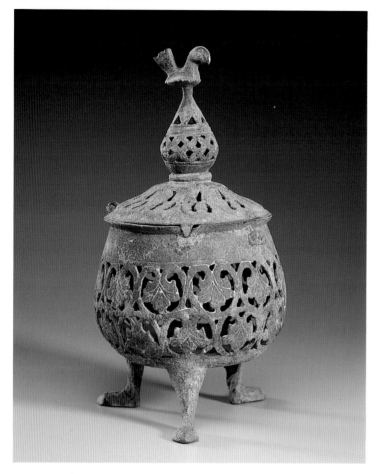

INCENSE BURNER

Iran or Syria; ca. 12th–13th century
Bronze
H: 9½ in. (23.7 cm)
Gift of the Asian Art Museum Foundation
B69 B12

Incense was part of everyday life among
well-to-do Near Easterners from Antiq-
uity onward. In the Islamic period, Egypt
in particular produced an ever-changing
succession of artistically wrought in-
cense burners for both Christians and
Muslims. Openwork cast-bronze in-
cense burners with grape leaves and bird
finials survive, dating from early Islamic
Egypt into the Fatimid dynasty (4th–6th
century A.H./10th–12th century A.D.).

The Antique model of freestanding
incense burner was small, with a long
handle. The handle was later eliminated
and the vessel enlarged, so that part of
it would remain cool enough to grasp
while it was in use. Later incense burners
often have trays inside for the incense.

While it fits within an established
genre, this vessel has an unusual shape:
a swelling openwork body, flat and solid
on the bottom, standing on three tapered
feet. The long handle, now missing, was
once riveted opposite the lid's hinge and
would have extended the composition
and balanced the body's roundness. The
vessel lacks a tray. Smoke rose through
the grape leaves in distinct streams,
merging like clouds around the bird.
The lid's slit openings may have been
designed to impart their profile to the
ascending smoke.

In both Egypt and Syria the motifs
and genres of Late Antique art lingered
for centuries after they had been dis-
placed in Iraq and Iran. The grape leaves,
with their incised details, are a specifi-
cally Egyptian design element. T.A.

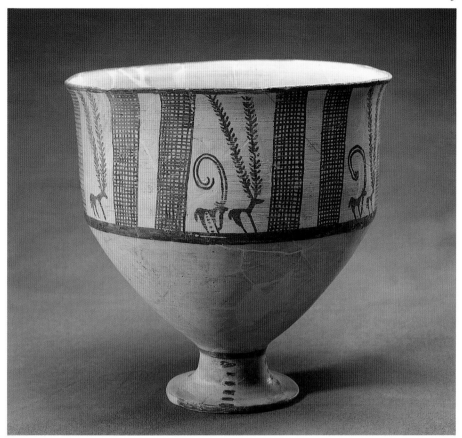

SIYALK STEMMED CUP

Iran; Siyalk Level III style,
late 4th millennium B.C.
Pottery with painted black motifs
H: 11½ in. (28.7 cm)
The Avery Brundage Collection
B60 P469

This large stemmed cup, likely used for social drinking occasions, belongs to a traditional type common in the mid-fourth millennium. Many similar cups have been excavated at Tappah Siyalk in western Iran.

Siyalk stemmed cups usually show animals in silhouette and contained by simple geometric frames. Sometimes the animals stand in linear groups on a ground line, like a frieze; birds may appear in stacked columns. Siyalk potters were interested in varying sharply the vessels' profiles. This one has a concave foot, a slightly convex lower body, and a straight-walled upper part that flares gently toward the rim.

The painter has rendered the antelope-like animals with lean and muscular silhouettes and a radically back-slanted posture expressive of their agility. The erect heads and loosely curving horns anchored to the upper border achieve a balance of forces that has the authority of numberless repetitions.

Vertical grids separate the animals and also focus the eye on them. Their finely drawn lines contrast with the thick-thin combinations of the upper and lower borders, organizing our gaze like good typography. Stippled on the foot, rows of upward-pointing isosceles triangles and soft, ovoid lozenges lead the eye up these most visible segments. The underside of the body has been left blank, to lighten the scheme. The cup's matte surface, characteristic of much prehistoric pottery, unifies the surface and fosters the perception that the painted decoration is part of the fabric of the vessel. T.A.

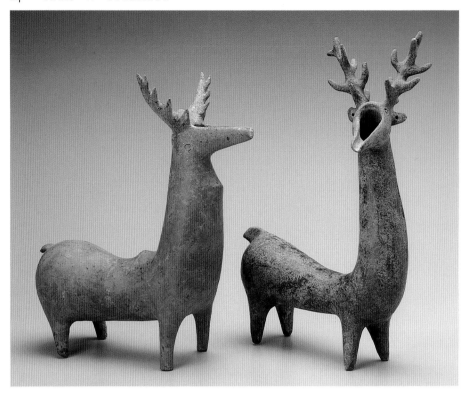

STAG-SHAPED VESSELS
Northwestern Iran, Amlash; Marlik style,
ca. 10th century B.C.
Earthenware
H. P1: 11 in. L: 9½ in.
(27.5 × 23.7 cm)
H. P9+: 11⅛ in. L: 8½ in.
(28.4 × 21.6 cm)
Gift of the Asian Art Museum Foundation
B68 P1, B62 P9+

Through the town of Amlash, on the Caspian Sea, the ceramics of an otherwise unknown ancient culture have reached the art market since the 1950s. They are presumed to come from the Iranian provinces of Gilan and Mazandaran, where excavations have revealed tombs containing a range of related pottery dating from the late second millennium B.C. well into the first. The wares include pitchers, cups, jugs, and figurines in the form of people as well as zoomorphic vessels. These examples are probably made for pouring rather than drinking, their heads forming spouts.

The two stags are sleek and smoothly modulated, but not at all simple. They are also surprisingly different, showing the wide variation possible within so restrained a genre. Both capture a certain foursquare, attentive stance but in opposed ways. The red stag stands assertively, the front of the body thrust forward, with a break in contour behind the shoulder; behind it the body swells toward solidly planted hindquarters.

The gray stag, by contrast, seems surprised and inquisitive, with ears laid back and head turned as if ready to bound away. The lines of the body are as smooth as possible and describe it less naturalistically, but they create a sharper contrast between the long, slender body and the spiky antlers and ears. This is a remarkable characterization subtly achieved. T.A.

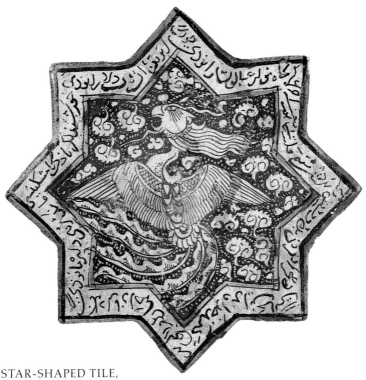

IL-KHANID STAR-SHAPED TILE,
dated 1293

Iran, probably from Sultanabad;
reign of Gaykhatu (1291–1295)
Earthenware with lustre decoration
Diam: 8 in. (20.0 cm)
The Avery Brundage Collection
B60 P2148

Chinese dragons and phoenixes flew into the art of Islamic Iran in the seventh century A.H./thirteenth century A.D., after Chinggis Khan established a trans-Asian empire. Though the years of the Mongol invasions had devastated Iran, Chinggis's successors in Iran, the Il-Khanids (r. 8th/ 14th century) presided over the most brilliant artistic florescence the Islamic world ever knew. By 691/1291, the Il-Khanids had revived the economy, arts, and traditional apparatus of culture in Iran, though they had not yet adopted Islam.

Very similar tiles dating to 671/1271 have been found in a secure archaeological context at Takht-i-Sulayman, where the Sasanians and after them the Mongols erected palaces. These dado tiles in-clude eight-pointed stars the same size as this one, and the cross shapes needed to complete a solid tile array.

In Islamic art the Chinese phoenix became the Iranian *simurgh,* the great royal bird of the epic *Shah Namah* (Book of Kings). Here it soars into a cloud-filled sky, its wings stretching to the points of the octogram. The cloud shapes derive from Chinese models, but are scattered in reserve against a dark ground in the same way that palmette leaves and birds are used in pre-Mongol Persian lustre pottery. Around the tile edge, Persian verses inscribed in an indifferent hand praise a slender, musky lover who is compared to the sun; the date appears in numerals in the upper right-hand corner. T.A.

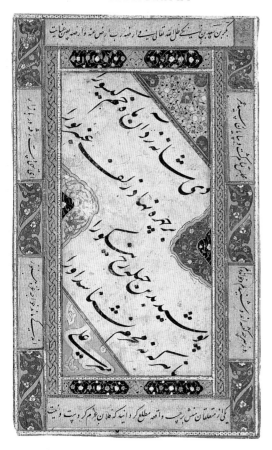

ILLUMINATED PAGE OF NASTA'LĪQ SCRIPT

Mir 'Alī Haravī (d. 1556)
Iran; Safavid dynasty, early 16th century
Ink and colors on paper
H: 8½ in. W: 5⅛ in. (21.6 × 13.0 cm)
Gift of the Todd G. Williams Memorial
Fund and the Society for Asian Art
B87 D6

Mir 'Alī Haravī produced calligraphy famous among and sought after by the princes of three dynasties. His birthdate is unknown, but he lived "for a long time" in Herat, even after the Timurid dynasty fell in 913 A.H./1507 A.D. and was replaced first by the Uzbek Turks, then the Safavids. In 1528 he was brought, apparently against his wishes, to the Uzbek capital, Bukhara, where he died thirty years later.

Mir 'Alī was a master of the nasta-'līq (hanging) script, in which this qit'a is written. In this genre a few lines of poetry are written diagonally on a small sheet, then illuminated and framed with decorative borders and smaller calligra-

phy samples from the same hand. All were written with a reed pen. Such pieces were avidly collected and often bound into albums.

These six unrelated lines were intended to be appreciated as examples of the calligrapher's art. Mir 'Alī's signature appears in the lower left triangle. The main inscription is from an unidentified poem. The six smaller lines of writing were cut from one or two folios of the Gulistan (Rose Garden) of the famous Persian poet Sa'dī.

The qit'a's ornamental panels may point to a date in the later ninth/fifteenth centuries. The panels' bold colors and the effortless rhythms of their coiled foliage are typical of Timurid manuscript illumination, as is the complex construction of the almost seamless finished page. The powerful composition is as much the work of the unknown illuminator as of Mir 'Alī. T.A.

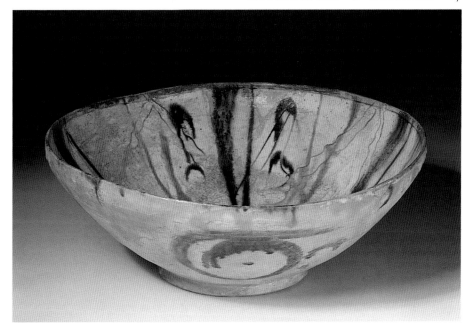

BOWL

Mesopotamia; 9th–10th century
Pottery with *sgraffito* and splashed
lead glaze
Diam: 13 in. (33.0 cm)
Gift of Lewis K. Land and Elizabeth Land
B84 P2

Soon after the first wave of the Arab conquest, Muslim caliphs founded new cities in southern Iraq, where troops of the Arab armies settled with their families. Vast new markets for consumer goods sprang up as wealth poured in from the newly conquered lands, and imported Chinese ceramics were among the most welcome commodities. Their arrival sparked the long development of colorful Islamic ceramics.

Among these Chinese import wares was *sancai,* three-color splash ware of a whitish, nonporcellaneous clay coated with white slip and decorated with several colors of lead-based glazes. Iraqi potters were producing the type by the end of the eighth century; called Samarra ware, it became one of the standard 'Abbasid pottery types.

Samarra ware is of a very fine clay body, usually yellow but occasionally orange, like this bowl. It is coated with white slip and an opaque white glaze containing tin. The interior has typical incised foliate decoration with green, ochre, and purple (manganese) glazes painted over the *sgraffiato* of four stemless palmettes separated by paired, parallel squiggles. Five radial lines of green and ochre glaze and five dabs of manganese oppose this fourfold symmetry. The unincised exterior bears only four loose circles in green and ochre with two curved strokes in manganese, a standard Samarra scheme.

Such ceramics were almost certainly not produced in Samarra, as the series began before that city was founded. But the remarkable consistency of both the style and the clay, from deposits along the Tigris or Euphrates, strongly suggests that their manufacture was a monopoly of one or two major centers, perhaps Basrah or Kufah. T.A.

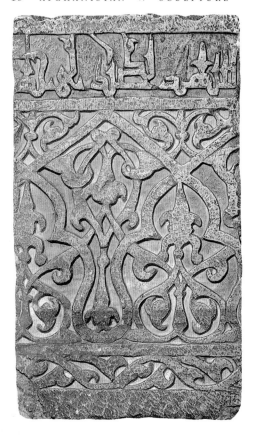

GHAZNAVID DADO PANEL

Afghanistan, Ghazni; early 12th century,
reign of Mas'ud III (1099–1115)
Marble architectural relief
H: 29¼ in. W: 17 in. (74.2 × 43.1 cm)
Gift of Shawn and Brook Byers and Peter
Marks in honor of Avery Brundage's
Centennial B87 S3

This pannel was once part of a marble
dado surrounding the courtyard of the
palace of the ruler Mas'ud III at Ghazni,
Afghanistan. The complete dado, now
widely scattered or lost, was 250 meters
long and once wrapped around the base
of the courtyard arcades. The palace is
dated to 505 A.H./1112 A.D. on the basis
of an Arabic inscription recovered there
during excavations. This panel was later
used to decorate a tomb. It is the only
major element of architectural decora-
tion from the Ghaznavid dynasty on
display in the United States.

Only in the great palace of the
'Abbasid caliphs in Samarra were dadoes
executed in marble, and then only in the
most important central areas. The long
poem on the dado of Mas'ud's palace is
of particular interest for its inscription,
written in Persian in *kufic* script. The
complete poem eulogized Mas'ud and
described his works. It is one of the ear-
liest examples of the use of Persian for
a monumental inscription, attesting
the rise of Persian as a high literary
language under the patronage of the
Turkish Ghaznavids.

The dado was originally painted in
ultramarine blue against a red ground,
a common color scheme in Islamic ar-
chitecture of the time. The inscription
may have been gilded. The main zone
of decoration is a frieze of two sets of
overlapping trefoil arches under which
abstract vegetation intertwines in a
well-developed arabesque, closed at the
top and with vertical axes correspond-
ing to those of the arches. The lower
band is carved with one of the many
Antique border designs that survive
in Islamic art. T.A.

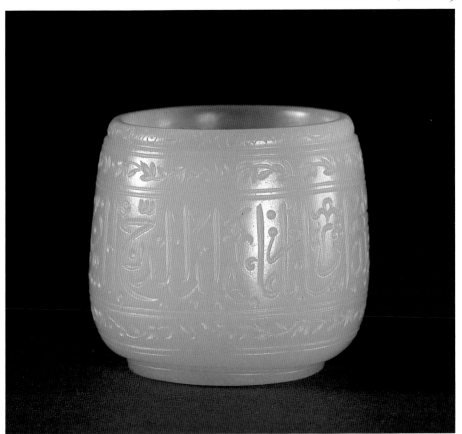

MINIATURE JEWEL BOX *(durg)*

Eastern Persia; Timurid era, 15th century
White jade
H: 1⅜ in. (3.44 cm)
The Avery Brundage Collection
B60 J619

This miniature round box bears inscriptions commemorating sultans of two dynasties. The earlier inscription in the *naskhi* script states that it was made for ʿAla al-Daulah ibn Baysunghur (820–65 A.H./1417–60 A.D.), a grandson of Timur, who reigned briefly at two different times during a period troubled by conspiracy and factionalism. A second sultan, the Mughal emperor Jahangir ibn Akbar, is named in the minuscule *nastaʿliq* inscription around the rim, which includes the date 1030/1621.

The Timurids were the first Islamic dynasty to use jade seriously as an artistic medium. Jade and possibly also jade carvers came to the Timurid court from Central Asia during the decades when

Samarqand was a power in East Turkistan. The choice of shape for objects like this pyxis may have derived from the size and shape of the jade pebbles from which they were carved.

This *durg*, as both inscriptions name it, was likely a term describing its shape, a small, round, open container; it seems too small to be a jewel box, another meaning of the word.

The surface of the *durg* is carved with undulating vine borders that enliven the stately rhythm established by the uprights of the main inscription. A circular spray of similar foliate decoration is carved in the bottom. The Mughal craftsman's bouncy curves of *nastaʿliq* script are unimpaired by its reduction to such a small scale because he strengthened his strokes, much as a type designer makes his small fonts more robust than those of normal size. T.A.

BOWL WITH FLORAL DECORATION

Turkey, Iznik site; Ottoman culture,
second half of the 16th century
Earthenware with white underglaze and
floral ornament in green, blue, and yellow
Diam: 13 in. (32.5 cm)
The Avery Brundage Collection
B60 P1949

The many wares produced during the early Ottoman period in Iznik (ancient Nicaea) mark the undisputed high point of later Islamic ceramics. This classical example of Iznik ware is executed with the traditional scheme of four colors including red. The naturalistic floral design is painted on white clay slip coating a white body. A superb transparent overglaze lends these pieces their characteristic glistening appearance.

All styles of Ottoman court art, from arabesques to various foliate decorations, were represented in the four-color-with-red technique. The Ottomans imported many ornamental plants from Iran, Central Asia, and India. The blossoms of these new cultivars appeared in design schemes, supplanting the old Islamic palmettes and the Chinese flowers that had followed them. This naturalistic style was developed in imperial ateliers by the 950s A.H./1640s A.D., in time for the rise, in the subsequent decade, of the full Iznik palette—cobalt, turquoise, green, purple, black, and a juicy tomato red.

Later Iznik pottery moved toward a less brilliant palette, simpler design, and looser execution. In the cavetto of this plate, a gently curving cypress spray is flanked by floral sprays, perhaps red roses and blue delphiniums with red centers. The border alternates pairs of black tulips and groups of three unidentified flowers. Influenced by imported Chinese ware, early Iznik plates had molded lotus-profile edges; later, as here (ca. 1010/1600), the lobed profile appears only as a casually drawn line. On the plate's exterior, crossed pairs of blue tulips alternate with unidentified red flowers lacking stems. T.A.

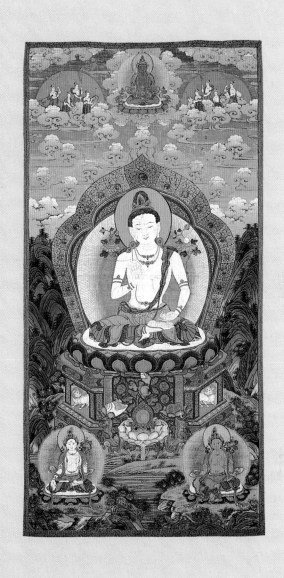

INDIA AND

THE HIMALAYAS

A bodhisattva is one who postponed attaining Buddhahood in favor of remaining on earth to help mankind. Instead of the simple garment of a Buddha, bodhisattvas wear royal garments and jewelry, and elaborate coiffeurs.

This sculpture comes from Gandhara, the area now occupied by present-day southern Afghanistan and northern Pakistan. Through the ages, Gandhara had strong and prolonged contact with many foreign cultures, including the armies of Alexander the Great. A distinctive school of Buddhist art developed in Gandhara in the second century, when it was part of the Roman Empire. This school was Indian in iconography and Greco-Roman, Central Asian, and Iranian in style. The image of the Buddha appeared for the first time, and simultaneously, in Gandhara and in Mathura, capital of the Kushan empire.

The bodhisattva's water bottle is an attribute that identifies him as Maitreya, the future Buddha. His broken right hand should have displayed the iconic gesture (mudra) of reassurance. Greco-Roman influence is quite evident in the powerful modeling of this figure, in the facial features, and in some of the jewelry. The bodhisattva wears strings of amulet boxes. Of particular interest is his necklace of centaurs supporting an amulet, creatures deriving specifically from Greek mythology.

This sculpture's size indicates that it was once used as a cult image. Although the temples and shrines of Gandhara no longer exist, a typical arrangement, seen in extant temples in India, would indicate that this was one of two bodhisattvas accompanying an image of a Buddha.

T.T.B.

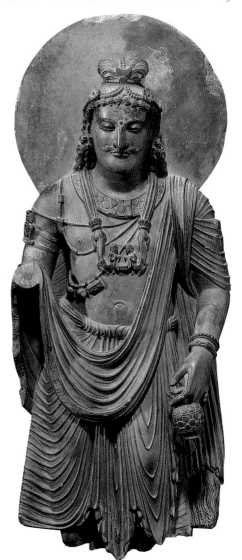

BODHISATTVA MAITREYA
India, Gandhara; Kushan period, 2nd–3rd century
Schist
H: 41 in. (105.0 cm)
The Avery Brundage Collection
B60 S597

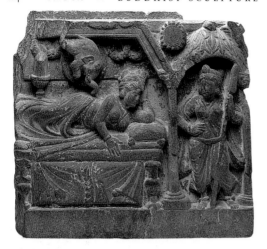

A. MAYA'S DREAM
India, Gandhara; Kushan period,
2nd–3rd century
Phyllite
H: 10 in. L: 11⅜ in. (25.0 × 28.44 cm)
The Avery Brundage Collection
B64 S5

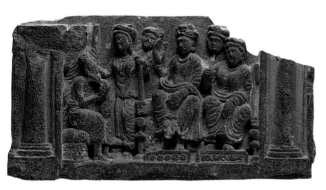

B. SAGE ASITA EXPLAINING
MAYA'S DREAM
India, Gandhara; Kushan period,
2nd–3rd century
Phyllite
H: 6⅜ in. L: 13 in. (16.2 × 33.0 cm)
Gift of Richard Gump B87 S2

EIGHT EPISODES IN THE LIFE OF SHAKYAMUNI

Although the monuments of Gandhara are gone, many small friezes that once decorated them illustrate in detail the life of Shakyamuni, the historical Buddha, and are the major contributions of the Gandharan school of sculpture. These fragments illustrate events from his conception through his death.

These friezes came from different sites. Some decorated the walls of monuments, bases of pedestals, and stair risers. Figures D and F form two sides of the base of a stupa. All served as didactic material for pilgrims circumambulating the sacred monument. The false gable (E), which also has a scene of the First Preaching, would have decorated the dome of a stupa.

Buddha Shakyamuni was born Prince Siddhartha around 563 B.C. in the foothills of the Himalayas, the son of Suddhodana, king of the Shakya clan. One night when the moon was full, as his mother Maya slept in the palace, she dreamed that a white elephant descended and entered her right side (A) while a *yavani*, a Greek female attendant, stood guard. The king and queen then consulted the sage Asita (B), the ascetic with topknot and beard seated on the left, listening with rapt attention as he reveals that she has conceived and that the baby will become either a universal monarch or a Buddha. The birth occurred in the Lumbini gardens under a *sal* tree in full bloom (C). The infant Siddhartha emerges from Maya's right side. Supported by her sister Prajapati,

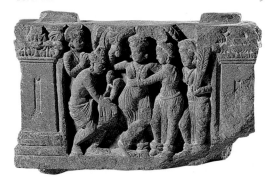

C. BIRTH OF BUDDHA IN THE
LUMBINI GARDENS
India, Gandhara; Kushan period,
2nd–3rd century
Phyllite
H: 7½ in. L: 12 in. (18.7 × 30.0 cm)
The Avery Brundage Collection
B62 S31+

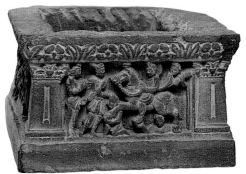

D. THE GREAT DEPARTURE
India, Gandhara; Kushan period,
2nd–3rd century
Phyllite
H: 7¼ in. L: 12⅜ in. (18.4 × 32.9 cm)
Gift of Mr. and Mrs. Richard
Dirickson, Jr. B84 S1

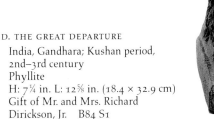

E. THE FIRST SERMON AT SARNATH
India, Gandhara; Kushan period,
2nd–3rd century
Phyllite
H: 27 in. (67.5 cm)
The Avery Brundage Collection
B60 S138+

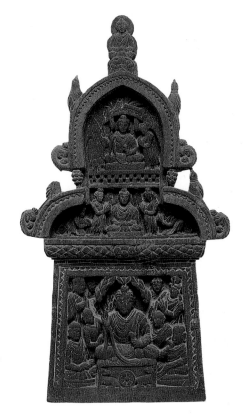

she grasps a branch in a pose highly
reminiscent of the Yakshi-and-tree mo-
tif in ancient Indian art. The god Indra
receives the child in a cloth of gold; the
goddess Lumbini, holding the water
vessel and a palm leaf, watches from
the right.

Prince Siddhartha excelled in all his
studies. He won the hand of Yasodhara,
who gave birth to their son Rahula. Al-
though King Suddhodana tried to shield
his son from the suffering of the world,
Siddhartha soon discovered it for him-
self and decided to renounce his life as
a prince. He then galloped away on his
steed Kanthaka in search of truth (D).
His departure was silent because earth

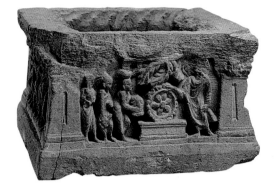

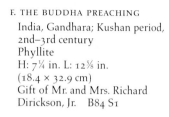

F. THE BUDDHA PREACHING
India, Gandhara; Kushan period,
2nd–3rd century
Phyllite
H: 7¼ in. L: 12⅝ in.
(18.4 × 32.9 cm)
Gift of Mr. and Mrs. Richard
Dirickson, Jr. B84 S1

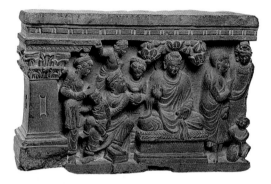

G. BUDDHA, YASODHARA,
AND RAHULA
India, Gandhara; Kushan period,
ca. 3rd century
Phyllite
H: 10½ in. L: 16½ in. (26.2 × 41.2 cm)
The Avery Brundage Collection
B60 S283

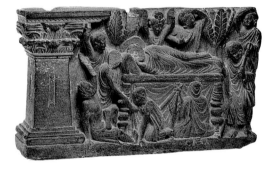

H. DEATH OF THE BUDDHA
India, Gandhara; Kushan period,
2nd–3rd century
Phyllite
H: 10½ in. W: 19½ in. (26.7 × 49.5 cm)
The Avery Brundage Collection
B60 S328

spirits supported the horse's hooves so their sound would not awaken the palace guards. After wandering for six years, Siddhartha sat down beneath a *bodhi* tree, where he meditated until he realized that man's worldly desires and the cycle of rebirth were the cause of human suffering. Through this enlightenment, he became a Buddha.

The false gable (E) depicts Buddha preaching his first sermon at the Deer Park at Sarnath, where he gained his first five disciples. Two deer and a wheel on the throne symbolize this event. Buddha preaching, or Turning the Wheel of the Law, is literally interpreted in the rendering on the stupa base (F). When the Buddha returned to the palace, Yasodhara brought their son Rahula to him to ask for his inheritance (G). The Buddha, deciding to give his son a spiritual rather than material inheritance, had him ordained as a monk.

Finally, in the Mahaparinirvana (H), the Buddha lies on a couch between two *sal* trees, surrounded by disciples and friends expressing various stages of grief. This is the final death which, he preached, would free one from the cycle of rebirth. T.T.B.

From about the middle of the eighth to the early twelfth century, the semi-feudal Pala dynasty ruled eastern India, an area corresponding to modern-day Bihar, West Bengal, and Bangladesh. The Pala kings, though they tolerated the Hindu and Jain religions, were the last royal patrons of Buddhist art on the subcontinent. They built Buddhist temples, repaired places of pilgrimage, enlarged the Buddhist monastic university at Nalanda, and founded new ones. These universities became famous throughout Asia, attracting scholars from China, Tibet, Nepal, and Southeast Asia.

Clear outlines, formal posture, smooth surfaces, and technical excellence that produced an almost metallic finish characterize Pala sculptures. Main images appear in high relief against a background of shallow carving. Early works tend to have simple compositions and rounded apexes; later ones are more complex, and the tops become progressively more pointed.

The Buddha Shakyamuni conquering Mara is a favorite subject of Pala sculptors. This Buddha sits on a cushion above a lion throne beneath branches of heart-shaped *bodhi* leaves (*Ficus religiosa*). His left hand relaxes in the meditation mode, and his right points downward in the gesture of earth touching (*bhumishparsha*).

This gesture recalls the moment when he was challenged by the demon Mara, and he called the earth goddess to witness his right to attain Buddhahood, thus defeating Mara and his host. Bodhgaya, the site of this momentous event, became the most sacred of all Buddhist pilgrimage sites.

Flanking the Buddha, two rampant, lionlike *vyalas* (mythical animals) spit pearls. The halo, a twisted garland of beads, encloses the Buddhist creed incised in low relief. An inscription on the base names the donor, the Elder Prajnaprabha, who may be the pious monk seated next to the lions. T.T.B.

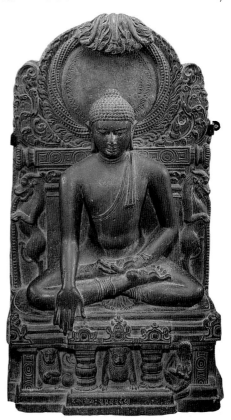

THE BUDDHA AS THE
CONQUEROR OF MARA

India, Bihar; Pala period, 9th century
Schist
H: 33 in. (82.5 cm)
The Avery Brundage Collection
B60 S598

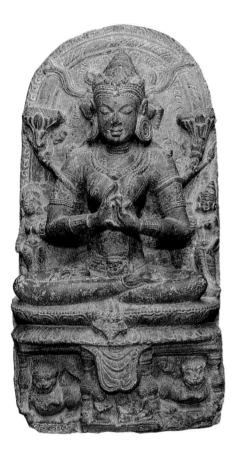

PRAJNAPARAMITA

India, Bihar, Bodhgaya; Pala period,
mid-9th century
Schist
H: 26 in. (65.0 cm)
The Avery Brundage Collection
B62 S32+

The growth of tantrism in the Pala period placed more emphasis on ritual and worship of female deities, and their images proliferated. Prajnaparamita, the Buddhist goddess of transcendent wisdom, personifies the Prajnaparamita Sutra, an important group of Mahayana Buddhist texts.

The goddess is seated in meditation on a lotus pedestal above a lion throne, her hands making the gesture of preaching. Two blue lotuses issue from beneath her upper arms and rise above her shoulders. They support two volumes of her sutra. At either side, her two female attendants each carry a lotus. Behind the goddess a flaming halo bordered with pearl and floral motifs encloses the Buddhist creed. An inscription on the base names the donor, Kikabhapurava. With her elaborate coiffeur and jewelry, Prajnaparamita wears a tight-fitting garment incised with floral patterns. The carving is taut and delicate, a style typical of the sophistication achieved by Pala sculptors.

Prajnaparamita usually carries one book, but when two books are present, an unusual form, she assumes the name Kanakaprajnaparamita. Though metal images of this form of the goddess exist, examples in stone are rare.

This sculpture was once in Bodhgaya. The British scholar Buchanan-Hamilton sketched some sculptures there in 1811. In 1838 another scholar, Montgomery Martin, published a book on eastern India, which included some of those sketches; among them is a rendering of this Prajnaparamita. T.T.B.

In India and elsewhere, Buddhist images
were donated to acquire spiritual merit,
to give thanks, or to increase wealth or
longevity. They were kept on personal
altars or given to monasteries as pious
gifts.

Padmapani, whose name means
'Lotus Bearer,' is a form of Avalokitesh-
vara, the Lord of Compassion—the 'all-
seeing lord' who saves all sentient beings
from peril. From the Gupta period on, in
various forms, he was second in popular-
ity only to Buddha.

Padmapani sits on a double-lotus
throne above a rectangular base. The
plain, broad lotus petals are typical of
the art of Kashmir, as is the base incised
with abstract lines representing a rocky
landscape with caves inhabited by two
animals.

Padmapani's hair is dressed in a tall
crown and ornamented with a seated
image of his spiritual father, Amitabha.
His right hand is turned toward his face
in a contemplative gesture; his left, rest-
ing on his knee, holds the long stem of
a full-blown lotus. His lower garment is
plain; his bare upper torso is draped with
the ascetic's antelope skin and a long gar-
land. His typical Kashmiri face has full
cheeks, a curved nose, large, silver-inlaid
eyes shaped like lotus petals, and a prom-
inent chin. The naturalistic modeling of
the pectoral and abdominal muscles, the
beaded aureoles, and the flaming nimbus
with typical zigzag incisions are also
Kashmiri characteristics.

By the seventh century, Kashmir
was a very important center for Buddhist
studies. Because of its northern location,
Kashmir also drew artistic inspiration
from the various countries of Central
Asia. These influences gave rise to a
style that greatly influenced the art
of western Tibet and China. T.T.B.

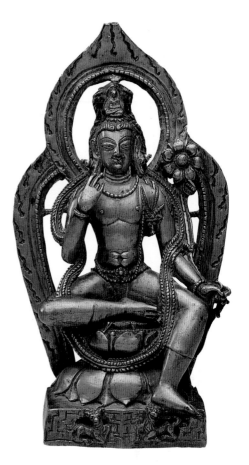

PADMAPANI

India, Kashmir; 11th–12th century
Brass inlaid with silver
H: 9½ in. (24.2 cm)
Gift of the L E F Foundation B86 B4

In India the god Shiva is worshiped in many forms. The most important is the *linga,* the phallic symbol and cult image of the god. In Indian temples dedicated to Shiva, the *linga* would have been placed in the *garbhagriha,* or womb chamber. The *linga* may be a natural pebble, a plain pillar with a rounded top, or one with many faces. This *linga* is the *ekamukha* type, with one face. Characteristic of the Shiva image is his third eye, here shown prominently on the forehead, symbolizing his omniscience. His hair, tied in an ascetic's knot, is adorned with the crescent moon.

Below the rounded column of this sculpture is an octagonal section that rests on a square base. Gupta period texts explain that the rounded portion represents Shiva, the octagonal section symbolizes Vishnu, and the square, the lowest part, stands for Brahma. This eclectic symbolism was employed to appease the various sects of Hinduism. The roughly finished octagonal and square sections were meant to be inserted into a base and thus would be invisible to devotees, for only the top portion of the *linga* was seen and worshiped.

This sculpture is very close in style to an early fifth-century *linga* found in situ at an archaeological site in Udayagiri, a discovery which helps confirm the date of this one. T.T.B.

EKAMUKHA LINGA
India, Madhya Pradesh; Gupta period,
early 5th century
Sandstone
H: 58 in. (145.0 cm)
The Avery Brundage Collection B69 S15

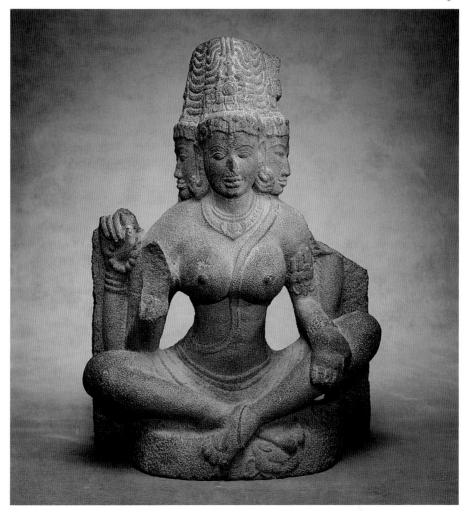

BRAHMANI

South India, probably from Kanchipuram;
Chola period, 9th century
Granite
H: 29 in. (72.5 cm)
The Avery Brundage Collection
B60 S47+

The triple heads of this impressive image of Brahmani identify her as the feminine aspect of Brahma the Creator. Seated on a low pedestal, her legs crossed, Brahmani is adorned with the crowns of matted locks that are peculiar to Brahma and other ascetics, and she carries prayer beads. Her major left hand points down with palm out in a gesture of blessing. One of her two missing hands probably held a water vessel, and the other would have made the gesture of reassurance. Her vehicle, the sacred goose (*hamsa*), appears in low relief beneath her feet. The sensuous facial features, heavy breasts, slender waist, and smooth articulations blend in the elegant and restrained style of Chola period sculptures.

Brahmani is also the initial deity in the group of Seven Mothers (Saptama-trikas). Such figures often occur in sets arranged in a row along temple walls. The other members of the set to which this Brahmani belonged may be found in a few major museums in Europe and America. T.T.B.

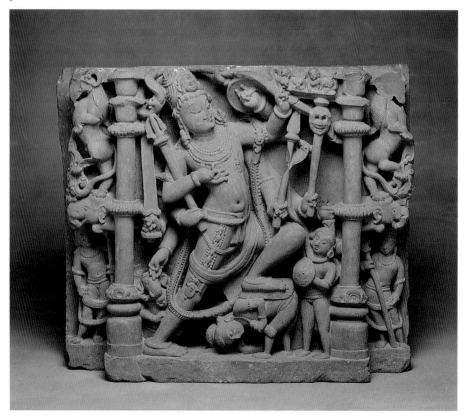

SHIVA TRIPURANTAKA

India, Rajasthan; ca. 11th century
Red sandstone
H: 24½ in. W: 29¾ in. (29.9 × 37.5 cm)
The Avery Brundage Collection B63 S6+

Hindu mythology reveals that both men and demons could obtain boons from the gods by performing austerities and penances. But to prevent the demons from becoming invincible, the gods would slyly include a condition in the boon, something seemingly impossible to the demons, but which the gods could accomplish.

Legend relates that the demons obtained a boon to build three indestructible cities in the triple universe of earth, air, and sky. Thinking themselves invincible, they emerged from their cities to ravage both gods and men, creating havoc. But the boon stipulated that once every thousand years the three cities would become one, and at that moment it would be possible to destroy them all with a single arrow.

In this relief, Shiva the Destroyer stands in the dramatic archer's pose, right leg drawn back and the left bent as he steps on the back of the demon Apasmarapurusha to release his single arrow. In the hands of his ten arms he carries the trident, shield, spear, skull club, cobra, and sword. A lower hand rests on the head of his son Ganesha, who in the midst of battle devours a bowl of sweetmeats. Four female spectators watch from the upper right-hand corner.

The central scene is enclosed by two elaborate ringed columns. On either side attendants stand in the triple-bend pose (*tribhanga*), holding weapons. Above them, prancing, lionlike *vyalas* step on elephants, typical motifs that decorate the sides of stelae of central India. A stele like this one, placed inside a niche, would once have ornamented the exterior of a temple. T.T.B.

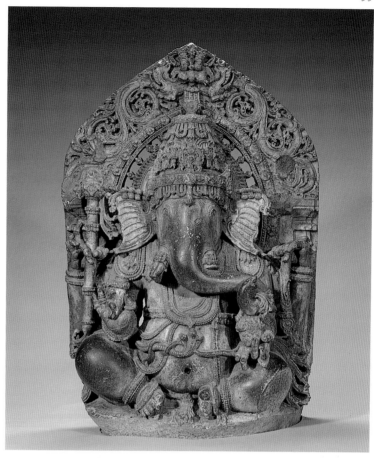

SEATED GANESHA

South India, Mysore; Hoysala period,
13th century
Chloritic schist
H: 35½ in. (88.7 cm)
Gift of the de Young Museum Society
B68 S4

Ganesha, the beloved elephant-headed god of the Hindus, is one of the sons of Shiva and Parvati. He has many names and titles. He is the god of wisdom and of wealth, and as Vighneshvara, Lord of Obstacles, who removes as well as imposes them, he is worshiped by all pious Hindus before beginning any enterprise.

This figure of Ganesha exhibits superb quality and workmanship. Here he sits in the posture of royal ease, one leg raised and the other bent at the knee. With him are his attributes the axe, lotus (broken off), basket of sweetmeats, and the broken tusk. He is sumptuously bejeweled with necklaces, bracelets, anklets, and rings on fingers and toes. Even his tusks are ornamented with monster masks, repeating the motif at the apex of the stele. The latter, however, is a more elaborate version with two *makaras* (crocodilians) sprouting tendrils that tumble forth, which gives the stele a fine sense of movement.

This sculpture epitomizes the height of the Hoysala style in its exuberance and elaborate ornamentation. These tribal chiefs who ruled the region of Mysore (12th–14th century) introduced a new style of architecture, erecting temples on star-shaped platforms with intricately carved sculptures and decorations. Sculptors in this region employed a fine-grained, dark-greenish chloritic schist that is soft when quarried but hardens on exposure to the air, thus lending itself to delicate carving. This type of Ganesha image would have been placed in a niche on the temple wall, or set up in a special shrine at its entrance. T.T.B.

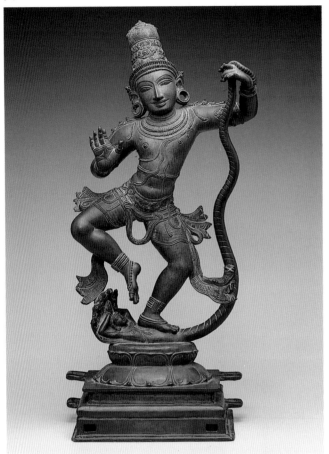

KALIYA KRISHNA

South India, Tamilnadu; Vijayanagar
period, ca. 15th century
Bronze
H: 27 in. (68.6 cm)
Purchase: The Avery Brundage Collection
B65 B72

Shiva as Lord of the Dance is the most
popular and widely known of Indian
dancing images. Krishna represents the
dancer among the Vaishnava gods. The
seventh incarnation of Vishnu the Pre-
server, he has a vast mythology. He
dances as an infant butter thief, and
when he is older, with the *gopis*, or milk-
maids. This rare and dramatic image por-
trays the dancing, youthful deity sub-
duing the serpent king Kaliya, who with
his family resided in the Yamuna River,
polluting it with their venom. Krishna
forced Kaliya to leave the river and thus
made its waters safe again for his and
his friends' cattle.

In this superb sculpture the young
god tramples Kaliya's torso. Kaliya,
whose five hoods denote his royal rank,
appears in anthropomorphic form and
submits to the god by holding his hands
above his head in the gesture of adora-
tion. Krishna, holding the snake's tail
aloft, dances with right foot raised and
right hand extended in the gesture of
reassurance. He is placed above a lotus
pedestal that sits on a rectangular plinth
with lugs, which allow the statue to be
carried in a procession.

The image of Kaliya Krishna first
appeared in south India, where it soon
became the prototype for such images
in painting and sculpture elsewhere in
India. Images cast during the Chola
period often show Krishna dancing right
above Kaliya's hoods. Other features
typical of the Vijayanagar period are the
profusion of jewelry, the fluttering ends
of Krishna's lower garment, and the
flowers on his shoulder. T.T.B.

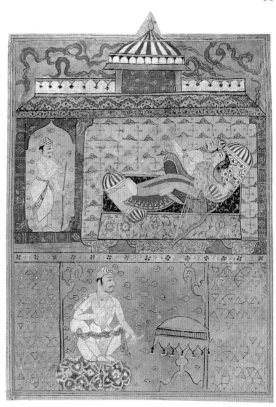

THE VISIT OF THE BRAHMIN
(Folio from a manuscript of the
Chandayana)

India, Uttar Pradesh, probably from
Jaunpur; ca. 1556–1570
Ink, gold, and colors on paper
H: 7⅞ in. W: 5⅝ in. (20.0 × 14.3 cm)
Gift of the Society for Asian Art
B81 D33.2

This painting is one of eighty folios
that were once bound in an album. The
Asian Art Museum of San Francisco
holds three of them, and nine are scat-
tered all over the world. The rest are in
the Prince of Wales Museum of western
India. The group illustrates scenes from
the *Chandayana* or *Laur Chanda,* an
ancient cowherd-caste folk romance. It
originated in Uttar Pradesh and Bihar
and was written in verse form by Mau-
lana Daud between 1377 and 1380. This
once-popular text was all but forgotten
until about thirty years ago, when this
album was rediscovered. In these im-
ages, for the first time, the indigenous
Indian painting style is combined with
the art of the Persian and Turkish min-
iature. This group of miniatures is in-
valuable for the study of pre-Mughal
and Sultanate paintings.

In the upper panel of this minia-
ture, a servant tells Laur and Chanda
of the arrival of a Brahmin. Below, this
guest, Surjan the caravan leader, sits on
a colorful cushion and awaits Laur. The
calligraphy on the verso is in Persian
script, a courtly and literary conven-
tion, but the language is Avadhi, a type
of Hindi.

Experts believe that the artist of
the manuscript was an Indian trained
in a mixed Turkish and Persian style of
painting. He frequently employs ara-
besques, Chinese ribbon-clouds, and
Turkish domes as decorative motifs.
The palette is muted, unlike the strong
colors typically preferred by Persian
miniature artists. The sense of great
beauty emanating from this miniature
is the result of careful use of subtle
colors, delicate brushwork, and sensi-
tive draftsmanship. T.T.B.

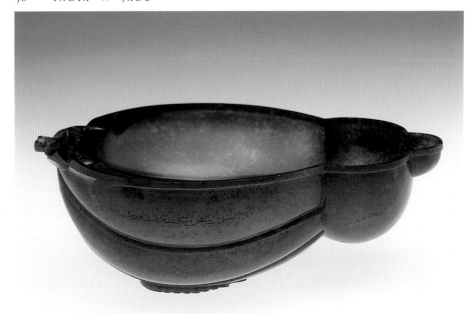

WINE CUP IN THE SHAPE OF A
TURBAN GOURD

India; Mughal period, mid-17th century
Green nephrite
L: 8 in. (20.3 cm)
The Avery Brundage Collection B60 J485

Mughal jade carving began in the early
seventeenth century during the reign of
Emperor Jahangir (1605–27). Jade was
used in many ways—for vessels, orna-
ments for weapons, and personal adorn-
ment. Like his Timurid forefathers, the
emperor was an avid collector of jade
objects. Mughal jades are noted for fine
workmanship, especially the extremely
thin walls, smoothly finished surfaces,
and the carvers' precision and skill in
depicting floral designs. Some pieces are
inlaid with semiprecious stones and are
set in gold. Examples of Mughal jades
were presented to the Qianlong emperor
of China in the eighteenth century; he
was so impressed by them that he not
only composed numerous poems in

praise of these "Hindustan" jades but
also ordered the imperial Chinese work-
shops to imitate them.

This outstanding piece of translu-
cent nephrite is carved in the shape of
a turban gourd cut in half. The walls are
thinly crafted, and the ribs between the
lobes are precisely carved. Five overlap-
ping leaves on the base act as a support.
An identical piece in the British Mu-
seum bears a Shah Jahan inscription;
another, in a private collection in Lon-
don, is a copy after a Mughal piece,
according to its inscription.

This bowl is inscribed in Persian
along one rim: "Drink at the order of
God . . ." identifying its purpose as a
drinking vessel. T.T.B.

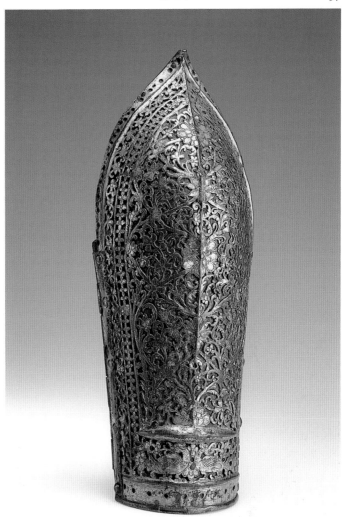

BAJUBAND OR VAMBRACE

South India; Mughal period, 17th century
Steel with gilt copper
L: 13½ in. (34.3 cm)
Gift of Gursharan and Elvira Sidhu
1993.129

Many of the weapons and armor pro-
duced during the Mughal period were
works of art as well as tools of war. The
bajuband, or vambrace, is an armguard
designed to protect the forearm during
combat. This particular type was worn
by officers of high rank in the Deccan
and south India from the sixteenth
through the eighteenth century. The
bajuband consists of two hinged sec-
tions that protect the forearm from

elbow to wrist; the hand would have
been protected by a gauntlet of chain
mail. The longer portion curves out on
top to accommodate the elbow and
comes to a point. The *bajuband* is made
of steel with gilt copper overlay. A ridge
forms a frame around the entire piece,
and there is a transverse elliptical rib at
the wrist. This superb example, made in
openwork with incised designs, is orna-
mented with flowers and vines con-
tained within decorative borders. Below
the rib is a pair of confronting *hamsa*
(sacred geese) with addorsed heads, a
motif typical of the Mysore region.

T.T.B.

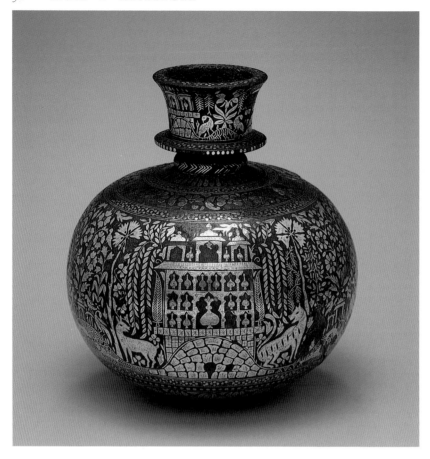

HUQQA BASE

India, Deccan; late 17th century
Bidri ware, alloy inlaid with silver
and brass
H: 7 ¼ in. (18.5 cm)
Gift of Marjorie Bissinger Seller
B86 M11

The origin of Bidri ware is uncertain, but it is named for Bidar, a city in the Deccan where such wares were produced in the seventeenth century. Bidri ware is related to the metalwork of the Islamic world; the technique, however, is truly Indian and not found elsewhere.

Bidri pieces are cast from zinc alloyed with small amounts of lead, tin, and copper. The engraved areas are then inlaid with silver, copper, brass, and occasionally gold. After the inlay is burnished, the vessel is coated with a mud-based paste containing ammonium chloride, potassium nitrate, sodium chloride, and copper sulfate. This treatment gives the body its characteristic dark appearance and achieves the striking contrast of the shiny, inlaid design and the dark, matte ground.

This compressed spherical vessel is the base of a *huqqa*, an Indian water pipe used for smoking hashish, opium, or tobacco. It is decorated in the *zarnishan* technique—the inlaid pieces of silver and brass are level with the surrounding area. Bidri ware usually has overall floral or geometric motifs, and vessels with pictorial elements, like this one, are rare. It has an undulating landscape filled with trees, flowers, birds, animals, and fish-filled ponds. The pavilions have niches containing vessels, a decorative element often found in Mughal architecture. The beauty and superb workmanship of this piece show that it was executed by a master artisan at the apex of his craft; it must have been commissioned by a discerning patron, possibly as a present for the court. T.T.B.

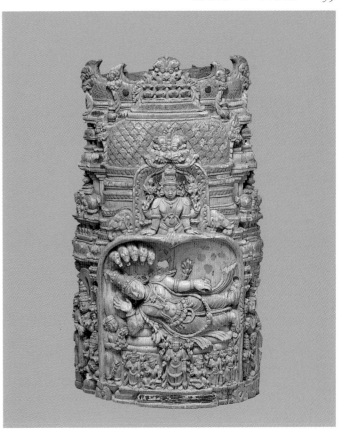

VAISHNAVITE SHRINE

India; Nayak period, 16th–17th century
Ivory with traces of polychrome
H: 8½ in. (21.6 cm)
Purchased with bequest funds from the
estates of Michael D. Weill and C. Barry
Randall B82 M4

This ivory shrine encloses the god Ranganatha, a form of Vishnu, recumbent on the coils of the five-headed serpent Shesha. He is much venerated in this form at the temple of Srirangam, the largest temple complex in southern India. It is among the great architectural achievements of the Nayaks, patrons of art, music, and literature, who rose to prominence after the collapse of the Vijayanagar kingdom in 1565, and who continued the temple building of their predecessors, but on a much larger scale. This shrine is shaped like a *gopuram*—an imposing tower over entrances to temples of southern India—and in fact it replicates the *gopuram* at Srirangam.

As Ranganatha (also called Sheshashayin), Vishnu gave birth to Brahma, who sits on a lotus blossom rising from his belly. Above him stands a partial image of Vishnu, with his attributes the lotus and conch, beneath an archway protected by a fierce-looking Kirttimukha (Face of Glory), who wards off evil and protects the devotee. Two naturalistic elephant heads flank this upper niche. Below Ranganatha stands a four-armed Vishnu accompanied by his consorts Sri and Bhu Devi and three more images of himself. The garland bearer on the left may be the donor who commissioned this shrine. Flanking the central image are two Vaishnavite guardians accompanied by a small figure of Ganesha (left), and another image of Vishnu (right).

This rare ivory carving is remarkable for its size, excellent state of preservation, meticulous rendering of a temple gateway, and exquisite execution of the numerous figures. T.T.B.

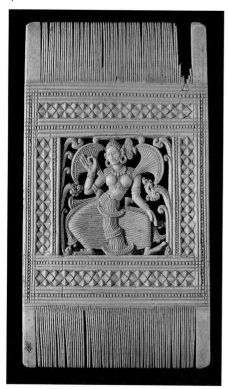

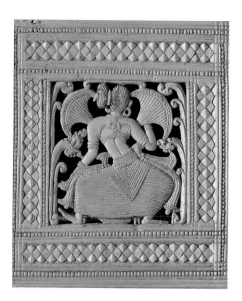

PANAVA (comb)

Sri Lanka, Kandi; 18th century
Ivory
H: 5½ in. (13.7 cm)
The Avery Brundage Collection
B60 M345

Sri Lanka has a long and rich tradition of ivory carving. Ivory came from the male elephant, and Sri Lankan ivory was especially treasured for its dense texture and delicate tint. Ivory carvers of Sri Lanka enjoyed a high position in the medieval period and ranked in esteem with goldsmiths, silversmiths, and painters. Ivory carving especially flourished in the Kandyan period, when Kandy was the capital of Sri Lanka.

This comb, or *panava*, has teeth on both ends. Its body encloses an elaborate dancer carved in openwork and framed by fernlike foliations. The dancer stands with her legs apart and bent at the knee, left foot pointing up as if in the act of tapping. She raises her right hand, thumb and forefinger touching, while her left hand drapes gracefully over her left knee. The densely spaced lines on her garment (a feature typical of Sri Lankan sculptures of this period), together with the fan-shaped shawls above her shoulders and the swaying tassels, all imbue her figure with a sense of movement. The modeling is superb, especially the detail paid to the folds of skin at the waist. The border decoration shows a combination of *arimbuva*, a motif of circles between lines, and *kundirakkan*, the so-called chip-carved diamond patterning, or diaperwork. These are typical patterns in the ivory carver's repertoire. T.T.B.

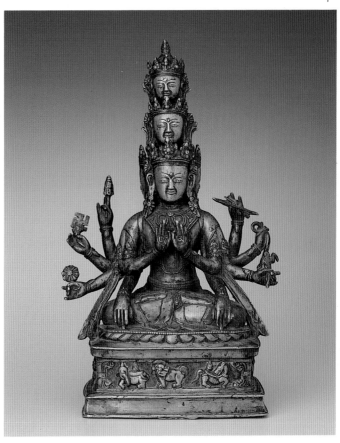

KUN-BZANG RGYAL-BA 'DUS-PA

Western Tibet; 14th century
Brass inlaid with silver
H: 13⅛ in. (33.4 cm)
The Museum General Acquisitions Fund
B84 B1

The swastika attribute and meditation pose with soles of the four feet facing upward identify this very rare Bon image, the first artifact of this religion to be acquired by the Asian Art Museum of San Francisco.

Bon, an indigenous Tibetan religion, predated Buddhism and has coexisted with it through the centuries. Highly ritualistic, Bon emphasizes the divine nature of kings and practices an elaborate cult of the dead. Though its followers, called Bonpos, were persecuted by Buddhists in the eighth century, Bon continued to flourish in outlying regions and was especially popular among nomads of northern Tibet.

Bon returned in full force in the eleventh century, absorbing many facets of Buddhism. Buddhism also assimilated Bon beliefs and practices; native gods and demons were subdued and then entered the Buddhist pantheon as protectors.

Kun-bzang rgyal-ba 'dus-pa is the Bon god of wisdom, a tranquil divinity who is always invoked first in formal rituals. This image came from western Tibet or northwestern Nepal; Kashmiri influence appears in the modeling of the body and the silver inlays of the eyes. Two of his ten hands are in front of his feet, and the two main hands hold disks inscribed with the Tibetan characters *ah* and *ma*. The remaining six carry the wheel, swastika (Bon symbol of indestructibility), umbrella, bow and arrow, noose, and what seems to be a flower. Like Buddhist images, he sits in meditation upon a lotus throne supported by a square pedestal and is guarded by a dragon, elephant, lion, horse, and peacock; the last four are Bon animals of the four directions. T.T.B.

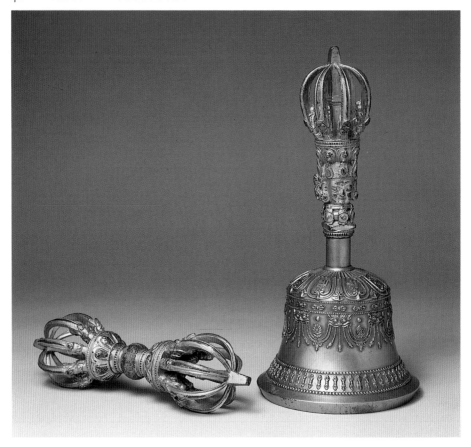

THUNDERBOLT AND BELL

Sino-Tibetan; Ming dynasty,
Yongle reign (1403–1424)
Gilt metal
L. Thunderbolt: 7 in. (17.5 cm)
H. Bell: 9 in. (22.5 cm)
Gift of Margaret Polak B85 B3

The thunderbolt (*dorje*) and bell (*drilbu*) are the most important ritual objects of Tibetan Buddhism. They are a necessary part of prayers and rituals. The thunderbolt represents the male aspect of skillful means, and the bell represents wisdom or supreme knowledge, a feminine aspect. The pair symbolizes the union of these aspects, which leads to liberation and enlightenment.

This nine-pronged gilt thunderbolt consists of eight slender, curved prongs that spring from *makara* heads (mythical crocodilians of Indian origin) positioned around a center post. The bell's handle includes a vase of plenty supporting the head of Prajna, the personi-fication of supreme knowledge, and half a thunderbolt. The goddess's broad face and distinctive five-leaf crown are stylistically consistent with Yongle bronze images; an inscription cast in relief inside the bell confirms that it was made during the Yongle reign.

The Yongle emperor, third emperor of the Ming dynasty, commissioned this superb pair of ritual objects, which are larger than is usual. A fervent Buddhist, he invited Tibetan high lamas and heads of various sects to visit China to instruct him in Tibetan Buddhism. These exalted guests received titles, fabulous gifts, and ritual objects made specially for them. The recipients' high regard for these gifts was confirmed 200 years later, when the Qianlong emperor of the Qing dynasty celebrated his seventieth birthday. Among the gifts he received from the Seventh Dalai Lama were a thunderbolt and bell set made during the Yongle era.

T.T.B.

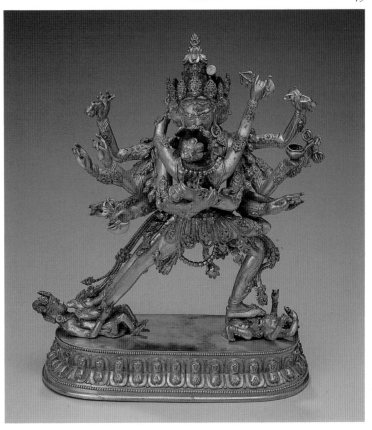

PARAMASUKHA-CHAKRASAMVARA AND VAJRAVARAHI

Sino-Tibetan; 17th century
Gilt bronze
H: 12 in. (30.0 cm)
The Avery Brundage Collection
B60 B179

This superbly cast piece continues the fine work begun in the Yongle period (1403–24), famous for its gilt-bronze images in the Sino-Tibetan style. An important *yidam* or tutelary deity worshiped by the major sects of Tibetan Buddhism, Paramasukha-Chakrasamvara is shown with four heads and twelve arms, holding his partner Vajravarahi in a tight embrace. Their union symbolizes the fusion of wisdom and compassion, which leads to enlightenment. Samvara's major hands, in the gesture of highest energy, hold the thunderbolt and bell. His partner carries the skull cup and the chopper with thunderbolt handle. Samvara is missing some attributes in his remaining hands. According to standard iconography, they should hold (clockwise, from lower left): trident, drum, chopper, axe, elephant hide (held by the two top hands), skull bowl (an alms bowl in this representation), *vajra* lasso (here twisted into the shape of a thunderbolt), the severed head of Brahma, and the *khatvanga*, a ritual staff with three human heads surmounted by a *vajra*.

The name 'Samvara' means 'supreme bliss,' the type of happiness which results from tantric meditation. His rank in the Buddhist pantheon equals that of a Buddha constrained neither by *samsara*, the cycle of death and rebirth, nor nirvana, a state of perfect eternal happiness attained by human beings on achieving Buddhahood. To illustrate this, Samvara stands triumphantly with his right foot over the goddess Kalaratri, who represents nirvana, and his left foot resting on Bhairava, who symbolizes *samsara*.

T.T.B. AND R.K.

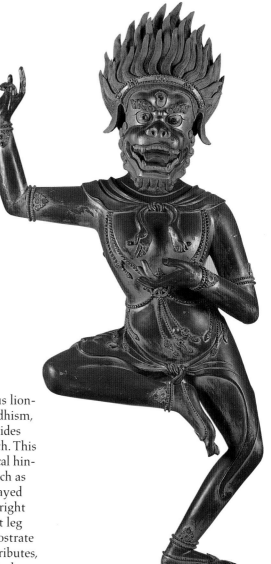

SIMHAVAKTRA DAKINI

Sino-Tibetan; 18th century
Lacquered wood
H: 56 in. (140.0 cm)
The Avery Brundage Collection
B60 S600

Simhavaktra Dakini, the ferocious lion-faced guardian of Vajrayana Buddhism, is a female "sky-walker" who guides human beings along the right path. This powerful spirit can remove physical hindrances and spiritual obstacles such as pride and ego. When she is portrayed alone, she dances gracefully; her right leg is raised and bent, and her left leg would usually be planted on a prostrate human figure (now lost). Her attributes, the skull bowl and a chopper with thunderbolt haft, are missing. She is naked except for jewelry (originally inset with semiprecious stones), a tiger skin girds her loins, and a human skin is knotted around her shoulders.

Together with Makaravaktra Dakini (a crocodile-headed form), Simhavaktra attends Palden Lhamo, the only female goddess among the Eight Guardians of the Law and a special protectress of the Gelug sect and its two leaders, the Dalai and Panchen lamas. Many images of Lhamo were made during the Qing dynasty, when Tibetan Buddhism was China's state religion and the Gelug sect was in favor. When she is in attendance, Simhavaktra Dakini walks behind Palden Lhamo as she rides her mule across a sea of blood, while Makaravaktra Dakini holds the reins and leads the procession.

The size and quality of this piece indicate that it was an imperial object made for the Qing court. Similar Buddhist images appear in old photographs of the imperial temples and shrines of Jehol, present-day Chengde. T.T.B.

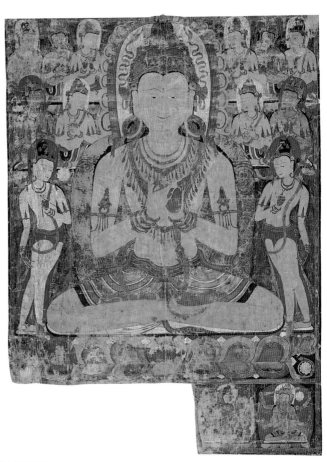

SEATED VAIROCANA WITH ATTENDANTS

Tibet, Tsang; 12th century
Colors on cotton
H: 39½ in. W: 28⅞ in. (100.3 × 72.2 cm)
Purchase: The Avery Brundage Collection,
Sharon Bacon, Mona J. Bolcom,
Dr. Edward P. Gerber, Jane R. Lurie,
Margaret Polak, Therese and Richard
Schoofs, Dr. and Mrs. William
Wedemeyer, and Anonymous Friends
of the Asian Art Museum 1992.58

The last two decades have seen the emergence of a number of newly discovered early (12th–13th century) Tibetan paintings. Linked strongly to the traditions of India and Nepal, these paintings were made during a new dawn of Buddhism in Tibet following a period of severe religious repression. Each new work greatly adds to our knowledge of this early formative period in the art of *thangka* painting.

Vairocana, whose name means 'Illuminator,' is one of the Five Tathagatas, or five transcendent Buddhas. He represents the principle of enlightenment. He usually makes the gesture of teaching and appears clad in white, but here he wears yellow and makes the similar but distinctive diamond-fist gesture that indicates Vairocana's beatific form. In this celestial form he is accompanied by two standing bodhisattvas and two rows of seated ones. The lower register originally contained five six-armed, sword-wielding forms of the Five Tathagatas. Amitabha (red) and Amoghasiddhi (green) remain; missing are the white Vairocana, Akshobhya (blue), and Ratnasambhava (yellow).

The warm palette, arrangement of minor figures in symmetrical registers, and attendants swaying with languorous grace all indicate that Tibetan art was heavily influenced by the Pala art of eastern India in this period.

R.K. AND T.T.B.

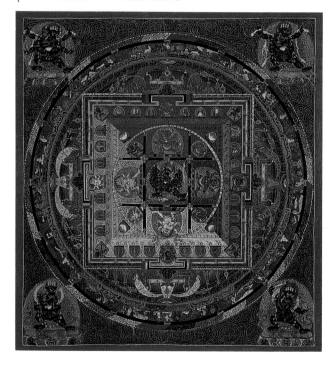

MANDALA OF VAJRABHAIRAVA

Tibet, Ngor Monastery;
17th–18th century
Colors on cotton
H: 16½ in. W: 15¾ in. (41.9 × 40.0 cm)
The Avery Brundage Collection
B63 D5+

In Tibetan Buddhism, the mandala, a mystical condensed image of the universe, is a valuable aid to meditation. Mandalas may be *thangkas,* wall paintings, three-dimensional forms of gilded metal inlaid with precious stones, or even drawings of colored sand for temporary worship.

The basic, circular mandala contains a square palace surrounded by elaborate gateways in the four directions. In a circle in its center a main deity resides, surrounded by numerous deities and guardian figures arranged according to their relationship to him. The palace is encircled by four concentric bands. The Mountain of Fire is outermost, a fiery band denying access to the uninitiated and symbolizing the burning away of ignorance to achieve knowledge. Next is the Girdle of Diamond, ornamented with golden thunderbolts and representing illumination. The Eight Graveyards of the third band remind the believer of the eight mental states to overcome to attain enlightenment. Here, eight morbid scenes marked by white *chortens,* or stupas, depict meditating ascetics among vultures and animals devouring corpses. The innermost band contains lotus leaves that open outward to signify rebirth.

Vajrabhairava, a form of Yamantaka (the wrathful form of Manjushri, conqueror of death) occupies the center of this mandala, and four different aspects of him guard its four corners. His weapon-attributes surround the palace walls; they are usually present on mandalas from Ngor Monastery depicting this deity. Clockwise from upper left they are: shield, drum, *dorje,* bow, bell, banner, flayed skin, banner, a mudra, hammer, spear, stove, pestle, spear, chopper, water sword, single-headed *dorje,* hook, skull club, arrow, axe, trident, *chakra* (wheel), and noose.

This mandala is painted in the Nepalese style, which is characterized by the floral convolutions of the background. It is a style usually associated with Ngor, the legacy of the Nepalese artists who were invited to decorate this monastery in 1429. T.T.B.

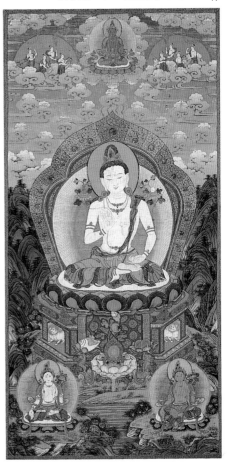

In 1778 the Qianlong emperor received word from the Sixth Panchen Lama that he would arrive in China the following year to celebrate the emperor's seventieth birthday. Delighted and flattered, the emperor ordered a temple to be built in the style of Tashilhunpo (Chinese: Xumifushou), the Panchen Lama's abode in Tibet. The temple complex, at the emperor's summer retreat in Jehol (present-day Chengde), northeastern Hebei province, was sumptuously furnished with Buddhist sculptures, *thangkas,* and ritual paraphernalia.

This painting was among those objects. A long Chinese inscription on the back states that it was one of six scrolls hanging on the east and west wooden walls of a building called The Source of Ten Thousand Laws, located behind the main temple complex. It once housed the Sixth Panchen Lama's relatives and attendants. This inscription allows us to trace the painting's history and date it precisely.

The painting depicts Samantabhadra, one of the eight great bodhisattvas. Behind him on a pale green and blue ground float *ruyi*-shaped clouds above a Chinese-style landscape. He carries the thunderbolt and moon disk on two lotus blossoms; a jeweled mandorla surrounds his elaborate throne. Before the throne, the so-called Offering of the Five Senses appears on lotus blossoms springing from the water below: a mirror (sight), cymbals (sound), conch containing curds (smell), fruit (taste), and a piece of silk (touch). Above Samantabhadra, Amitayus, the Buddha of Infinite Life, holds his attribute, the vase containing the water of life, from which a tree grows. Before Samantabhadra sit the two female deities, White Tara (p. 49) and Green Tara. Amitayus and White Tara are worshiped for long life; Green Tara grants all wishes. They form a powerful triad for the granting of longevity, an appropriate motif for the emperor's birthday. T.T.B.

SAMANTABHADRA

China, Chengde, from the Xumifushou Temple; made ca. 1779–1780,
Qianlong reign (1736–1795)
Colors on cotton
H: 56½ in. W: 27¾ in. (143.5 × 75.0 cm)
Gift of Katherine Ball B72 D67

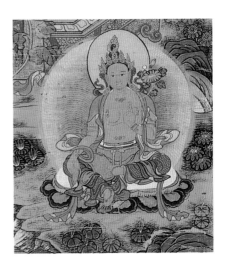

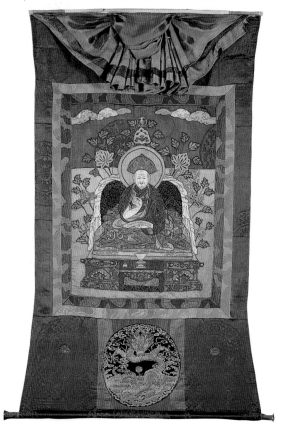

PORTRAIT OF SHAKYA GYALTSEN

Bhutan; 19th century
Brocade appliqué embellished with embroidery
H: 26⅛ in. W: 20¼ in. (66.6 × 51.3 cm)
The Avery Brundage Collection
B62 D34

In Bhutan, male needleworkers and monks make popular appliquéd images of sacred beings and famous monks. Of Chinese origin, this technique is widely practiced in Tibet, Mongolia, and other Himalayan countries.

The ground and figure of this *thangka* consist of colored, appliquéd silk tabby, damask, and silk brocades. Details are embroidered with multicolored silk floss in basic satin, encroaching satin, chain, outline, and seed-knot stitches. Outlines are couched in gold-wrapped thread.

The *thangka* depicts a lama of high rank, richly clad in an abbot's robes and sitting on a pile of cushions above a throne, with his legs wrapped in his outer garment. His right hand is raised in the gesture of argument; his left hand holds a book. The red hat, elaborately couched with a design of the Wheel of the Law, identifies the Drukpa sect of Bhutan. Across the back of the throne is draped a white silk ceremonial scarf; lotus blossoms spring from behind it. A small image of the Buddha Vajrasattva, holding a bell and thunderbolt, surmounts the *thangka*.

From the early seventeenth century until 1907, Bhutan practiced a dual system of administration whereby a spiritual leader ruled the clergy, and a temporal ruler looked after affairs of state. A Bhutanese inscription on a paper tag attached to this work identifies the central image as Shakya Gyaltsen (1813–75), who was twice head abbot of Bhutan, in 1865–69 and again in 1875. This *thangka* is thus not only a beautiful work of art, but an important document reflecting Bhutan's unique system of government.

T.T.B.

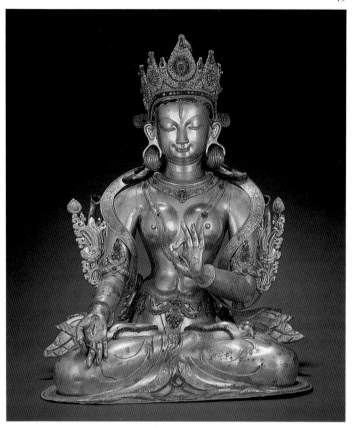

WHITE TARA

Nepal; 15th–16th century
H: 21½ in. (53.7 cm)
Gilt bronze repoussé inlaid with
precious stones
The Avery Brundage Collection
B60 S22+

Widely worshiped as the Buddhist god-
dess of compassion, Tara is a female
bodhisattva, Avalokiteshvara's counter-
part. The tears he shed for suffering
sentient beings created her. Tara has
twenty-one forms; the peaceful White
Tara comes from tears of Avalokitesh-
vara's left eye, the fierce Green Tara
from those of his right.

White Tara has a third eye on her
forehead and eyes incised on her palms
and soles. Devotees invoke her for de-
liverance from the Eight Great Perils—
shipwreck, fire, mad elephant, brigands,
pouncing lion, serpent, prison, and
demons.

The youthful goddess sits with
her feet in the posture of meditation,
left arm raised in the gesture of argu-
ment and the right one lowered in the
gesture of blessing. Both hands hold
lotus stalks that were once attached to
now-lost blossoms at her shoulders.
Her headdress and jewelry are inlaid
with turquoise, lapis lazuli, and foiled
crystals. This elegant statue was created
by the Newars of the Kathmandu valley,
who remain among the best artists and
craftsmen of Asia, and who excelled in
bronze casting and repoussé work. They
decorated the temples of Tibet as far
back as the seventh century. In the thir-
teenth century, a group of Newari artists
was summoned to China by Khubilai
Khan, thus introducing Nepalese art to
the imperial court of China.

This sculpture was made in several
pieces, welded together, and fire-gilded
—a process by which gold dissolved in
mercury is applied, then heated to vola-
tilize the mercury, leaving the gold ad-
hering to the surface. T.T.B.

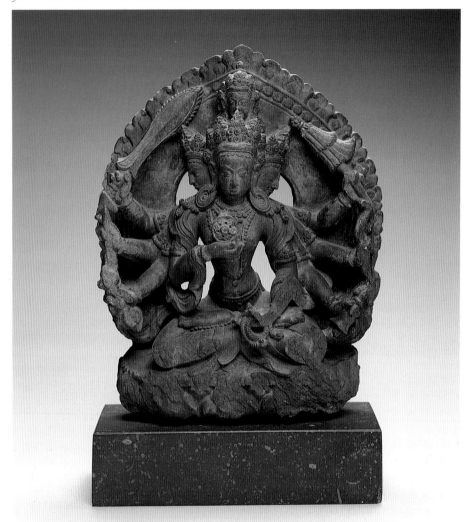

MAHAPRATISARA (?)

Nepal; 16th century
Schist
H: 9½ in. (23.7 cm)
The Avery Brundage Collection B69 S9

This four-headed, eight-armed deity is tentatively identified as Mahapratisara, chief among the Pancaraksha, the five goddesses of spells, who are Buddhism's protectors. Like Prajnaparamita (p. 28), who personifies the sutra for which she is named, Mahapratisara and her four companion goddesses personify the spells of the *Pancaraksha* manuscript, a popular book in Buddhist households. The five goddesses are invoked for protection against all sorts of trouble and misery, including drought. Women especially invoke Mahapratisara to grant them a safe gestation and childbirth.

In this sculpture she is conceived as a youthful goddess with three heads and eight arms, seated with her legs locked in meditation. She is an emanation of Buddha Ratnasambhava, and his head appears above her three heads. Her major hands hold the discus and noose; the other hands grasp the sword and parasol, arrow and bow, and thunderbolt and bell. Not all her attributes correspond to those described in the standard iconography books; this rendering, however, may be a later Nepalese version.

Like the ivory Buddha (p. 52), this sculpture also shows the influence of Pala period carvings. T.T.B.

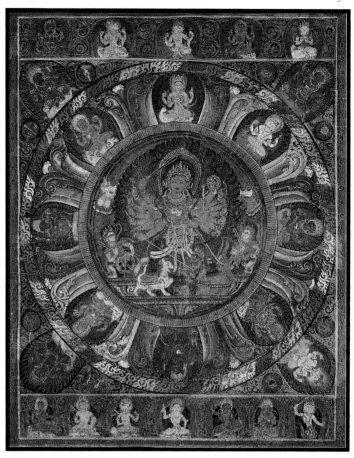

DURGA MANDALA

Nepal; ca. 1500
Colors on cotton
H: 31 in. W: 25¼ in. (78.7 × 64.1 cm)
Gift of Margaret Polak B87 D22

The mandala, a mystical diagram composed of geometrical shapes (usually a circle within a square), is used to aid meditation and is prevalent in both Hindu and Buddhist art. The central deity of this painting is Durga Mahishasuramardini, the powerful goddess that the Hindu gods created to combat the buffalo demon Mahisha.

Surrounded by flames, the militant Durga stands on a stylized lotus pedestal, her eighteen arms brandishing various weapons. She plunges her trident into the demon, who has just emerged from the beheaded buffalo. Her lion mount stands before her, confronting her enemy.

Durga is surrounded by the eight mother goddesses, the *shakti*, female energies of the gods. Clockwise, from the top, they are: Brahmani, Maheshvari, Kaumari, Vaishnavi, Varahi, Indrani, Chamunda, and Devi. The four corners are guarded by Bhairava, a red goddess on a deer, a red god on an elephant, and the elephant-headed Ganesha (see p. 33). Various gods and the nine planetary deities occupy niches in the top and bottom borders, on a ground of curling tendrils.

Red predominates in Nepalese paintings of this period; the use of primary colors, stylized lotus pedestals and flames, and the tendency to fill all available space with foliation are also characteristic. The Newari artists brought this style to Tibet, where it continued to flourish in the wall paintings and *thangkas* of Sakya and other temples. T.T.B.

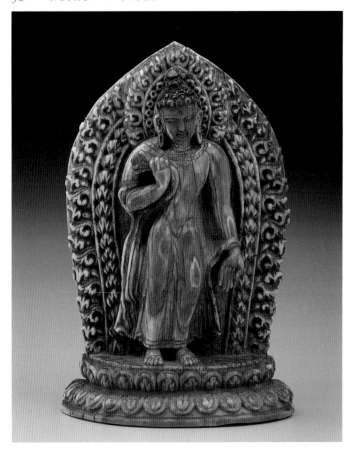

STANDING BUDDHA

Nepal; ca. 12th century
Ivory with pigments
H: 4¼ in. (10.8 cm)
Gift of the Connoisseur's Council
B87 M19

Ivory carvings from Nepal are rare, especially works of high quality. This exquisite carving shows the Buddha Shakyamuni standing with a slight sway on a double-lotus pedestal. His left hand grasps part of his cloak; his right is lowered in *varada mudra*, the gesture of bestowing gifts. A flaming halo and an elegant aureole incised in low relief surround him.

This work is reminiscent of the eastern Indian Pala style of Buddhist sculpture (see p. 27), which made a profound impact upon the early Buddhist art of India's neighboring countries. When Muslims destroyed the Buddhist centers of the Palas in the twelfth century, many monks fled to Nepal, Tibet, and the countries of Southeast Asia, bringing the Pala style with them.

Although the style of this piece reflects the clear outlines and formal posture of the Pala tradition, the sweet facial expression and graceful movement indicate a Nepalese provenance. The richness of the flaming halo also is more characteristic of Nepalese workmanship.

The blue hair indicates that this piece was once in Tibet, where Buddhist images were customarily painted in various colors that identify them and symbolize their special attributes. The color blue indicates peaceful deities, such as this one, while guardians and other ferocious deities have red-painted hair. A small image like this one would have been placed in a private shrine. This work could have been carved by a Nepalese craftsman in Tibet, or traded or otherwise transported there from Nepal.

T.T.B.

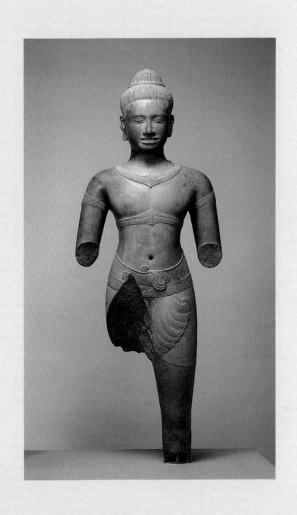

SOUTHEAST ASIA

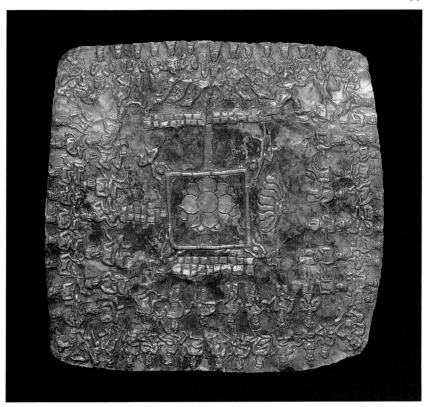

DEDICATORY PLAQUE

Cambodia; 8th–9th century(?)
Gold repoussé
H: 10½ in. W: 11½ in. (26.7 × 29.2 cm)
Gift of the Walter and
Phyllis Shorenstein Fund 1988.12

The dedication of a temple in ancient Southeast Asia was an important religious and secular event. The temple, usually located on a hill, represented a microcosm of the universe—the gods' domain on earth. A ruler legitimized his power through its establishment, and it served as the center of his kingdom.

The *Agni Purana* states that a tortoise and five objects of cosmological significance should be buried in the foundation of a temple. Gold repoussé images of gods, lotuses, and animals often were buried to commemorate it. This dedicatory plaque, much larger and of greater iconographic complexity than any previously discovered, may derive from the *Vastupurushamandala*, a cosmological diagram of a Hindu temple. It transforms secular into sacred space and must be inscribed at the site before the temple's dedication.

If the plaque derives from this diagram, the thirty-two figures along three sides of the square represent the *nakshastras,* constellations sacred to particular divinities. On the fourth (top) side, the *adityas,* months of the solar year, flank an unusual composite Vishnu-Surya image that holds the reins of Surya's chariot. Puranic literature and a syncretic tendency in Southeast Asian religion support this interpretation.

The Hindu god of fortune, Ganesha, appears at each corner. A single dancing figure below the *adityas* and to the right of the central lotus may personify Vishnu's weapon the *chakra,* or discus, although this dancing *chakrapurusha* (wheel person) is unusual in Southeast Asia.

One version of the *Vastupurushamandala* has sixty-four squares. The figures on this plaque total sixty-four, plus Vishnu-Surya, the Ganeshas, and the *chakrapurusha.* Thus their numbers support this identification. N.T.

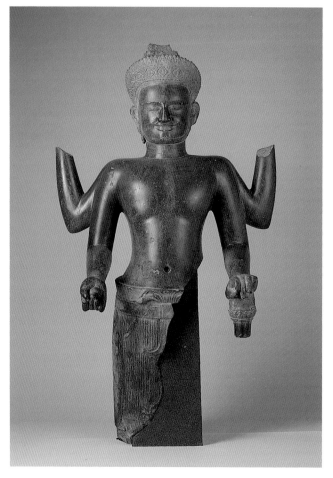

VISHNU

Cambodia; Pre Rup style,
mid-10th century
Gray sandstone
H: 56 in. (140.0 cm)
The Avery Brundage Collection B65 S7

During the earliest period of Indian influence (5th–8th century), the Cambodian region's sculpture and temples reflected the worship of Vishnu. Between the ninth and thirteenth centuries the Khmer (Cambodian) kings dedicated a multitude of temples to Hindu gods and goddesses, especially in the great city of Angkor, but in the ninth century they turned, with a few exceptions, to the worship of Shiva. Still, the aristocracy continued to produce images of Vishnu, dedicating some of their temples to him. Vishnu's role as the preserver or protector of the cosmos contributed to his popularity. He saved the world from demons and perils, a responsibility requiring him to assume various forms, or avatars, such as Rama or Krishna.

As Vishnu he holds a conch, discus, lotus, and a club or mace. In Southeast Asia the lotus was often replaced by a circular object that may be a lotus bud but is sometimes interpreted as a clod of earth. Although this Vishnu has two broken hands, the mace in his lower left hand and the circular object in his lower right identify him.

Tenth-century Khmer sculpture tends to be bold and powerful, with large, smooth surfaces of flesh broken by dramatic sweeps of cloth, as in Vishnu's skirt. Typical of the Pre Rup style are the high, arched forehead, the sharp ridge of the continuous eyebrows, and the distant but benign expression. The most spectacular feature may well be the octagonal tiara and high diadem of the headdress. N.T.

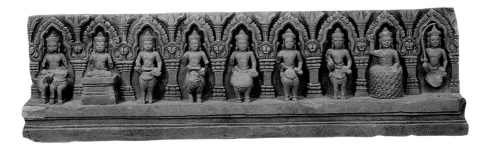

THE NINE PLANETARY DEITIES

Cambodia; 11th century
Sandstone
H: 14¾ in. L: 54¾ in. (36.8 × 136.8 cm)
Gift of Ed Nagel B71 S9

The Indian Puranas, texts relating the legends of the Hindu gods, are a source for the cosmology and much of the iconography in the decoration of a Hindu temple. In both India and Southeast Asia, the desire to recreate a complete universe in microcosmic form led to the construction of elaborately decorated and ritually significant temples.

The *Agni Purana* describes a group of nine planetary deities, the *navagraha,* or 'nine seizers,' a term indicating each one's ability to seize upon humans and influence their destiny. The Purana prescribes that these deities be placed in their own building. In eastern India, however, the *navagraha* adorned the lintel over the door; elsewhere in India, these minor deities were placed in the porch of the temple.

Khmer sculptors and architects interpreted the texts literally, apparently installing the *navagraha* separately in the temple compound. The freestanding nature of this frieze and many like it attest this group's importance.

We can identify the deities in the individual niches of this frieze (from left to right) by their mounts or vehicles: Surya (Ravi), the sun god in his horse-drawn chariot; Chandra (Soma), the moon god; Mangala, the planet Mars, on his goat; Budha, the planet Mercury, on his bird; Brihaspati (or Indra), the planet Jupiter, on his elephant; Shukra, the planet Venus, on his horse; Shani (Yama), the planet Saturn, on his buffalo; Rahu, the ascending node of the moon, standing in clouds; and Ketu, the descending node of the moon, on his lion. He carries a snake noose. N.T.

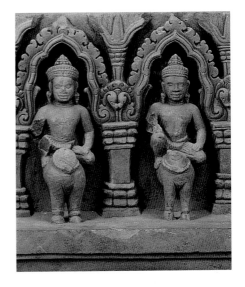

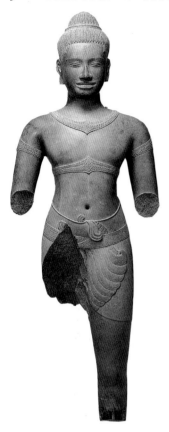
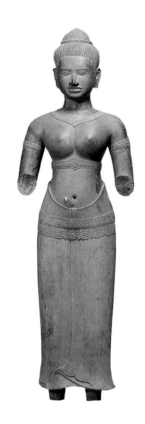

SHIVA AND UMA

Cambodia; Baphuon style,
late 11th century
Veined sandstone
H. S2: 44 in. (110.0 cm)
H. S3: 41 in. (102.5 cm)
The Avery Brundage Collection
B66 S2, B66 S3

The Khmer architects and sculptors of
the kingdom of Angkor peopled their
temples with sculptures worthy of the
gods. Dedicated to the Hindu deities
Vishnu and Shiva, or to figures of the
Buddhist pantheon, such as the Buddha,
Lokeshvara, and Prajnaparamita, these
temples served a religious function and
also formed the central locus of an ex-
tensive city, rich and varied.

The Khmer people combined ele-
ments of their indigenous religion with
the Hinduism and Buddhism they had
adopted from India. Two important as-
pects of this indigenous religion involve
the worship of ancestors and mountains.
Khmer architects combined Hindu in-
digenous mountain imagery into their
pyramidal temples, and temple sculp-
tures often bore the names of both an
ancestor and a god. Whether this Shiva
and Uma were ancestor figures is not
known.

The third eye incised on his fore-
head identifies Shiva, and we can as-
sume that his consort is either Parvati
or Uma. The style of carving, with its
smooth planes and surfaces of flesh
contrasting with finely detailed cloth-
ing and jewels, and its ideal of feminine
beauty, are consistent with sculptures
of the Baphuon period. The skirt, which
rises high in the back, is also a trait of
Baphuon period sculpture.

The stone for these two figures
comes from the same quarry. A study
of it revealed that the color difference
of these two sculptures indicates where
in the quarry the stone was excavated.
Apparently the sculptor selected the
lighter stone for the female and the
darker, from lower in the quarry, for
the male. N.T.

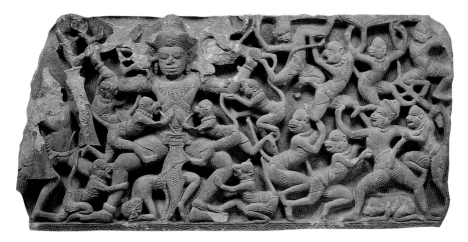

LINTEL

Cambodia; first half of 12th century
Sandstone
H: 35 in. W: 74 in. (87.5 × 187.9 cm)
The Avery Brundage Collection B66 S7

The people of Southeast Asia warmly embraced the great Indian epic the *Ramayana,* in which Rama, an incarnation of Vishnu, triumphs over the ten-headed demon Ravana, who has kidnapped Sita, his wife. The monkey general Hanuman and his armies help Rama to rescue her. It was this portion of the epic that most attracted Southeast Asian artists.

One especially loved episode describes Ravana's gigantic brother Kumbhakarna, who ate and slept prodigiously. A popular scene in Khmer (Cambodian) sculpture shows Kumbhakarna being wakened for battle by a swarm of much smaller demons.

Here the giant engages with the monkeys, who swirl in antagonistic fury around him. Even aided by Sugriva the monkey king (on the right), they were unable to subdue him. Only Rama, with his bow and magic arrows, was able to bring him down.

The artist has captured the lifelike postures and the chaos of the monkeys' movements. Their frantic activity contrasts with Kumbhakarna's stolid resistance, lending expressive tension to the carving. The deep relief creates dark shadow behind the pale stone of the figures, reinforcing the effect of its three-dimensional character.

Door lintels provided an ideal surface for relief carving. Often an abbreviated version of the *Ramayana* would appear on them, single episodes above door after door, the story sequence leading the devotee around the temple.

The style and depth of carving on this lintel differ from the type found in the Khmer capital of Angkor, suggesting it was a provincial production. In the twelfth century the Khmer kingdom included parts of modern Thailand, a production center for sculpture and the location of several great temples. This lintel may have originated there.

N.T.

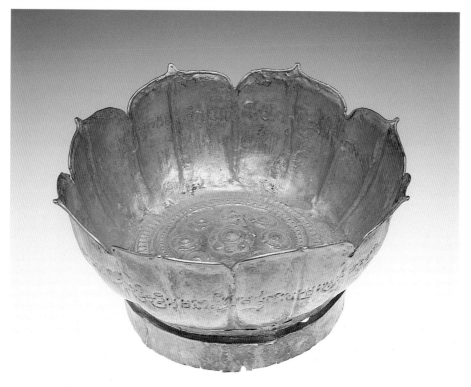

LOTUS-SHAPED BOWL

Cambodia; 12th century
Metal alloy with gold
Diam: 8½ in. (21.6 cm)
Gift of the Connoisseur's Council
1990.201

The offering of lamps, vessels, bronze images, bronze images, incense, and flowers is a common practice in both Hindu and Buddhist temples. In Southeast Asia, a region with abundant gold, gold objects and jewelry were given as temple offerings or as tribute or taxes to a local ruler. Most extant vessels from Cambodia are bronze; this gold alloy bowl is an especially rare object.

The cavetto of the bowl is in the form of a lotus with eight petals. The outer margin of the petals is edged with a soldered gold wire, and the petals are each delineated by ridges in the middle and sides. Like other repoussé bowls throughout Southeast Asia, this one appears to be of one piece, with a soldered base. A central rosette with eight smaller rosettes adorns the bottom of the bowl's interior.

An inscription engraved on the exterior of the cavetto is only partly decipherable, but reveals that the bowl was of Khmer production. Vessels are often difficult to date, but this script can be dated to the twelfth century. The Khmer title *kamrateng* is legible, as is the name *aditya* or *manaditya*, which occurs twice. This name is of interest, as it indicates the bowl was not a product of royal patronage; Khmer rulers' names invariably ended in *-varman*. A place indicator, *vrah srok sri,* is also legible but of little use, because the name of the town where the vessel was produced or the temple where it was dedicated is unreadable. N.T.

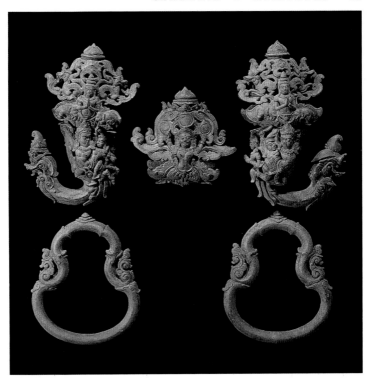

PALANQUIN FITTINGS

Cambodia; late 12th century
Bronze
(Clockwise from top left) H. 1: 13⅛ in.
(33.5 cm); H. 2: 8¼ in.; (21.0 cm); H. 3:
13¾ in. (34.1 cm); H. 4, 5: 10 in. (25.4 cm)
Purchase: The Avery Brundage Collection
1992.346.1–5

The carved reliefs in the galleries of twelfth-century Angkor Wat or thirteenth-century Bayon, in the ancient city of Angkor, evoke echoes of horses' hooves and the bustle of commerce. These sculptural reliefs confirm thirteenth-century Chinese descriptions of the life and possessions of the Khmer people, whose wealthy citizens rode horses or elephants, or were carried about in palanquins by slaves.

A variety of bronze fittings adorned palanquins, chariots, and saddles. The relief carvings of Angkor depict a wide range of these finials and hooks, part of battle regalia in the scenes of combat that form the theme for this great art.

This set of hooks and rings functions differently from palanquin fittings depicted in Angkor Wat carvings. Here the tubular central piece and hooks (top) received poles, to which these fittings would have been fastened by pins or bolts to prevent them from sliding. The palanquin itself was lashed with rope or fabric to the rings, which were suspended from the hooks. Bearers carried the whole apparatus by the poles.

Nagas (snakes) and *garudas* (Vishnu's mythical bird) were the most common motifs for palanquin fittings. Elaborate, dragonlike *nagas* appear on the upper part of these hooks, and smaller versions flank their topmost part and the central piece. This clear representation of the *naga* differs from most bronze examples of this time; more commonly the *nagas, garudas,* horses, or elephants are lost in abstract foliage and curlicues.

A pair of figures locked in combat appears on the hooks. Above them an adoring female emerges from foliage; the elephants flanking her identify her as Lakshmi. Another adoring female, in profile on the side opposite the hook, raises her hands to her chest and smiles as if to deny the chaos around her.

N.T.

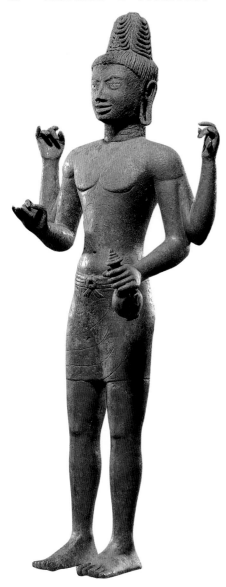

MAHAKARUNA LOKESHVARA
Thailand; 7th–8th century
Bronze
H: 27½ in. (68.7 cm)
The Avery Brundage Collection
B65 B57

The monsoon rains that hit Pra Khon Chai, Thailand, in 1964 revealed a burial chamber in the foundations of a local temple, where amazed villagers discovered a hoard of bronze Buddhist sculptures. One scholar suggests that a change in the religious affiliation of the Canasa kings, who ruled this area during the seventh through tenth centuries, had forced local Buddhists to hide the bronzes.

Most of these sculptures are the bodhisattvas of Mahayana Buddhism, benevolent, enlightened beings who postpone their own enlightenment to aid all sentient creatures on that path. Mahayana Buddhism offered the possibility of enlightenment to all beings through the bodhisattva's intervention.

A few of the Pra Khon Chai pieces represent the Buddha. One oddity of the group is the disparity in style between the Buddhas and the bodhisattvas; the bodhisattvas are closer to Khmer (Cambodian) sculpture, while the Buddhas relate more to Dvaravati (Thai) sculpture. Yet similarities appear in the bronze used for both. Inlay is used in the eyes of some figures, and other shared details suggest that they may come from the same workshop.

The seated Buddha in the headdress of this piece identifies a form of Lokeshvara, the bodhisattva of compassion. This four-armed version of the bodhisattva holds the water vessel, book, lotus bud, and rosary—attributes of Mahakaruna Lokeshvara, whose ability to offer protection from danger may have accounted for his enormous popularity throughout much of Southeast Asia.

N.T.

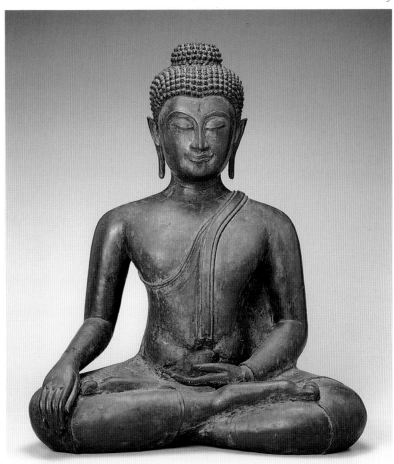

BUDDHA

Thailand; Lan Na style, 16th century
Bronze
H: 26½ in. (63.3 cm)
The Avery Brundage Collection
B60 S150+

King Tiloka reconstructed the seven stations of Bodhgaya, the site of Buddha's enlightenment, in Chiang Mai, south of Chiang Saen. The attempt to relocate the sanctity of Bodhgaya in Thailand also included a nostalgic reliance on earlier styles of sculpture. Thus sculptures of the period recall the Pala-Sena style (8th–12th century) of northeast India. So little remains of the earlier Buddhist art of northern Thailand that for lack of evidence we cannot study the evolution of the style.

Lan Na Buddha images fall into the early (14th–15th century) and late periods (late 15th–16th century). We know little of the stylistic development of these images, but more about the later than the earlier group.

Inscribed bronzes from northern Thailand place the late Chiang Saen style images between 1470 and 1565. Typically the shoulders are broad, the face is a rounded and full oval, and the drapery opens on the right shoulder. The legs are folded in the lotus position, and the Buddha holds his right hand in the *bhumishparsa mudra,* the earth-touching gesture. This example also relates to images from Phitsanulok.

Thai artisans relied on the metaphoric language of Indian texts for their representations of the Buddha: nose like a parrot's beak, shoulders like the trunk of an elephant, hands opened like a lotus. These attributes contribute to the elegance of this Buddha, while the taste for convex curves and voluptuous forms adds to its sensuality. N.T.

ROOF RIDGE OR GABLE FINIAL

Thailand, Sukhothai; 14th–15th century
Stoneware
H: 20¾ in. (52.5 cm)
The James and Elaine Connell Collection
of Thai Ceramics 1990.16

In the fourteenth- through sixteenth-centuries, kilns of central Thailand produced a wide range of ceramics for domestic use and export. Si Satchanalai, one of the twin cities of the kingdom of Sukhothai, perfected glazed ceramics in the region. Its production center included up to 800 kilns, while the city of Sukhothai itself, with its coarser, dark clay, constructed approximately 50 kilns.

Dishes, covered boxes, lamps, *kendis*, incense holders, and waterdroppers were created for domestic use and export. Objects such as small figurines to people the Thai spirit houses, and architectural elements, remained in Thailand.

Architectural elements were created at the cities of Sukhothai and Si Satchanalai. They are so similar in style that often only differences in the clay reveal the kiln site. Although today none of these finials remains in situ, we know ceramic end-tiles adorned wooden roofs, as illustrated in one relief carving from the fourteenth-century temple Wat Si Chum, in Sukhothai. The adoring figure (*thepannom*) is a typical subject for these finials, which were attached to the roof by a dowel. Here the *thepannom*, surrounded by tendrils, bursts out of a lotus blossom.

Khmer (Cambodian) architecture provided a precedent for triangular or leaf-shaped elements placed on the temple roof. While Sukhothai and Khmer architecture differ, details of the earlier were adopted in the Sukhothai region in both ceramic and stucco decoration. Domestic architecture was constructed in wood, as were some of the buildings in the temple compounds; the more elaborate of these buildings were probably also decorated with ceramic fittings. N.T.

PHRA MALAI MANUSCRIPT,
dated 1844

Thailand
Colors on paper
H: 5⅜ in. W: 27 in. (13.6 × 68.5 cm)
The Museum General Acquisitions Fund
1993.10

To acquire spiritual merit, a Buddhist layman can perform numerous acts of piety—make offerings to a temple, feed a monk on his daily rounds, or commission a manuscript of a sacred text. In Thailand, manuscripts are produced on palm leaf or, like this book, on paper, which could be folded like a fan to produce a two-sided book.

In the nineteenth century the most common subject of illustrated Thai manuscripts was the account of the monk Phra Malai, who journeyed to heaven and hell. His accumulated merit and meditation enabled him to fly. This text was often recited at funerals to remind mourners of what awaits us after death. An inscription dates this manuscript to 1844, which is unusual, as manuscripts before 1850 are rarely inscribed. The Thai text is written in Cambodian script.

The full-page hell scene describes the torments Phra Malai witnessed in the course of his journey. Here adulterers are condemned endlessly to climb a thorn tree while being attacked by vicious animals and hell guardians. In the central scene a man is inserted to boil in a cauldron fueled by a body, while a fantastic monkey dances, musicians play, and below, a dog devours a corpse.

The head of one figure has been removed, possibly for medicinal use. At the right Phra Malai, in his red monk's robes, flies over two skeletal beings who raise their hands in devotional attitudes and ask him to take cautionary messages back to their families at home. N.T.

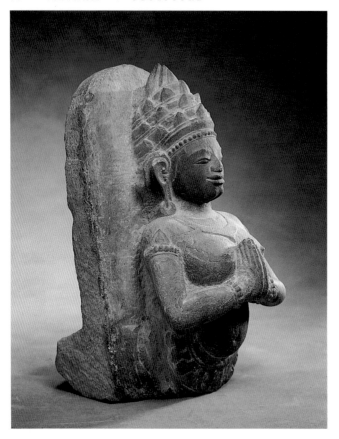

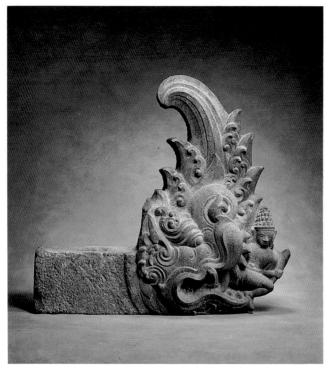

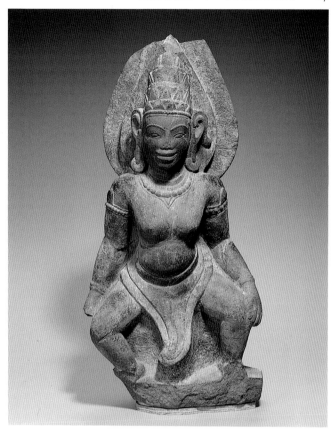

DEVOTIONAL FIGURE, MAKARA, AND DANCER

Vietnam; Thu Thien, 13th century
Stone
H. S1: 37 in. (94.0 cm); H. S2: 22½ in.
(57.2 cm); H. S3: 28 in. (71.1 cm)
On loan from the Christensen Fund
BL77 S1, BL77 S2, BL77 S3

From the fourth century on, the Cham, an Austroasiatic people who speak a Malayo-Polynesian language, occupied the narrow strip of land in Vietnam that borders the South China Sea. Their earliest capital was located close to present-day Danang, but their flourishing mercantile nation was gradually pushed south by the Vietnamese, who finally conquered them in the fifteenth century.

Indian culture had a profound effect on the Cham; their inscriptions often appear in both Cham and Sanskrit, and they adopted Hinduism and Buddhism, which in turn absorbed the mountain worship they practiced. Their most sacred temple complex was located in a valley near the sacred mountain Mi Son, but most Cham temples are situated on mountaintops and likened to mountains.

These two figures and the *makara*, a fanciful crocodilian, were once mounted inside Thu Thien, a thirteenth-century temple located in Binh Dinh province. Typical of sculptures of this date are the big, broad surfaces and blocky figures barely sketched in the stone from which they are carved.

Like the majority of Cham temples, Thu Thien was dedicated to Shiva, who is often known as the king of the mountain. Cham temples frequently contained elaborate altars and minor deities. A popular Hindu invocation states: "All beings dwelling in the three worlds assemble there [in the temple] to witness the celestial dance [of Shiva] and hear the music of the divine choir at twilight."

N.T.

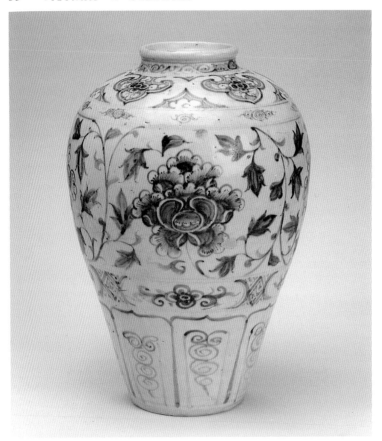

BALUSTER JAR

Vietnam; 15th–16th century
Stoneware
H: 15½ in. (39.3 cm)
Gift of Betty Alberts, Forrest Mortimer,
C. David Bromwell, David Buchanan,
Marjorie Seller, and the Connoisseur's
Council 1992.347

In the fourteenth century potters began to decorate fine, white-bodied wares with underglaze iron black. Chinese political ascendancy in the Ming period (1363–1644) and the popularity of Chinese porcelains influenced and stimulated the development of Vietnamese blue-and-white decorated wares, which were eventually exported in large numbers to Indonesia, the Philippines, and locations around the South China Sea.

Vietnamese potters experimented with reproducing their underglaze-iron designs in cobalt imported from Yunan in southern China. This cobalt did not yield the fine blues of the Chinese potters' Persian cobalt, but tended to fire gray; only in the fifteenth century did the Vietnamese acquire a cobalt that fired a true blue. The base of this jar reveals an unglazed, grayish-white clay. The glaze bubbled at firing, apparently a frequent problem, as many Vietnamese blue-and-white wares exhibit this flaw.

The gray-blue decoration of this baluster jar may indicate a relatively early date. Bands of decoration adorn it from lip to foot: a scroll pattern, a series of trefoil motifs, stylized clouds, diamonds, flowers, lotus petals, and big, droopy peonies that fill the large panels of the body. The lotus motif and the painting style of the peonies are consistent with decoration on fifteenth- and sixteenth-century vessels.

Large blue-and-white baluster jars of this type are still used on Buddhist altars in Vietnam, and we can assume that Buddhist devotees once used this one for that purpose. N.T.

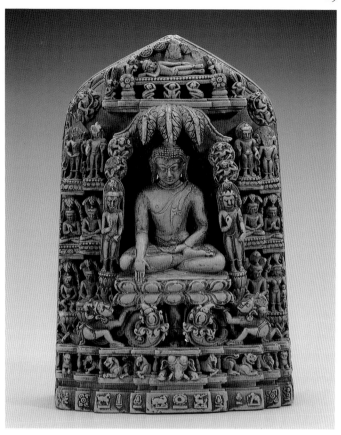

ANDAGU

Burma (Myanmar) or northeastern
India(?); ca. 12th century
Pyrophyllite
H: 6½ in. (16.5 cm)
Gift of the Connoisseur's Council
1991.224

Andagus are small plaques illustrating the eight scenes from the life of the Buddha and the activities of the seven weeks following his enlightenment. The original provenance of these small portable plaques is problematic, but recently most have been found in Burma and Tibet. The majority of *andagus* are most consistent with the iconography and style of Burma, suggesting that they were produced there. The Tibetan inscription on the back, *om ah hum* (body, speech, mind), indicates that this example traveled to Tibet.

The central, seated Buddha holding his hand in *bhumishparsa mudra* illustrates his triumph over Mara. Other scenes depicted are (from lower right, outer register): Buddha's birth, first sermon, the taming of Nalagiri, the Parinirvana (at the top), the descent from Trayastrimsa, the miracle of Sravasti, and the monkey's offering. The inside register and the central image illustrate the activities of the seven weeks following the Buddha's enlightenment, an iconography of particular interest to the Burmese.

Though iconographically consistent with comparable pieces, this *andagu* is stylistically aberrant. The central Buddha does not have the short neck and chin-to-chest posture nor does it have the delicate, childlike body of most Burmese-style Buddhas, and the oval face is more similar to northeastern Pala sculpture. N.T.

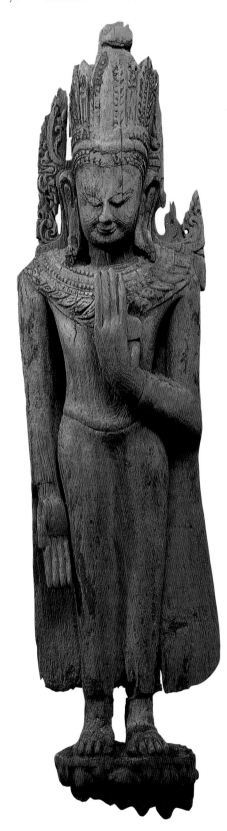

CROWNED BUDDHA

Burma (Myanmar); 12th–13th century
Teak
H: 50¾ in. (129.0 cm)
Gift of Raymond G. and Milla L. Handley
B86 S7

Tall Burmese carved wood figures of this type, with their elaborate headgear and necklaces, were once regarded as effigies of royal personages. But crowned images of the Buddha are common in Burma, even though Buddha's iconography dictates that he wear no jewels.

An apocryphal story, recorded since the seventeenth century, explains the Burmese preference for the adorned Buddha. The vain mythical king Jambupati boasted that he was the most handsome and wonderful man in the world. Then the Buddha appeared in his glory, bedecked and bejeweled, before the abashed Jambupati. We do not know if this story was created to explain earlier images whose meaning was no longer understood, or whether it was handed down as part of the oral tradition.

Similar wooden sculptures were discovered at the twelfth- to thirteenth-century temple of Kyaukku Ohnmin in the city of Pagan, center of Burmese culture at that time. Because the custom of donating Buddhas to a temple has prevailed in Burma from the seventh century to the present, it is not possible to date movable objects contemporary to a temple. Carbon-14 dating, however, yielded the date for the wood from which this sculpture is carved.

Like all wooden Buddhas of this type, this one holds the right hand in the gift-bestowing gesture. Left hand to chest, he grasps either the end of his robe or a book. The work elegantly characterizes Buddha's eloquent calm, gentleness, and all-embracing sweetness. The surface of the sculpture is worn, but areas of paint and lacquer attest past decoration.

N.T.

PLAQUE

Burma (Myanmar); Pegu,
15th–16th century
Terra cotta
H: 19½ in. (49.5 cm)
Gift of Jonathan Cobb 1992.198

Burmese sculpture is almost exclu-
sively Buddhist, except for carvings
of the *nats*, or spirits. Buddhist art in
this country consists of sculptures of
the previous lives (*jatakas*) of the Bud-
dha, the life of the Buddha Shakyamuni,
and Shakyamuni himself. The narrative
sculpture is depicted on tiles that orna-
ment the base of temples and stupas
(reliquary mounds), and sometimes
temple roofs.

Tiles like this one adorned the walls
of the temple compound dedicated to the
Buddha's seven weeks at Bodhgaya. King
Dhammaceti (1472–92) constructed the
complex in the fifteenth-century Mon
capital of Pegu. The now largely de-
stroyed central building, Shwegugyi
Pagoda, symbolized the Buddha's first
week at Bodhgaya and his triumph over
the demon Mara's army.

Terra cotta tiles depicting the demon
army were set into the compound wall
of the Shwegugyi Pagoda. These two
figures are typical of the animal-headed
demons going to battle. On other panels
they are depicted in contorted versions
that represent their demise after their
defeat by the Buddha.

Relief sculpture of the fifteenth and
sixteenth centuries includes large figures
on an empty ground. Earlier works tend
to be more spatially developed and con-
tain smaller figures. Though these two
figures are frontally posed, we see that
they walk to the right by the placement
of their feet, the direction of their pro-
files, and the trailing draperies incised
on their legs. N.T.

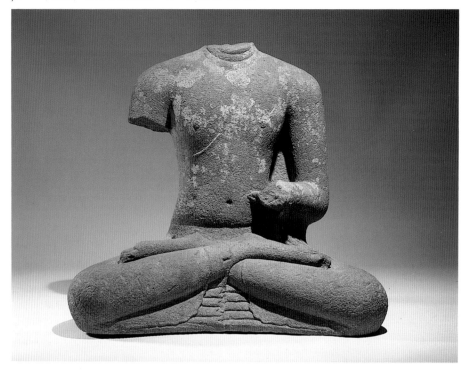

BUDDHA TORSO

Indonesia, Central Java; early 9th century
Volcanic stone
H: 31 in. (77.5 cm)
Gift of The Society for Asian Art and the
Michael D. Weill Bequest Fund B79 S2

Both Hinduism and Buddhism greatly influenced the art of Java, first in Central Java (7th–10th century), then to the east (11th–16th century). Though the earlier sculpture and architecture is heavily influenced by Indian art, it is not possible to link the Javanese style to a specific region of India.

This Buddha may be from Candi Sewu, on the Prambanan plain, or more likely Borobudur, north of Yogyakarta. Borobudur is a Buddhist reliquary mound arranged in five levels of square terraces that are surmounted by three circular terraces. Open-air corridors with over 2 kilometers of relief sculpture line the square terraces and are intersected by stairs on each side.

Ascending the stairs, one moves through an ingeniously conceived sculptural statement of a complex philosophical system. The builders of Borobudur drew on a variety of tantras, sutras, *jatakas* (stories of Buddha's previous lives), and the life of Buddha Shakyamuni to make sculpted reliefs that illustrate increasingly abstract Buddhist texts. The ascending pilgrim thus moves from a mundane world to a realm of higher consciousness.

Perforated stupas, or reliquary mounds, containing seated Buddhas ring the three circular terraces. In Borobudur this Buddha would have been placed on the first circular level inside one of the small, dome-shaped stupas at the top.

Although the Buddha's hands are broken, they could only have made the gesture known as Turning the Wheel of the Law, which is generally associated with Shakyamuni. In later Buddhism, which relied on tantric texts, this gesture sometimes identified the Buddha Vairocana. N.T.

The islands of Java and Sumatra once produced some of the world's finest metal sculpture. Small portable bronzes of Buddhist and Hindu figures first appeared in Southeast Asia in the fourth century. The earliest recall south Indian and Sinhalese sculpture; in the fifth and sixth centuries, the north Indian Gupta style prevailed. In Indonesia, similarity between Pala-style bronzes of north India and Central Javanese bronzes of the eighth through tenth centuries marked the next major influence.

The Buddha Vairocana was one of the five Buddhas depicted at Borobudur, and the major image in nearby Candi Mendut. Vairocana personifies the totality of the universe, and in some systems of Buddhism he is a manifestation of the supreme Adi-Buddha. Here, seated in full yoga posture, Vairocana grasps with his right hand the upraised finger of his left, a typical gesture.

His elaborately decorated skirt has a four-petaled flower motif, echoed in the central medallion above his hands, which may represent a four-pronged *vajra* (thunderbolt). He wears elaborate armbands, necklaces, bracelets, and a sacred thread. The floral detail of the necklace became popular in the tenth and eleventh centuries in the region around Kediri, in Eastern Java; five-pointed crowns are uncommon in South and Southeast Asia before that time.

A lion roars on the front of the throne. His four legs are displayed on its sides, and the tail and hindquarters on the back. Elaborately decorated square thrones are found in Java, Sumatra (Srivijaya), and the Champa kingdom of Vietnam (see p. 67), while the lotus portion, and specifically the double-petaled lotus, is typical of Java. N.T.

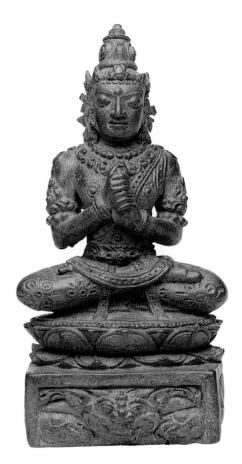

VAIROCANA

Indonesia, Java or Srivijaya;
10th–11th century
Bronze
H: 5 ¼ in. (13.3 cm)
The Museum General Acquisitions Fund
1991.5

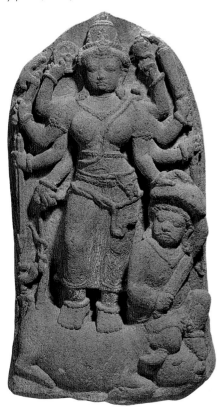

DURGA MAHISHASURAMARDINI

Indonesia, Java; 10th–11th century
Stone
H: 30 in. (75.0 cm)
The Avery Brundage Collection B70 S3

The male gods, unable to defeat the demon Mahisha, each gave a weapon to Durga, enabling her to vanquish him when he assumed the form of a bull. The victorious Durga came to symbolize religious attainment or victory. Hindu Shaivite temples of Java included a Durga, either in an exterior niche or inside, as a primary image. In either place she would be the final image a devotee passed in ritual circumambulation of the temple.

Here Durga, weapons radiating from her hands, grasps Mahisha in his demonic form, while his bull-form body lies prone. This active representation of Durga is typical of both Central and Eastern Java. It derives from north Indian models more animated than their south Indian counterparts, which stand sedately on the decapitated head of the

bull-demon. This sculpture's frontal pose with back slightly arched is a characteristic representation.

A 1917 photograph reveals that this sculpture came from the collapsed Candi Noesokan in the district of Soerakarta, northeast of Yogyakarta. Also appearing in the photo is a seated Shiva, whose three-dimensionality suggests he was placed inside the temple rather than in a niche; we surmise that this Durga was also placed inside.

Durga's full face, heavy body, clothing, and headdress relate to an earlier, more conservative period of Javanese sculpture than the style of the Shiva in the photo might imply. The three-dimensional demon, who twists in space, one arm raised and the other grasping a sword, recalls later demonic figures that protect Eastern Javanese temples. N.T.

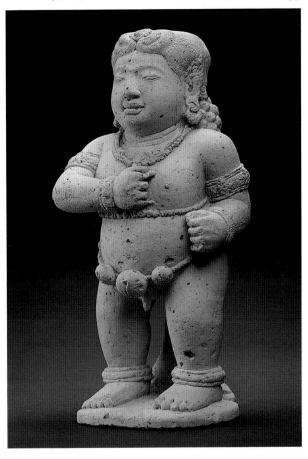

BOY

Indonesia, Java; Majapahit period,
14th–15th century
Tuff
H: 11 in. (27.9 cm)
Gift of Dr. and Mrs. David Buchanan
1991.199

The bells around this young boy's waist suggest an active toddler whose mother is intent on tracing his whereabouts. The rounded face and chubby body and hands also indicate that the figure is a child. Fine-grained and lightweight tuff, a type of volcanic rock, lends itself to detailed and delicate carving, and many of these tuff pieces exhibit a charm and naturalness not commonly found in religious sculpture. Many represent females preening; other subjects are pudgy, seated males, austere or ascetic ones, and religious images.

Few of these three-dimensional tuff pieces have been scientifically excavated, so we remain uncertain about their use. They may have represented the dead in certain ceremonies, or perhaps were arranged in scenes from the fables and epics so popular with the Javanese. They may have been placed as static figures or manipulated during storytelling, as in today's popular puppet performances.

The sculptures are generally dated on the basis of their findspot, Trawulan, capital of the Eastern Javanese mercantile Majapahit dynasty, which flourished from 1293 to 1527. Yet archaeological evidence suggests a longer habitation period for the site. For instance, Chinese Tang and Song ceramics (7th–13th century) have been discovered there, though they may have been imported at a later time. Indigenous ceramics, such as domestic pots and *kendis*, evolve from rougher and coarser wares deriving from Song shapes to particularly fine, burnished, sophisticated wares. Thus the tuff pieces probably span the centuries when Trawulan thrived.

N.T.

MEANDERING CLOUD EARRING

Indonesia, Java; 11th–12th century
Gold
H: ¹¹⁄₁₆ in. (1.8 cm)
Gift of Mrs. Linda Noe Laine in Memory
of the Honorable Clare Booth Luce
B87 M17

Gold ornaments are among the most common seventh- through sixteenth-century Indonesian artifacts. Accidental finds have been an important source of their recovery; most gold of this period has been found in hoards, often buried in cylindrical bronze or clay containers. (The few objects scientifically excavated from archaeological sites in Java come from temple foundations or graves.) Lack of archaeological context makes the dating of jewelry highly conjectural, though a few objects can be dated by comparison with stone and bronze sculpture.

Early Indian and Chinese sources suggest that Java was rich in gold mines, and Javanese inscriptions mention both mines and goldsmiths. But so far, nei-ther mines nor smithies have been discovered in Java.

Gold from the Central (7th–10th century) and Eastern Javanese (11th–16th century) periods was worked in a variety of ways. During these 900 years, jewelry was most commonly cast rather than made by the repoussé technique usually employed today. Rings are the most abundant item, and numerous inscriptions mention gold rings given as tribute to temples or royalty.

Ear ornaments range from small, geometrically designed earcuffs to more elaborate cast ones, such as this meandering cloud ornament. The cloud motif did not become popular until the early Eastern Javanese period, so this cuff cannot date earlier than the eleventh to twelfth century.

Earcuffs were worn on the upper part of an extremely elongated earlobe, as we see in many stone sculptures from the earliest period of Central Javanese art through the Eastern Javanese period.

N.T.

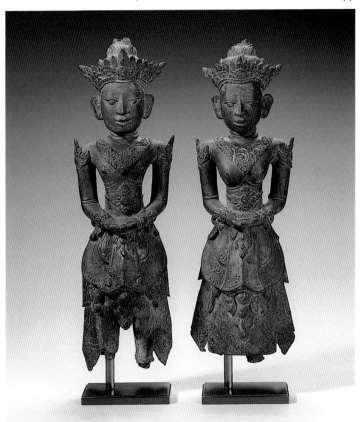

ANCESTOR FIGURES

Indonesia, Bali; 15th–16th century
Bronze
H. B6a: 14⅛ in. (36.0 cm)
H. B6b: 14⅞ in. (37.9 cm)
Gift of the Connoisseur's Council, Shawn
and Brook Byers, and The Museum
General Acquisitions Fund B86 B6a, b

Balinese religion assimilates Hindu-Buddhist beliefs and indigenous beliefs in which ancestor worship plays a prominent role. These rare bronze sculptures probably functioned as ancestor figures. The use of bronze for an image is unusual in Bali; wood or other perishable materials are the traditional media.

In the period preceding the creation of these pieces, a strongly Hindu-oriented Javanese influence accounted for the production of numerous stone sculptures. This bronze couple echoes many stylistic features of the stone images' pose, clothing, crown type, and jewelry, suggesting that the stone and bronze figures served the same purpose. Inscriptions indicate that the stone works were commissioned by individuals.

Both these figures stand in a rigid frontal pose, hands crossed as if suggesting they may once have held an offering. Their clothing, jewelry, and crowns are nearly identical, indicating they are a pair, and were perhaps commissioned by descendants of the deceased for ritual use.

Present Balinese practice requires a cremation, which may take place long after death and burial. Often a few families share the cost of offerings. Sometimes years after the death, purification of the soul takes place, a ritual requiring effigies representing both the body and the soul.

The strong magical quality ascribed to metal would have made these bronzes particularly powerful and important images. A group of comparable pieces was considered so sacred they were kept hidden in a temple until an attempted theft brought them to light in 1928.

N.T.

BURIAL URNS

Philippines, Mindanao; ca. 600
Limestone
H. 1: 28½ in. (72.4 cm)
H. 2: 27 in. (68.6 cm)
Gift of Marion Greene 1991.323.1–2

These burial urns relate to limestone urns excavated at the archaeological site of Seminoho Rock Shelter, Cotabato province, in southern Mindanao. Thirty-six of the Seminoho urns were examined, and carbon-14 dating of human bones associated with them yielded a date of 600. This early date is further substantiated by earthenware found with the jars; it resembles Sa-huynh-Kalanay and Bau-Malay pottery dating to 500.

Limestone jars also occur with this type of earthenware in Vietnam, indicating strong ties between the Philippines and other areas of Southeast Asia. Similarly decorated burial jars have been discovered in Indonesia. A tradition of jar burials existed in the Philippines from the early Neolithic period and continues in this region to the present.

These two limestone jars were discovered in a cave in Cotabato province by residents of a Manobo village. Both are square, with incised ridges on each side. On both jars, zigzags on one side alternate with a continuous diamond pattern on the adjacent side. The lid of one vessel is decorated with the three-dimensional head and arms of a man. The face is quite detailed, depicting eyes, nose, mouth, ears, and a tuft of hair. An incised line circling the head may be interpreted as a diadem.

The other urn has particularly fine, continuous diamond patterning on two sides. The lid is decorated with a cylinder topped with a flat, upward-looking face with cursory features—drilled holes for eyes and nostrils, a common decoration on the lids of these jars. N.T.

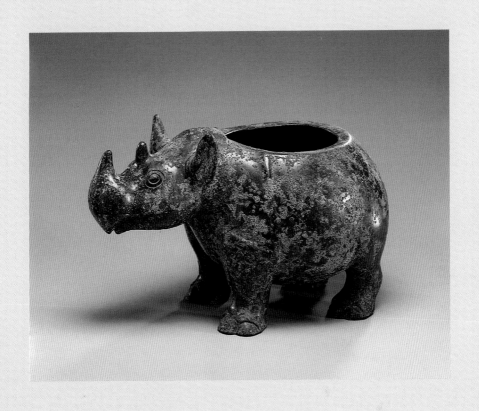

CHINA

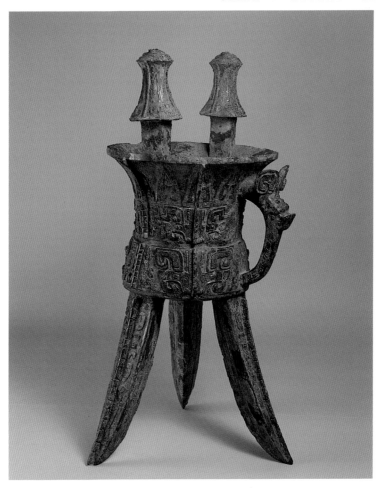

THE YAYI JIA

China; late Shang dynasty, ca. 1300 B.C.
Bronze
H: 29⅜ in. (74.0 cm)
The Avery Brundage Collection
B61 B11+

This monumental *jia*, or wine pourer, was cast as part of a set of bronzes said to come from the tomb of a late Shang dynasty king at Anyang. The entire *jia* is covered with the bas-relief decoration that gained currency around 1300 B.C. Three pairs of animal masks separated by crenellated flanges fill the body. They are arranged in strict symmetry in two registers, which are topped by a third, of standing blades. The handle is a strongly modeled bovine head that devours a bird whose body dissolves into spirals.

The form and decoration of this *jia* are reminiscent of a group of equally large ones excavated at Anyang from the tomb of Fu Hao, the extraordinary and powerful woman who was probably the wife of King Wu Ding (p.129). More ritual events were recorded in the oracle bones incised during his reign than ever before or after; he must have been an active advocate and patron of the ritual arts. Though this *jia* and those of Fu Hao are conservative in shape, they are innovative and even audacious in surface design. The Fu Hao pieces may have been among the first experiments in a new style employing relief decoration against a flatter ground of squared spirals.

On the base of this *jia* is a cast-in mark, a man with outstretched arms carrying a cruciform *yaxing* on his head, which may be read *yayi*. It is likely to be a clan or lineage mark, which appears on many Anyang bronzes. P.B.

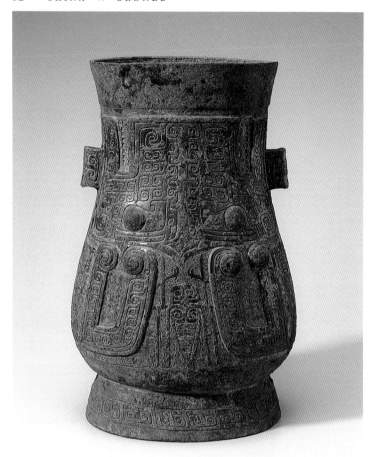

YOU WINE VESSEL

China; probably from Shaanxi province;
Late Shang dynasty,
ca. 13th–12th century B.C.
Bronze
H: 14 in. (35.6 cm)
The Avery Brundage Collection
B60 B6+

In 1959, a commune member stumbled across a late Shang dynasty tomb in Shilou county, Shaanxi province. It held human remains decorated with gold plaques and was equipped, in the Shang style, with a guardian pit and a cache of bronze sacrificial vessels. One of them, a *you* wine container with a loop handle, proved to be a near-mate to this hitherto unique vessel, sharing its unusual use of standard Shang dynasty motifs.

Both vessels use the fierce bovine mask of Shang bronzes in a way that hints at Shang beliefs about ancestral sacrifices and the usefulness of certain animals to effect earth-to-heaven crossings. The mask on this *you* is, as usual, flattened and split in a double profile, each wrapping half the vessel. Though this type of split representation is characteristic of Shang bronzes, the designer of these two vessels turned the masks on end, making their mouths those of ravenous beasts. The composite animal—part ox, part cat, part insect, and master of many environments—literally subsumed the sacrificial wine poured into the vessel, transformed it into a substance the ancestors could enjoy, then spewed it out. This striking alteration of traditional design responds to a trend in later Shang bronze casting that resulted in such sculptural shapes as the *gong* and the double-owl *you* (p. 83), where the animal and the vessel are completely identified with each other, and the inside of the vessel becomes the belly or gullet of the beast. P.B.

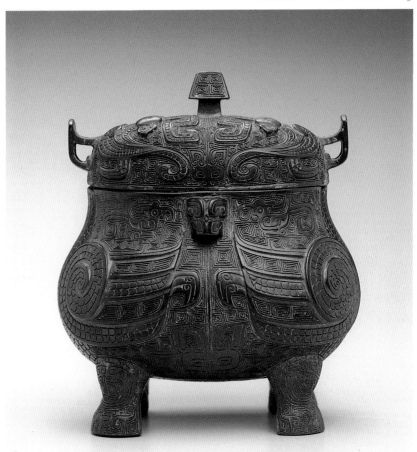

DOUBLE-OWL YOU

China; late Shang dynasty,
ca. 12th century B.C.
Bronze
H: 7⅛ in. (18.1 cm)
The Avery Brundage Collection
B60 B336

This small, elegant double-owl *you* sits sturdily on four plump legs, two per owl. The birds' bodies, placed back to back, are smoothly joined and blended with an overall squared spiral pattern of *leiwen* (thunder pattern). Their wings begin as powerful scaled spirals and thrust backward into wing primaries and tail feathers. This strong but decorative illusionism is interrupted by the appearance of flush, long-tailed birds and horned *taotie* masks in higher relief. The lid of the *you*, though it continues the decorative scheme of the body, relies even less on the natural shape of an owl, but makes playful use of the similarity of shapes from one body part to the next. The beaks (or perhaps feathered horns) of the owls are cast in openwork and point upward; the bosslike eyes are also the eyes of pairs of long-tailed birds. Thunder patterns and *taotie* masks fill every available empty space; even the base is decorated with a flattened turtle, its shell covered with spiraling whorls.

The double-owl *you* is one of eight or nine variations of the *you* form, and one of a separate group based on the form of the owl. The ambiguous, horn-like beaks of this *you* suggest that Shang bronze casters recognized the similarity of different kinds of buckets and played off the resemblance of the owl's predatory, downturning beak and pointed feather horns against the upturning flanges of the bail-handled *you*, a shape typical of the last years of the Shang and the early Western Zhou dynasties.

P.B.

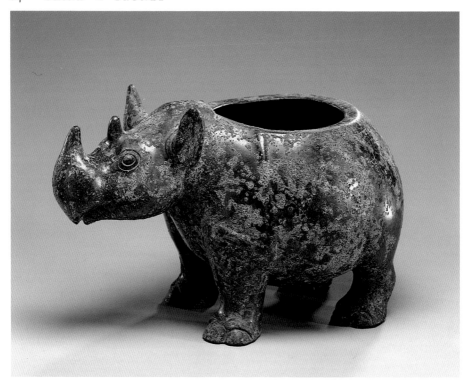

THE RHINOCEROS-SHAPED ZUN

China, Shouchang, Shandong province;
late Shang dynasty, probably
late 12th century B.C.
Bronze
H: 9 in. L: 13 in. (22.9 × 33.0 cm)
The Avery Brundage Collection
B60 B1+

This rhinoceros *zun* was first published in 1845 shortly after its discovery in a buried cache of seven bronzes. By that time it had passed into the hands of the Kong family, lineal descendants of Confucius charged with maintaining his rituals in his home city of Qufu, Shandong. The rhinoceros has been the subject of controversy and delight ever since. Its unadorned, natural form, cleverly integrated with its function as a wine container, and its lengthy and detailed inscription make a unique contrast with most ceremonial vessels of the Shang dynasty, which, if they are ornamented, are richly decorated and tersely inscribed.

A 27-graph inscription cast into the inside of the rhinoceros's belly records the name Xiaochen Yu, who commissioned the vessel. It mentions as well an unnamed king's trip to Kui; a gift of cowrie shells to Yu, who was perhaps a functionary stationed at Kui; and the king's campaign against the troublesome Renfang, who lived in the Huai River valley south of Anyang.

By this time bronze technology was so widely dispersed in China that a number of distinct regional styles had been established. The late Shang bronze art of the capital at Anyang is rich in the imagery of hybrid animals composed of creatures of the air, water, and land, but few vessels represent actual living creatures. Therefore this rhinoceros, because of its sophistication and daring representational simplicity, must be dated to a period late in Shang history. P.B.

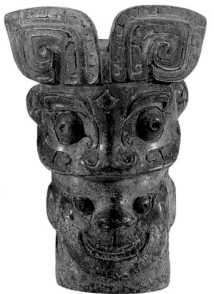

PAIR OF STAFF OR CHARIOT FINIALS

China; late Shang–early Western Zhou
period, ca. 12th century B.C.
Bronze
H. (each): 6 in. (15.0 cm)
The Avery Brundage Collection
B60 B1024, B60 B1025

Human images are relatively rare in
Shang and Zhou bronze art, and when
they do appear, their meaning is often
deeply ambiguous. These two finials,
for example, are two-sided: the front
(or back) of each has a human head that
either wears a hat or mask in the form
of a horned ram, or is being devoured
by one. The reverse shows a pair of
grimacing beasts, one with a flange that
transforms it into an elephant, and also
wearing hats or masks of heads that
seem to gnaw on their skulls. The effect
is one of endless transformation, as the
upper heads devour those below, and,
when the finials were rotated on stan-
dards or on a passing chariot, revealing
first one set of faces, then another.

Most bronzes of the late Shang and
early Western Zhou reflect a delight in
the implications of ambiguous shapes—
a beak becomes a horn, a tail becomes a
chest, a face mask sits unexpectedly at
the base of a spine. Bronze vessels were
often conceived as composite animals,
whose varied natures—bird, tiger, in-
sect, fish, dragon—suggested an ability
to travel through any medium. It is
clear that the peoples of the Shang and
early Zhou period tried to capture and
hold fast the symbolic power in this
ambivalence. These bronze finials sug-
gest that the state of being nearly de-
voured must have held great potency for
them, bringing unity with forces beyond
their everyday ken. P.B.

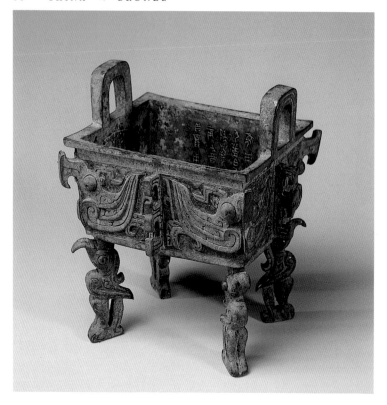

THE RAN FANGDING

China; early Western Zhou dynasty,
ca. late 11th century B.C.
Bronze
H: 10 in. (25.4 cm)
The Avery Brundage Collection
B60 B2+

The 34-character inscription inside
this vessel names a certain Ran, who
commissioned it. The *fangding* was un-
earthed in 1924 at Lingshan, Shaanxi,
from the tomb of Duke Wen of Qin,
who died in the eighth century B.C.,
several centuries after it was cast. Its
design is elegant and unprecedented;
the bold use of paired birds placed diag-
onally as legs, beaks jutting out, is an
imaginative three-dimensional replay
of the split representation typical of
Shang and Zhou bronzes. The inscrip-
tion alludes to the campaign of the
Duke of Zhou against Yi, the Earl of
Feng, and thus the *fangding* may be
dated with some precision between
1024 and 1005 B.C.

For several decades, however, the
inscription's content as well as its char-
acters caused controversy. Details of
the duke's campaign are available in

classical texts, and the calligraphy, with
some graphs of an archaic form harking
back to Shang oracle bones, and others
looking forward in style to nearly mod-
ern times, raised questions about its
authenticity.

But in 1986, X-ray imaging estab-
lished the bona fides of the Ran *fang-
ding*. Early Chinese bronzes were cast
in paired clay molds, and bronze spacers
were used to separate the interior and
exterior mold sections. These spacers
fused with the vessel wall when the
molten bronze was poured, but some-
times they left shallow bumps or discol-
orations on the surface. Bronze casters
understood the risk of surface distor-
tion, however, and carefully placed spac-
ers to avoid warping any text block cast
into the design. Radiological examina-
tion of the Ran *fangding* confirmed that
it was cast in this manner, and that the
inscription was part of its original fabric.
It stands as a masterful and revolution-
ary example of Western Zhou bronze
design and a monument in the study
of early Chinese script. P.B.

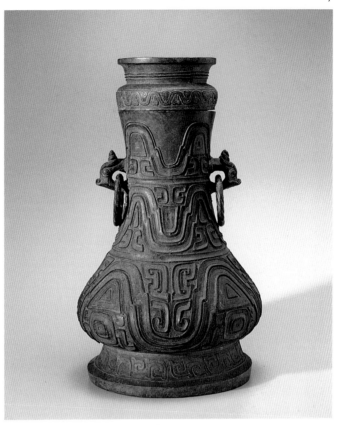

THE FAN JU SHENG BRIDAL HU

China; Western Zhou dynasty,
late 10th–9th century B.C.
Bronze
H: 24 in. (61.0 cm)
The Avery Brundage Collection
B60 B972

By the ninth century B.C., about the time this *hu* may have been cast, inscriptions indicate that bronze vessels served many more functions than in the Shang dynasty. They were given to commemorate events, as rewards, and accompanied the dead to their tombs. This stately *hu* was a wedding gift. A 32-character inscription inside its lid reads:

> In the twenty-sixth year, during the tenth month, on the *jimao* day after the new moon, Fan Ju Sheng cast this *hu* as a bridal gift for his first child, Meng Fei Guai. May sons and grandsons forever treasure and use it.

Between the tenth and eighth centuries B.C., only three Western Zhou kings reigned for twenty-six years, which narrows the date of the *hu*. The grandeur and sheer mass of this vessel suggest that Fan Ju Sheng was a man of means, and the marriage of his daughter a matter of importance and a reason for the exchange of opulent gifts.

As the Western Zhou dynasty came to an end, the iconography of bronzes lost its original meanings, and the old combinations of animals and patterned ground were reworked for their purely abstract qualities. The continuous waves that decorate the registers of this *hu* are typical of the ninth century B.C., when the animal masks of Shang seemed to dissolve and fragment. By the end of the tenth century, even the old curls of the jaw, rendered originally as serpents standing on their noses, became simplified, forceful commas, and the towering horns and squat, spiraling nostrils of earlier pieces have either disappeared or achieved a new fluent equality and balance. P.B.

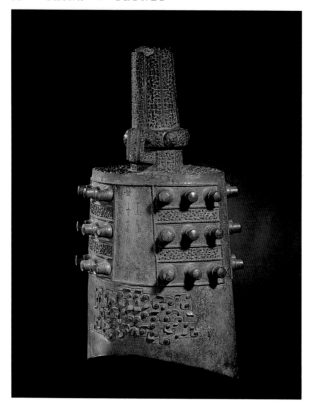

THE WANGSUN YIZHE YONGZHONG

China, Yidu, Hubei province; Eastern
Zhou, late Spring and Autumn period,
ca. 550–525 B.C.
Bronze
H: 23 in. (58.4 cm)
The Avery Brundage Collection
B60 S552

Zhong bells became essential compo-
nents of court ritual during the Spring
and Autumn (770–476 B.C.) and War-
ring States (476–221 B.C.) periods, both
in the northern Zhou homeland and in
the increasingly sophisticated court of
the Chu state to the south. The *zhong*
could be played as a solo instrument,
struck either on the sounding panel on
the bottom of the skirt, or on the sides,
to produce two different tones. Bells of
different sizes were also hung on timber
racks in sets, to create polyphonic chimes.
The largest known set was discovered in
Hubei in the tomb of Marquis Yi of Zeng
(d. ca. 433 B.C.); it is made up of sixty-
five bells that range in tone from treble
to bass.

This bell is a *yongzhong,* a type
suspended from a cord slung around its
cylindrical handle. It comes from Yidu,
Hubei, a site within the boundaries of
the Chu state, and its long, 113-graph
inscription records that it was cast by
Wangsun Yizhe, a member of the Chu
ruling family, to honor his deceased
father Wen. It also expresses the hope
that the bell's sound would entertain
Wen and bring happiness, decorum,
and sagacious virtue to his survivors.

More than half of this inscription
corresponds exactly to text on a 26-bell
chime in a tomb at Xisi, Xichuan, Henan
province, dedicated sometime between
550–525 B.C. by Wangsun Gao, another
member of the Chu ruling house. They
share with this bell a decorative scheme
of abstract dragons fragmented into a
complex pattern of relief hooks, which
was especially fashionable in Chu and
the small vassal states surrounding it
in the early sixth to fifth centuries B.C.

P.B.

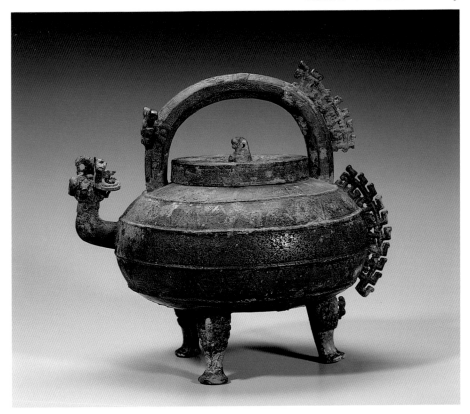

HE WINE POURER

China; Eastern Zhou, late Spring and
Autumn period, ca. 6th century B.C.
Bronze
H: 9¼ in. (23.5 cm)
The Avery Brundage Collection
B60 B458

In the last centuries of Eastern Zhou,
vibrant regional cultures emerged as
the influence of the Zhou royal family
declined. Large, increasingly powerful
states soon hemmed Zhou in on the
north and south. To the south, the Chu
state especially developed a unique style;
the sheer inspiration of its artistic pro-
ductions had a lasting effect on the Han
dynasty.

From most of the eighth through
third centuries B.C., Chu was the main
arbiter of taste in southern China.
Scholars of the twentieth century have
since realized that the writhing inter-
laced serpents and reticulated flanges
of Chu-influenced bronze productions
were distinct from northern bronzes;
the style was widespread but specifically
southern.

This finely wrought *he* wine pourer
resembles a number of bronze and ce-
ramic *he* excavated in recent years from
areas controlled by Chu, Wu, Yue, and
their northern allies. Only details of
the decoration vary from one example
to another. Here, the surface of the belly
is divided into registers, each filled with
a triangular fret. The lid is arranged in
concentric circles around a medallion of
interlaced snakes. The spout is a fantas-
tic beast with serpentine locks, and the
handle and flange at the back are reticu-
lated into a complex fret.

A few other pieces like this *he* sug-
gest that it was made during the sixth
to early fifth centuries B.C. A fascinating
group of stoneware "proto-porcelain"
vessels with a thin, mottled, yellowish-
green glaze was produced in the area
of Wu and Yue during the late sixth
century B.C. Many consciously mimic
bronze vessels, including the *he* shape.

P.B.

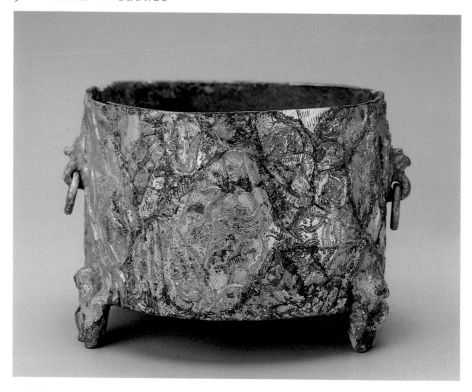

WINE WARMER

China; Western Han dynasty,
ca. 1st century B.C.
Gilt bronze
H: 5 in. (12.7 cm)
The Avery Brundage Collection
B60 B951

The cylindrical bronze wine warmer (*wenjiuzun*), originally equipped with a lid that also functioned as a bowl, is a radically new shape that first appeared in China's bronze repertory during the Warring States period. The earliest examples are decorated with stylized and intertwined hooked dragons, descendants of the animal masks of the Shang and early Zhou periods.

The untamed mountain landscape cast into this wine warmer also recalls the contemporary Warring States tradition of the pictorial or hunting bronzes, which were sometimes decorated with dramatic confrontations between beasts and men. By the Western Han this imagery of wilderness, united with the most elegant craftsmanship, had struck a responsive chord among poets and their imperial patrons. The most complete realization of this concept was the *boshanlu*, an incense burner cast in the shape of a primeval, smoke-wreathed mountain inhabited by animals and immortals.

The style had a literary counterpart in the descriptive prose-poems that preserve so much of the richness of life at the Western Han court. Sima Xiangru's opulent work *Zixu* (Sir Fantasy) conjures up for the pleasure of the Western Han emperor Wudi (r. 140–86 B.C.) the fabulous game parks of the kings of Qi and Chu—a world "filled with prowling white tigers and black panthers, leopards, lynxes, and jackals," all pursued by "hunters racing like the whirlwind." It could stand as a description of this wine warmer, with its mountains, birds, bears, tigers, and galloping archer taking his prey in a daring, backward Parthian shot. P.B.

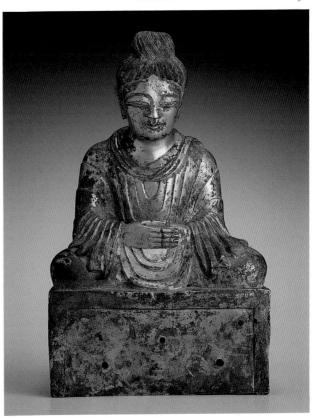

SEATED BUDDHA, dated 338

China; Later Zhao dynasty
Gilt bronze
H: 15½ in. (39.4 cm)
The Avery Brundage Collection
B60 B1034

A fragmentary inscription on the back of the dais dates this sculpture to 338, making it the earliest known dated Chinese Buddha image. It names the Jianwu reign of emperor Shi Hu, ruler of the benighted Later Zhao state, which briefly controlled a large portion of north China from 329 to 350. Shi Hu belonged to a steppe tribe, the non-Chinese Jie. He presided over a terrorist state constantly at war with its neighbors and uneasy with its Chinese population.

Buddhism had not prospered in north China until the Later Zhao. Shi Hu apparently employed the skills in magic and political finesse of Central Asian Buddhists and their Chinese disciples to his advantage. While the stable society of southern Chinese Buddhists created an elegant atmosphere of religious debate, the devotional creed of Central Asia found great favor in north China. Its practice encouraged the creation of small votive images for personal use. A prodigious production of them began in the mid-fourth century with pieces resembling this Buddha.

This figure recalls the Apollonian first- to fourth-century Buddhas of Gandhara. But it has undergone minor modifications that in conception make it tentatively Chinese, rather than completely Indian. Its ovoid head is strongly geometric, the nose is treated as a simple wedge, and the eyes look Chinese. The rectilinear folds of the cowled robe have a regular, linear pattern that has little to do with actual cloth or with the more sculptural idealization of Gandharan images.

Parts of this Buddha are apparently missing. A large lug on its back may have held a halo, and three holes in the lotus scroll of the dais may have held an attached incense burner flanked by lions or attendants. P.B.

BUDDHIST VOTIVE STELE,
dated 549

China; Western Wei dynasty
Limestone
H: 67 in. (167.5 cm)
The Avery Brundage Collection
B62 S2+

Mahayana Buddhists believe that making images of the Buddha is an act of merit for both artist and patron. During the Northern Wei and subsequent brief dynasties, groups of lay Buddhists often pooled their patronage to produce stone stelae, which promoted the dharma through instructive illustrations and also publicized individual acts of generosity by long, inscribed donor lists.

A group of donors from Taiping county, in modern Shanxi province, collaborated to produce this stele. Their names are incised in registers on its bottom and sides, and a register of eight particularly prominent donors appears on the front, along with generalized, full-length portraits. The inscription also contains the date, which corresponds to 549 in the Western Wei.

The stele reflects a period when Buddhism had just begun to develop a uniquely Chinese form. The top front register, framed by two dragons, illustrates the debate between the wealthy layman Vimalakirti and the bodhisattva of wisdom, Manjushri. Their encounter is described in the text of a sutra important to Chinese Buddhists because it demonstrated how a family man with all worldly and material advantages could still win a debate on Buddhist doctrine with a bodhisattva, a perfected, enlightened being. It reassured them that it was possible to honor Buddhist spiritual values as well as the family obligations embedded in native Chinese Confucianism.

The iconography of the stele includes Shakyamuni's disciples, monks and important bodhisattvas, and the theme of rebirth in Amitabha's Western Paradise. The theme of rebirth appears on the canopy above the main image, where four reborn souls emerge from lotus calyxes. P.B.

In north China in the fifth and sixth centuries, Buddhist devotional cults arose among both monastic and lay believers. Devotion to Maitreya, the next actor after the historical Buddha Shakyamuni in the endless cycle of Buddhas, had gained special appeal among a select group of monks as early as the fourth century, since by contemporary calculations the end of Shakyamuni's millennium was approaching. Because Maitreya's career was to be analogous to his predecessor's, it is sometimes difficult to establish the precise identity of figures representing a young, meditating, still unenlightened prince. Siddhartha/Shakyamuni or Ajita/Maitreya both appeared as early as the third century in Gandharan sculpture with one leg crossed over the other, and a hand raised to support the slightly tilted, crowned head.

The tree motif was a constant for Shakyamuni, whose life transitions occurred in the shade of trees. Maitreya would attain enlightenment under the dragon flower tree (*nagavraksha*). The Maitreya cult flourished in the sixth century in Dingzhou, Hebei province, where white marble images of the meditating prince bear inscriptions identifying the dragon flower tree. Dragons twining around the trunks of the tree here make it clear that the figure is Maitreya, though the somewhat ambiguous inscription does not name him.

This prince is guarded by two Heavenly Kings and two lions, attesting his royal status. Bodhisattvas flank him, and heavenly beings intertwine in the tree above him. The entire sculpture was originally polychromed and gilded. The back and sides of the dais show a line of pious donors, presumably the family mentioned in the inscription.　　P.B.

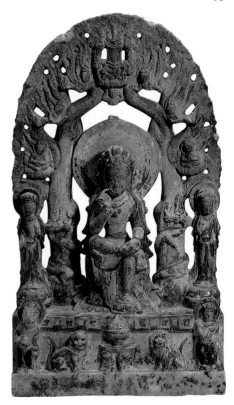

MEDITATING MAITREYA,
dated 551

China, Dingzhou, Hebei type;
Northern Qi dynasty
Marble with painting in polychrome
and gilt
H: 22¾ in. (56.8 cm)
The Avery Brundage Collection
B60 S279

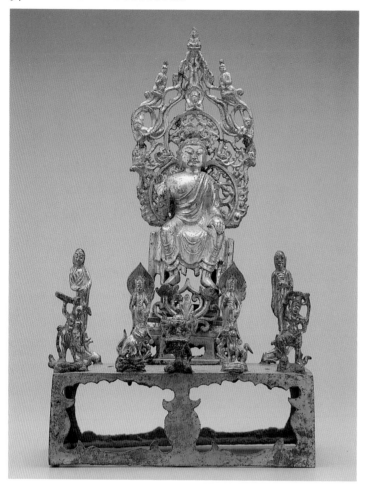

MAITREYA ALTAR

China; Tang dynasty, late 7th century
Gilt bronze
H: 12¾ in. (33.7 cm)
The Avery Brundage Collection
B60 B8+

Maitreya Buddha, shown seated in the European position (legs down) against an elaborate, openwork double aureole, is the focus of this gilt altar group. Maitreya is the Buddha of the Future, the third of three Buddhas (after Dipankara and Shakyamuni), who will reign over the last of three separate epochs. In China, from the fifth century on, Maitreya was a symbol of salvation and political renewal, and in the Tang dynasty his importance was reaffirmed when the Dowager Empress Wu Zhao (Wu Zetian) claimed his identity as a way of legitimizing her assumption of imperial power in 690. During the last years of the seventh century, great numbers of Maitreya images were cast in bronze, painted, and carved in stone in response to Empress Wu's proclamation of a new age, a Buddhist utopia ruled by a female universal emperor.

This Maitreya has the slim, elegant body and rounded, sensual face that characterize mid-Tang Buddhist art. He is joined on his elegant, cusped dais by two guardians (a Vajrapani and a Lokapala), two lions guarding an incense burner held aloft by a squat atlantid, two bodhisattvas whose diminutive scale suggests that they may originally have been part of a different ensemble, and two monks, one old, one young. The figures of this composite altar evoke the jewellike beauty of the future Buddha's paradise, a perfection that was cleverly played upon in the political symbolism of the day. P.B.

Some early texts describe Shakyamuni, the historical Buddha, as containing the entire cosmos. A few representations illustrate this concept by surrounding him with *jatakas,* tales of scenes from his earlier life on earth, as well as the tortures of hell and the delights of heaven, suggesting that creation and the past, present, and future emanate from him. This cosmic Buddha follows an even more graphic iconography developed along the Central Asian Silk Road. The figure's surface is covered with a presentation of Buddha's past lives intertwined with a complex but clear scheme of the universe.

This hierarchy of worlds begins at the lower hem of the robe, with visions of judgment (upper right) and the tortures of hell. Above this scene, a walled city exemplifies the terrestrial world and Shakyamuni's departure from his palace, to begin the last stages of his progress toward enlightenment and nirvana. The Parinirvana, the final moment of his life, appears just above, cradled in the cosmic Buddha's lap, as though he were nurturing his own destiny. The debating Vimalakirti and Manjushri (see p. 92) appear in Shakyamuni's armpits, and between them a scaly *naga* rises on his chest to support Mount Sumeru, whose towers and pavilions provide a glimpse of heaven.

The bloated, low-browed face of this image ties it to a specific group of mid-eighth-century Tang dynasty sculptures from Mount Wutai, Shanxi. The unusual ogive halos of the two meditating Buddhas seated in the petals of the lotus throne also help confirm this date.

P.B.

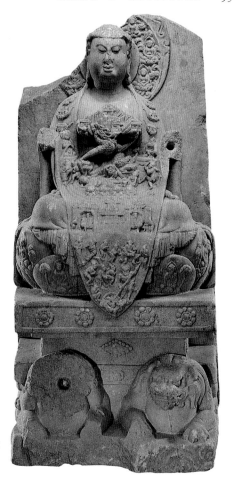

THE COSMIC BUDDHA
SHAKYAMUNI

China, probably northern Shanxi
province; Tang dynasty, mid-8th century
Gray limestone
H: 41 in. (101.1 cm)
The Avery Brundage Collection
B60 S279

STANDING JEWELED BUDDHA

Central Asia, Uighur or Tangut;
ca. 10th–11th century
Iron inlaid with gold and silver
H: 11⅛ in. (28.2 cm)
Gift of the Connoisseur's Council
B87 B3

As China's control over its frontiers weakened toward the end of the Tang dynasty, the non-Chinese Tangut Xixia and Turkic Uighurs arose along the Silk Road where it crossed the Gansu Corridor. They became brokers for Chinese silk and Central Asian jade, intermediaries in the increasing Buddhist exchanges among Tibet, Central Asia, and China.

The Uighurs supported important Buddhist monasteries in their capital near Turfan, and Xixia, also a Buddhist state, had separate Buddhist communities catering to different facets of its multi-ethnic population.

This iron plaque, inlaid with thin lines of gold and silver, depicts a standing Buddha with a striking resemblance to Buddhist art of the Xixia Pure Land sect, and to the cave paintings of Uighur Bezeklik. In each context the Buddha appears in nearly three-quarter view, wearing heavy monastic robes and long strands of jewels. His right hand is raised in the discussion mudra. His heavy form recalls the Tang Chinese preference for buoyant, sensual bulk, but his thin, curled moustache is distinctly Central Asian, recalling the early Buddhist art of Gandhara.

Votive plaques of wood, painted with similar images of the Buddha, have been found in abundance at Buddhist sites along the southern Silk Road. Votive plaques of seated or frontal Buddhas in gilt bronze or other alloys were popular in the Tang dynasty, in the northern Liao empire (937–1125), and in the Nanchao and Dali kingdoms of Yunnan (8th–11th century). This example in inlaid iron, however, is so far unique.

P.B.

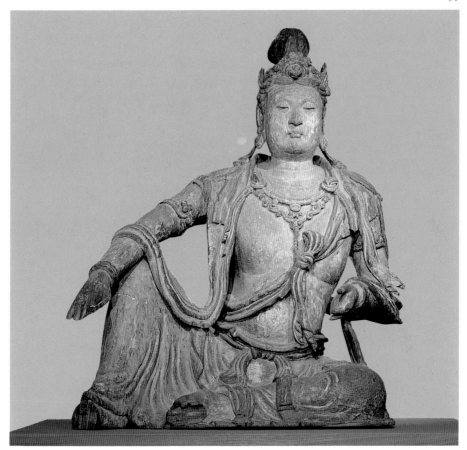

SEATED GUANYIN

China; Song dynasty, ca. 12th century
Wood with traces of pigment
H: 52 in. (130.0 cm)
The Avery Brundage Collection
B60 S24+

The bodhisattva Avalokiteshvara, whose Chinese name Guanyin means 'Sound Observer,' is the most beloved of all Buddhist figures in China. He was worshiped as one of the bodhisattvas attending Amitabha, Buddha of the Western Paradise. Chapter 25 of the Lotus Sutra lists his thirty-three forms and relates his ability to rescue believers from peril. Its vivid descriptions of Guanyin's transformations, male to female, old to young, were a prime source for Tang and later artists.

This massive image depicts Guanyin seated in the position of royal ease, right hand resting on his bent knee and the left in the gift-bestowing gesture. He is dressed as an Indian prince in a long, fluidly carved *dhoti*; his chest is crisscrossed with sashes, scarves, and delicately rendered jewels. Unlike most other representations, this Guanyin does not wear an image of his spiritual father Amitabha in his crown.

In style this Guanyin follows standards established at the height of the Tang dynasty, and its iconography may allude to Guanyin types revealed in Chapter 25 of the Lotus Sutra. The figure lacks its original and probably elaborate sculptural setting, but his posture and demeanor suggest that he sits on a rocky shore at Mount Potalaka, his spiritual home. By the Song dynasty, when this figure was carved, popular variations included the Potalaka Guanyin and the feminine Nanhai (South Seas) Guanyin, popular among Chinese pilgrims who believed that Putuo Island, off the Zhejiang coast, was Guanyin's true home. P.B.

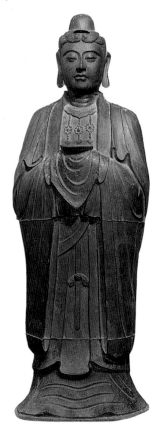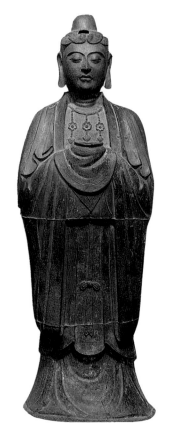

PAIR OF ATTENDANTS, dated 1489
China; Ming dynasty,
Hongzhi reign (1488–1505)
Cast iron
H. S6: 52¾ in. (131.8 cm)
H. S7: 53¼ in. (133.1 cm)
The Avery Brundage Collection
B68 S6, B68 S7

Ming dynasty Buddhists revitalized many innovative Buddhist institutions developed during the Song, particularly the benevolent associations devoted to communal chanting of Amitabha's name. One of this pair of cast-iron attendants has a dated inscription that alludes to the contributions of several benefactors and names the Jie'erbao Association. In 1112 this association had a hand in casting a seated Guanyin which, like these figures, wears a collar with three beaded pendants and has an indented and perforated cranium that probably allowed him to wear a separate crown. This detail, and the rough seams of the piece mold, are both traits of most Song and Ming iron sculptures

of bodhisattvas and attendants. This pair may once have held the flat jade scepters of the Confucian court.

Ming sculptors in iron paid almost slavish technical and stylistic attention to their Song sources, making it difficult to attribute uninscribed pieces in one or the other period.

The precise identity of these two figures is uncertain. Buddhism of the Ming period was imbued with non-Buddhist ideals. The Hongzhi emperor, in whose reign the figures were cast, was profoundly Confucian, and by the Wanli period (1573–1620) and the great late Ming revival of Buddhism, the concept of the unity of Confucianism, Buddhism, and Daoism was widespread. Buddhism was by then flexible enough to accommodate the moral tenets of Confucianism and Daoist beliefs in immortality, and to accept an austere Confucian demeanor for its bodhisattvas. But this assimilation tended to blur iconographic distinctions. P.B.

JUG WITH ROOF-SHAPED TOP

China, Qinghai province; Neolithic
period, Qijia culture, ca. 2500–1500 B.C.
Buff earthenware
H: 9 in. (22.7 cm)
Gift of Marjorie Bissinger Seller and
The Museum General Acquisitions Fund
B86 P9

The material remains of the Qijia people
intermingle with the bones of pigs,
cattle, and sheep, suggesting that they
were advanced farmers dependent on
animal husbandry. During the third and
second millennia B.C., they dominated
the arid area centered around the upper
Wei River valley. They cultivated millet
and incorporated elements of the earlier
Yangshao culture into their lives, in-
cluding variations of its typical painted
pottery. A few Qijia sites have included
objects usually associated with early
civilized life: animal scapula used as
oracle bones, woven hemp fabric, and
copper slugs, knives, awls, and mirrors.

This buff earthenware jug is similar
in form to a group of owl-shaped jugs
found among ordinary utensils that
were excavated at the cemetery site of
Liuwan, in Qinghai province, the most
remote part of the Qijia cultural sphere.
These Liuwan owl-shaped jugs have a
hemispherical splash-guard appliquéd
with pinched strips of clay to resemble
the head of a bird, and two pouring
holes double as the owl's eyes.

The top of this jug is similarly dec-
orated with appliquéd clay in the shape
of a pitched house roof. The single pour-
ing hole has a simply formed lip that
improves its efficiency as a pitcher. The
Qijia potter has taken the most common
shape in his repertory, a handbuilt, cord-
marked, sharp-shouldered jar, but has
given it a more specialized function with
the addition of a plain loop handle and a
cleverly designed pouring spout. P.B.

TOMB FIGURINE OF
A WATCHDOG

Southern China, probably from Hunan
province; Han dynasty, 206 B.C.–220 A.D.
Brown earthenware with
reddish-brown glaze
H: 14¾ in. L: 13½ in. (37.5 × 34.3 cm)
The Avery Brundage Collection
B60 P83+

The people of Han were obsessed with
the cosmic order and the fate of man
after death. Their grave goods reveal an
extensive repertory of low-fired, lead-
glazed models, and watchdogs are a
favorite subject.

Image making in Han China was
often dominated by unnatural or hybrid
animal types—mythical beasts, mon-
sters, demons, and dragons. Han Feici, a
contemporary writer, acknowledged the
Han propensity for fantasy and abstrac-
tion, noting that likenesses of real dogs
and horses are difficult to produce, but
"since . . . various beings of the Spirit
World . . . have no definite form, and
since no one has ever seen them any-
way, they are easy to execute."

This dog figurine has a summarily
rendered form. The neck is treated as a
cylinder, the body as a mere squarish
lump, the tail as a cone, and the dispro-
portionately small feet as mere bumps.
The head and face concentrate the dog's
lively expression and attest keenly ob-
served canine behavior. Its comical ex-
pression is hardly that of a menacing
watchdog, but its barking action and ex-
aggeratedly long neck are in fact over-
statements of its role in defending the
sacrosanct tomb.

Han texts mention three categories
of dogs according to their usefulness to
man rather than as specific breeds. They
were noted for hunting or herding abil-
ity, for qualities of alertness or menac-
ing demeanor as watchdogs, and for
providing meat for banquets or blood
for medical curatives. A pet category is
conspicuously absent, although one em-
peror maintained a kennel and awarded
a favorite dog an official's hat and belt.
Han literature also notes dog-devils,
dog-demons, and the well-known exor-
cistic powers of dogs of certain colors
and markings. C.F.S.

MOLDED ARCHITECTURAL TILE WITH CENTRAL ASIAN DANCER

China, from the Red Pagoda of Xiuding
Temple near Anyang, Henan province;
Tang dynasty, Taizong reign (627–650)
Grey pottery with reddish slip
H: 21½ in. (53.7 cm)
The Avery Brundage Collection
B60 S74+

This architectural tile, one of a group of ten, for many years lacked an archaeological context. This lack, combined with its atypical imagery, caused many notable scholars to question its Chinese provenance as well as its authenticity. As early as 1946, however, a Beijing dealer claimed that it came from a temple in Henan. It has only recently been confirmed that the tile was in fact originally one of 3442 molded tiles that formed the facade of the seventh-century Red Pagoda at Xiuding Temple, located 25 miles from Anyang, in Henan. This isolated architectural monument had been preserved from further pillaging by the local people, who had overcoated the entire relief-tiled surface with white plaster to hide it permanently.

The Xiuding Temple originated as a Chan (Zen) Buddhist temple in the late fifth or early sixth century. It was destroyed in the anti-Buddhist persecution of 576, then reestablished during the Sui dynasty (581–618), to placate the ghosts of soldiers killed in battle along the Central Asian frontiers, and to console their families. The pagoda's tile ensemble forms a composition approximating the appearance of a Central Asian tent propped up by four pillarlike tent poles embellished with Islamic motifs. Individual tiles bear Buddhist and Chinese as well as exotic content, but the majority have Buddhist iconography, and some tiles bear a braided-cord pattern that clearly alludes to textiles, probably to a Buddhist-inspired tent.

Though ethnic Central Asian figures are found among tomb retinues, this lozenge-shaped tile with a foreigner dancing ecstatically is a rarity. On the basis of costume and the style of the dance, Chinese scholars have identified the figure as a member of the Hu nationality, who dwelt on the northern frontiers.　　　C.F.S.

TOMB FIGURINE OF A BACTRIAN CAMEL

China, probably produced at the Gongxian
kilns, Henan province; Tang dynasty,
late 7th–early 8th century
Pinkish-white earthenware with
sancai glaze
H: 33⅜ in. L: 29¾ in. (83.4 × 74.3 cm)
The Avery Brundage Collection B60 S95

The three-color *sancai* ware of the Tang
period is unquestionably the most ad-
mired in the West for its bravura and
ornate beauty. Produced solely as grave
goods, *sancai* ware appears in an exten-
sive variety of shapes and glazing tech-
niques, but its vividly realistic animals
are the most popular and most highly
esteemed.

Sancai animal figures stolen from
local tombs first appeared in the late
nineteenth and early twentieth centuries.
They were overwhelmingly shunned by
Chinese antiquarians, who feared that to
possess ancient grave goods would bring
them generations of bad luck. Western
collectors, however, sought them for
their inherent human interest and his-
torical insight.

Camels, mules, and horses were in-
dispensable beasts of burden in the trade
and cultural exchanges between Tang
China and the outside world—particu-
larly the world connected to the Middle
Kingdom by the Silk Road. Camel tomb
figures provided a symbolic continuance
of prosperity.

This monumental, naturalistically
modeled camel is shown in full, steady
gait, so active that its humps sway in
opposite directions. It balances a packed
load for an arduous literal and figurative
journey, including a pilgrim's bottle, a
haunch of dried meat, and blankets. Its
bulging saddlebags have the form of
monster masks, which bear the same
truculent expressions of the guardian
figures that avert evil.

The burial practice of including
camels loaded for a journey originated
in the sixth century and reached its
height with monumental and naturalis-
tic examples like these. The date of this
figure is confirmed by others similar in
size and artistic execution, and known
from the tombs of a General Yang, bur-
ied in 693, and a Chancellor Liu Tingxu,
buried in 728. C.F.S.

PILLOW WITH BOY AND FUNGUS

China; Northern Song dynasty,
ca. 12th century
Ding porcelain with creamy glaze
H: 6 in. (15.2 cm)
The Avery Brundage Collection
B60 P1315

From the Western perspective, the hard wooden and ceramic pillows of China seem more sleep-defying than sleep-inducing. Yet their advocates claim that sleeping on a soft pillow robs the body of its vitality. From very ancient times, the Chinese used wooden headrests and armrests, some fitted with compartments to hold healing and aromatic herbs. Not later than the Tang dynasty (618–906), they had begun to make ceramic pillows, which kept their popular appeal through the Song and Yuan periods.

Ceramic pillows were made at all the major Song dynasty kilns in both north and south China; each produced its own versions of fashionable shapes and motifs. Pillows were a perfect format to express auspicious wishes, and this one, fashioned in the form of a young boy and a fungus, addresses at least two concerns simultaneously. The boy, shown reclining on a bed, carries wishes for many sons, and the curved headrest he holds aloft is the fungus of immortality, the source of long life.

During the Five Dynasties and Northern Song periods, production of the Ding kilns expanded in response to huge demand. Bowls and dishes with carved designs, fitted with metal lips to hide the fact that they were fired on their unglazed rims, were by far the greatest part of that production. Pillows show a different side of the Ding potter —a playful sculptural sense that took advantage of the warm, white porcelain Ding body. P.B.

EWER WITH CHRYSANTHEMUM SCROLL

China; Northern Song dynasty,
ca. 12th century
Northern Celadon, stoneware with olive-
green glaze, Yaozhou type
H: 9 in. (22.9 cm)
The Avery Brundage Collection
B60 P1233

Separate traditions of green celadon glazing, differing because of the nature of available materials and firing techniques, developed in both north and south China during the centuries following the Tang dynasty. This Northern Celadon ewer is the product of one of a group of related kilns, most of them near Yaozhou in modern Shaanxi province, which specialized in high-fired, green-glazed stonewares from the tenth century on. Like other celadons, it owes its green color to the small amount of iron oxides present in the glaze materials, and to reduction firing—that is, in a low-oxygen kiln atmosphere. Unlike celadons from the southern Yue and Longquan kilns, which vary from bluish gray to sea green, Northern Celadons are usually a somber olive green laid over a deeply carved gray or gray-brown body.

Ewers were an important part of the Chinese potter's repertory from the sixth century on, and this ewer's globular body, ribbed handle and neck, and clumsily bent spout are typical of those made in the late eleventh and twelfth centuries in any number of northern kilns, including Ding, Cizhou, Yaozhou, and even the southern *qingbai* porcelain kilns at Jingdezhen, in Jiangxi (see p. 105). The formalized chrysanthemum scroll carved below the spout is also identical to scrolls that are found on late eleventh- and twelfth-century sherds from Huangbaozhen, a celadon kiln near Yaozhou. P.B.

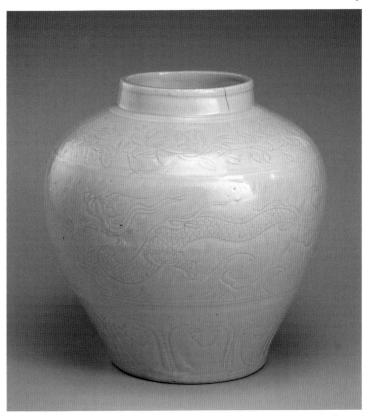

TEMPLE JAR

China, produced at the Jingdezhen kilns,
Jiangxi province; Yuan dynasty, made
between 1320 and 1330
Porcelain with *qingbai* glaze
over decoration
H: 12¼ in. (30.6 cm)
The Avery Brundage Collection B60 P48

The move south of the imperial court, first to Kaifeng, then Hangzhou, increased imperial patronage of the southern kilns. The now world-famous center of Jingdezhen, in Fouliang county, started producing fine white porcelain ware during the Northern Song era. The earliest known *qingbai* (clear bluish) ware, sometimes called *yingqing*, or shadow blue, comes from a 1027 tomb. The glaze is noted for its delicate, subtle bluish tints that pool and deepen in tone where applied more thickly, or where it accumulates in the shallow depressions of incised, carved, or molded decorations. It is thought to be the decorative precursor of fourteenth-century blue-and-white porcelains.

Song and Yuan *qingbai* porcelains differ radically—Song taste preferred elegant, simple forms and delicate clay bodies, while Yuan favored more robust, heavier bodies and bold forms and decorations. This shift occurred rapidly, and was perhaps induced by widening markets abroad.

This masterful *qingbai* temple jar, or *guan*, typical of fourteenth-century sturdiness and boldness, incorporates the distinctive features of the *guan* shape, a globular body with massive, high shoulders, a short, straight neck, and a rolled, reinforced mouth rim. The main decoration, a dragon among cloud scrolls and waves, is bordered above and below by floral motifs. In Chinese mythology, the beneficent dragon moves seasonally from watery depths to celestial abodes. This fluent and heavily outlined dragon, so meticulously and boldly described, reflects a refreshing and energized freedom of execution, and parallels similarly styled figures that appeared at the same time on an innovative series of blue-and-white porcelains.

C.F.S.

"BUNCHES OF GRAPES" DISH

China; produced at the Jingdezhen kilns,
Jiangxi province; Ming dynasty,
Yongle reign (1403–1424)
Porcelain with underglaze-blue
decoration
Diam: 14¾ in. (37.5 cm)
The Avery Brundage Collection
B60 P78+

Blue-and-white porcelains did not enter
the mainstream of Chinese ceramics
until the fourteenth century, though
isolated regional use of cobalt decora-
tion occurred earlier. The Chinese pot-
ter's use of blue extends back to Tang
sancai wares of the eighth century. The
revolutionary appearance of porcelain
underglaze-blue decoration at the kilns
of Jingdezhen, even before the court
demanded it, arose from demands of
international trade and diplomatic trib-
ute, particularly with the Middle East
khanates.

The center of this serving dish is
decorated with three hanging bunches
of grapes painted in strong blue with
blackish spots, in the so-called "heap
and pile" effect. A vigorous wave pat-
tern adorns the rim, and twelve flowers
linked by vine scrolls occupy the ca-
vetto. They are the chrysanthemum,
Camellia sassanqua, Camellia japonica,
morning glory, dianthus, peony, garde-
nia, pomegranate, rose mallow, an un-
identified star-shaped flower, and a com-
posite asterlike flower. This floral scroll
is repeated on the cavetto's exterior.

The Islamic Middle East favored
certain shapes and decor. This type of
large, deep serving plate with flat rim
was ideally suited to the communal din-
ing customs of the Muslims. Not only
Middle Easterners but also the ruling
Indian Muslim couriers ardently col-
lected Chinese Ming porcelains. An in-
scription identifies this plate as having
been in the court collection of the In-
dian Mughal Shah Jahan in the year
1643–44.

Recent Chinese archaeological
evidence proves that this early fifteenth-
century grape plate series was made as
high-quality tribute or trade porcelain
rather than for imperial consumption.

C.F.S.

IMPERIAL POTICHE WITH COVER

China; produced at the Jingdezhen kilns,
Jiangxi province; Ming dynasty,
Jiajing mark and reign (1522–1566)
Porcelain with underglaze-blue decora-
tion and overglaze *wucai* enamels
H: 17¾ in. (44.3 cm)
The Avery Brundage Collection
B60 P78+

This robust, bulbous jar is painted with
underglaze cobalt blue and overglaze
enamels of iron red, green, yellow, and
brownish black. Only the finest quality
cobalt was used for palace-bound porce-
lains; its dark-violet hue here is clearly
identifiable. Five-color porcelains (the
so-called *wucai* palette) appeared for
the first time in the Jiajing reign and
are well recorded in historical texts, but
these records fail to identify specific ob-
ject types, such as this fish jar series.
This brilliant, seemingly avant-garde
decoration became popular through im-
perial support during subsequent eras,
but scholars and collectors shunned the
ware when it was first made.

The decoration of this pot consists
of gold carp swimming in a pond rich in
vegetation that includes lotus, caltrop,
lily, common hornwort, duckweed, and
water-shield. The brilliance of the fish
was achieved by painting translucent
yellow enamels over a light iron red;
the flushed orange tone was achieved in
firing. The design of this jar is thought
to derive from old silk brocades. Its lid
has a beaded-string motif that forms a
medallion around the central knob. Its
sides echo the aquatic scene on the jar's
belly.

This jar's clear and brilliant colora-
tion runs counter to the Chinese trend
toward conservative decor. Only a pa-
tron like the Jiajing emperor, with his
flamboyant tastes and interest in Dao-
ist alchemy and the transmutation of
earthy minerals, could have encouraged
and supported the innovative experi-
ments in brilliant glazes by potters of
Jingdezhen in these initial stages.

C.F.S.

DISH IN THE FORM OF MOUNT FUJI

China; Ming dynasty,
Tianqi reign (1621–1627)
Kosometsuke (Old Blue-and-white)
porcelain
W: 11 in. (27.5 cm)
The Roy Leventritt Collection B69 P98L

In 1620 the imperial porcelain kilns at Jingdezhen, Jiangxi, ceased production of wares intended for the palace, victims of the growing unrest that ended the Ming dynasty twenty-five years later. But the potters of Jingdezhen almost immediately found a new source of prosperity in domestic and foreign markets. Of these, the Dutch and the Japanese motivated some of the most significant developments in taste.

The transitional period between the Ming and Qing periods corresponded with a growing interest in Japan in the tea ceremony, spurred by such masters as Sen no Rikyu (1522–1591) and his foremost disciple, Furuta Oribe (1544–1615; see p. 171). Tea masters found that the quickly produced, spontaneous blue-and-white ceramics created at Jingdezhen for the popular market suited their taste perfectly, but they also ordered designs made specifically for the *kaiseki* meal that accompanied the formal service of tea. These two types, both carefully preserved in Japan, are grouped as *kosometsuke*, Old Blue-and-white ware.

This dish, an example of the second type of *kosometsuke*, is based on a Japanese Oribe prototype. It is molded in the form of Mount Fuji, and the inside is decorated with a mountain landscape painted quickly in vivid cobalt blue outline and wash. A couplet in the center evokes the freedom of a life in nature, "living among trees and rocks, gamboling with deer and horses."

Like most *kosometsuke*, this dish is built of poorly levigated clay and covered with a thick, bubbly, ill-fitting glaze that has flaked off on the edges to create the *mushikui* (worm-eaten) effect beloved by Japanese connoisseurs. P.B.

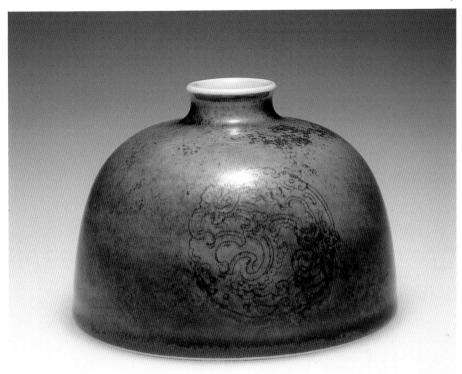

IMPERIAL WATERPOT

China, produced at the Jingdezhen kilns,
Jiangxi province; Qing dynasty,
Kangxi mark and reign (1662–1722)
White porcelain with peachbloom glaze
H: 3½ in. (8.7 cm)
The Avery Brundage Collection
B60 P1266

The French Jesuit scholar Père d'Entre-colles visited Jingdezhen in 1712 and observed firsthand the making of peach-bloom-glazed porcelains. His letters to Europe offer detailed observations from that already famous site. Of peachbloom wares, he remarked: "This sort of porce-lain is still more expensive and rarer than the *langyao* red monochromes because the execution is much more difficult if one wants to preserve all the requisite proportions."

Peachbloom is the most tricky glaze effect to achieve. Other monochrome-glazed wares of the time were essen-tially dipped in liquid glaze, but the peachbloom effect was obtained by blowing raw, dry glaze on the vessel with a bamboo tube, in several thin applications across the surface of the bisque. It also allowed the progressive

introduction of trace elements such as tin and iron into the copper-base mix to aid in the colloidal effect of the copper. The pot was then fired in a reduction atmosphere and finished in an oxidizing one. This time-consuming application and practice yielded fortuitous, deep, richly textured tones, often a dominant rosy red flecked with mossy to emerald greens. Each peachbloom-glazed pot is unique because of variations in glaze application and firing.

Peachbloom glaze was restricted to only eight shapes. This water pot form is the one most sought-after by connois-seurs and collectors. Present-day Chinese scholars call its distinctive, squat shape a *jizhao zun*, or chicken-coop vase, since it resembles indigenous basketwork coops prevalent in China.

The peachbloom *jizhao zun* series is marked by simplicity of form and mini-mal decoration. The faintly impressed medallion of an archaistic dragon on this jar would have appealed to the antiquar-ian bent of the Chinese scholar-literati's refined taste. C.F.S.

TRAVELERS AMONG VALLEYS
AND PEAKS

Anonymous
China; Jin dynasty (1115–1234)
Hanging scroll; ink and colors on silk
H: 42 in. W: 15¾ in. (106.5 × 39.9 cm)
The Avery Brundage Collection B66 D1

In 1126 the Jurchen Tartars consolidated their control over northern China and assumed the dynastic name Jin. They supplanted the Southern Song emperors, who fled south and eventually established a new capital at Nanjing. These exiles had limited contact with the north, maintaining peace through payment of tribute. In the wake of the loss of half an empire, the art and philosophy of the south assumed an introspective turn of thought in the examination of self and nature.

In the north the Tartars, who had long admired Chinese culture, developed a sinicized but distinctly separate culture from the Southern Song. Their painting seems to have been an independent artistic development based on styles and subject matter drawn mainly from Northern Song scholar-painters.

This painting is based on the monumental landscape style of Guo Xi (ca. 1020–90). His *Early Spring,* believed to have been in the Jin imperial collection, may have inspired many other Jin landscapes, which all tend to reveal a transformation of the Guo Xi style. They exhibit a concern for surface composition, which translates to distortion of physical forms, simpler brushwork, and greater calligraphic emphasis in details.

This hanging scroll utilizes some of Guo Xi's compositional devices, especially the evolution of forms into space, and space into forms. Expressive manipulation of ink textures and tonalities creates misty mountains, clear streams, and luxuriant foliage. A scholar and his attendant wander leisurely through this formidable view of nature, their destination a distant temple at the foot of the mountain. This kind of secluded life close to nature was idealized by Chinese scholars, who longed to free themselves of social obligations and administrative responsibilities. S.K.N.

ORCHIDS AND SOUTHERN GRASSES (*Lanhui Tu*), dated 1304

Zhao Mengfu (1254–1322)
China; Yuan dynasty
Handscroll; ink on sized paper
H: 4¾ in. L: 10⅞ in. (25.6 × 106.0 cm)
On loan from the Collection of Mr. and
Mrs. Walter H. Shorenstein BL87 D1

Zhao Mengfu painted this quick, vivid study as a going-away present for Wang Yuanzhang, son of a close friend. The subject likely held complex meanings for him. The orchid, symbol of virtue and purity, was also a plant of the south and full of significance for scholar-officials disenfranchised by Mongol rule, for it evoked the region of exile for generations of dissident scholar-officials, their roots, like orchids, without soil.

Zhao was a member of the Song imperial family, which had been supplanted by the Mongols in 1280. Rather than live in quiet and safe retirement, Zhao served his foreign masters with honor. For this he bore criticism from his Chinese peers, and his relationship with both seemed tinged with deep ambivalence. He held the conservative scholarly values of a Chinese gentleman but worked within the Mongol infrastructure, and in art produced profound transformations of traditional forms.

Perhaps Zhao made this work to encourage the young Wang Yuanzhang to cultivate the purity and detachment of the orchid, but the flowers' forms surely provided him the perfect opportunity to unite painting and calligraphy, as he did in many of his most creative works. *Orchids and Southern Grasses* is both conservative and experimental. It closely resembles part of an instructional handscroll on orchid painting by the artist Zhao Mengjian (1199–1267). Zhao Mengfu carries the exercise into abstraction, almost as if he sees the orchid's petals, stems, and leaves as parts of an intricate, three-dimensional character whose form is governed by nature.

P.B.

RIVER PAVILION, MOUNTAIN
SCENERY, dated 1368

Ni Zan (1301–1374)
China; Yuan dynasty
Hanging scroll; ink on paper
H: 32¼ in. W: 13⅝ in. (82.1 × 33.6 cm)
On loan from the Collection of the Tang
Family L1989.1

By the 1350s the painter Ni Zan had de-
termined the compositional format that
occupied his experiments for the rest of
his life. This work, a classic example of
his mature style, shows the three-part
composition he adapted from China's
earliest landscape painters: a foreground
pavilion and sparse trees, a middle ground,
and a far distant mountain range. In the
course of experimenting with this de-
ceptively simple structure, Ni Zan moved
from a tight massing of the three ele-
ments to an increasing isolation of each
section.

Ni Zan's late masterpiece *The
Rongxi Studio* (1372; National Palace
Museum, Taiwan) is almost perfectly
static because of the separation of its
elements and the carefully calculated
balance of masses and spaces. Its cool,
bland mood exemplifies Yuan scholarly
style, expressing the disinterested out-
look so valued among scholars alienated
by their Mongol overlords. Despite his
personal eccentricities, and partly be-
cause of them, Ni Zan, known as one
of the Four Great Masters of the Yuan
dynasty, was admired and emulated.

River Pavilion fits into a formative
decade of Ni Zan's life, for which few
paintings have been recorded. The fore-
ground, weightier than in his last works,
shows both a rigorous simplicity and the
artist's subtle control of the brush. This
tree group barely touches the spits of
land pushing into the middle ground.
They are linked to the distant moun-
tains by an understated circular move-
ment to the right.

Ni Zan spent much of his career
traveling along the rivers of southern
China. He painted for the friends and
associates on whose hospitality he de-
pended. His inscription in the upper
right relates circumstances of the paint-
ing's creation and evokes a lonely trav-
eler's melancholy mood. P.B.

r.

l.

TRIBUTE BEARERS

Ren Bowen (ca. mid-14th century)
China; Yuan dynasty
Handscroll; ink, colors, and gold on silk
H: 13¾ in. L: 87 in. (34.6 × 220.5 cm)
The Avery Brundage Collection
B60 D100

This procession of foreign envoys bringing tribute to the imperial court at Chang'an is a copy of a Tang dynasty picture. The gifts include a statue of a lion, an incense burner, and three magnificent horses, from the Bactrian region of Afghanistan, wearing richly brocaded blankets. The Chinese emperors were especially fond of these Central Asian horses, sparing no expense to acquire and keep them.

The cosmopolitan and expansive policies of the prosperous Tang empire created political and economic contacts with many remote cultures. Native Chinese were fascinated by the exotic clothes and physiognomies of the foreigners who became a common sight in China's major cities and trading centers.

Tang court painters recorded these emissaries and the favorite tribute items, especially horses.

Ren Bowen was the grandson of Ren Renfa (1254–1327), an official in the Mongol government who also attained artistic fame as a painter of horses, and who held a prominent place among early Yuan painters. The horses of this scroll derive from the elder Ren's style. The Indians, Tartars, and Turks are rendered in the peculiar Tang "western" manner of depicting foreigners, with emphasis on parallel drapery lines. The swirling curves of the flowing scarves, and the curl of the garment ends, as if moving in a small breeze, are also typical. Ren lavished careful attention on details and patterns of the foreigners'

garments. He concentrated much effort on the horses, bringing to life their individuality and spirit.

An inscription added later, by Wen Zhengming (1470–after 1559), provides an art historical footnote. It names the original artist, Yan Liben (ca. 600–73), the leading master at the beginning of the Tang period, who painted this scene during the influx of foreign "barbarians [who] approached civilization (our country)." Wen Zhengming also speculates that an earlier copy he has seen, by the artist Qian Xuan (1235–after 1300), may also derive from the same original.

S.K.N.

Except for commemorative tablets, calligraphy was done in intimate, small formats until the fourteenth century, when such works assumed a larger scale for more decorative purposes. This calligraphy is one of the finest examples of Chen Xianzhang's mature work in the gestural style for which he was admired. The character forms vary greatly in size and degree of abbreviation or distortion. They break abruptly and freely into surrounding visual and physical spaces in a motion that reverberates throughout the composition. They are executed with the reed brush that Chen preferred in his later works; in some of the long, dragging strokes, its split tips produce the "flying white" effect characteristic of his writing.

Traces of earlier masters appear in Chen's work, but his writings in this extravagantly cursive style seem to be inspired from the Chan (Zen) spirit prevalent in the twelfth century. Chen was one of the few renowned scholars and artists from the southern provinces. Though he passed his local civil service exams, he failed the provincial test and returned to his native town, Baisha, to teach and write. He became so formidable a scholar that he was summoned to Beijing by the emperor to accept the position of Fellow of the Academy. But the unconventional Chen refused the appointment, preferring to remain as a teacher in the tranquillity of Baisha.

Chen's poem, written to the tune of the song that gives the painting its title, captures a moment in the green-clad mountains after the rains stop and the birds and flowers again "come alive [to] face a clear morning sky." S.K.N.

SONG OF THE FISHERMAN

Chen Xianzhang (1428–1500)
China; Ming dynasty
Hanging scroll; ink on paper
H: 50 in. W: 20¼ in. (127.2 × 51.3 cm)
Gift of the Asian Art Museum Foundation
B68 D6

THE STONE TABLE GARDEN,
dated 1572

Sun Kehong (1532–1610)
China; Ming dynasty
Handscroll; ink and colors on paper
H: 12¼ in. L: 146 in. (31.1 × 370.8 cm)
Gift of Mrs. Mary Gary Harrison
B69 D52

The Stone Table Garden is an intimate and sensitive portrayal of a country villa by one garden lover admiring the masterwork of a fellow enthusiast. Sun Kehong's inscription explains that he made this handscroll for his long-time friend Lu Yashan, who owned and created the garden where he frequently hosted gatherings for the scholars, artists, and monks who were his friends. Sun describes feasting, games, and evenings of poetry among Lu's assemblage of strange rocks and exotic plants—all the preoccupations of Jiangnan's scholar-gentry during the Ming and Qing periods, when most of China's wealth and talent were concentrated in this area.

Both Sun and his father had been government officials, and on his estate in his native Huating, Sun had his own garden. His paintings provide a rare glimpse into the private world of the educated class in sixteenth-century China.

This handscroll is a gentle depiction of that life. From an unkempt countryside, one passes through an arched doorway into Lu's lush and carefully planned garden. At the small house with the thatched roof, he might receive guests after they had a chance to enjoy their first view of the garden. Past a stone-paved pond and a bamboo grove, two cranes lead the way toward the opening in the fence. In the main section of the picture Lu, with his books, archaic vessels, and a flower arrangement, sits in the Stone Table Pavilion, supervising his gardener. The paved path to the pavilion goes on to disappear behind a bamboo thicket, and the scroll ends as we emerge from the garden once more into the visual metaphor of uncultivated terrain.

S.K.N.

LANDSCAPE AFTER WANG WEI'S
"WANGCHUAN PICTURE,"
dated 1574

> Song Xu (1525–ca. 1605)
> China; Ming dynasty
> Handscroll; ink and colors on paper
> H: 12⅜ in. L: 350 in. (31.4 × 889.0 cm)
> Gift of the Asian Art Museum Foundation
> B67 D2

Tradition plays an important role in the culture and arts of China. The works and styles of ancient masters were honored, assimilated, and given new vigor by succeeding artists who copied them. Wang Wei's original eighth-century rendition of his mountain retreat on the Wangchuan River, in Shanxi province, perished long ago, but continued its existence in numerous copies, including stone carvings. Later artists and historians respected Wang as the founder of the literati tradition of ink painting, and idealized his Wangchuan villa as the embodiment of the leisurely retreat. The countryside's idyllic beauty is further immortalized through a series of twenty poems that Wang exchanged with his friend Pei Di.

Song Xu's inscription at the end of this scroll explains that he painted this copy at the suggestion of a friend upon their viewing the fourteenth-century artist Wang Meng's interpretation of the famous earlier painting. Song laments his inability to capture even Wang Meng's brushwork, let alone aspire to approach the height of Wang Wei's earlier artistry.

Song's panoramic view of the scenic region orchestrates the lakes and streams, mountains and forests, and hills and ravines where gardens, studios, lodges, and pavilions are secluded. His version displays typical Ming dynasty brushwork and style, but the painting alludes to imagery evoked in Wang Wei's poems. They celebrate the joys of hospitality; the melancholy of parting, distance, and the passing of seasons; the beauty of natural events; and a joyous hope for long life.

S.K.N.

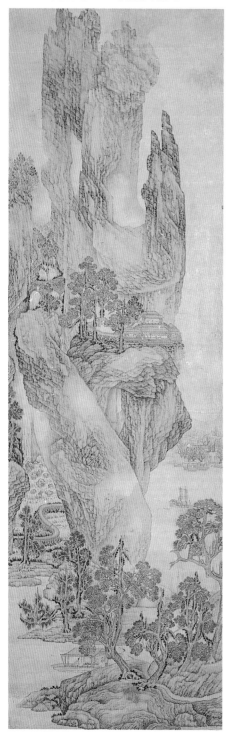

PINE LODGE AMID TALL MOUNTAINS

Wu Bin (act. 1590–1625)
China; Ming dynasty
Hanging scroll; ink and colors on paper
H: 121¼ in. W: 38¾ in. (307.3 × 98.4 cm)
Gift of the Brundage Symposium Funds
and the M. H. de Young Trust Funds
B69 D17

Wu Bin, a native of the southern coastal region of Putian, Fujian, was a professional painter who specialized in Buddhist and landscape paintings. A court painter under the Wanli emperor (r. 1573–1620), the outspoken Wu made political enemies, and his candor eventually cost him his position.

Wu began as a conservative painter in the tradition of the prevailing Wu school of Suzhou. He was then influenced by amateur artists interested in reviving the monumental styles of the Northern Song period. Their work is marked by deliberate exaggerations of realistic Song models into visions of fantastic grandeur. Wu Bin, among the more talented, could translate these devices into compelling images of amazing and grandiose proportions, with meticulously rendered forms and a profusion of detail evolving into bizarre and wonderfully organic shapes.

Wu Bin's view of nature is carefully manipulated with a kind of decorative mannerism. His renditions of peaks and gorges are said to possess the sharpness of cut jade, and his surviving paintings fulfill this praise. They are generally very tall works, and crowded with fantastically shaped boulders and cliffs; their forms and shapes function in the paintings in the ways fantastic rocks in Chinese gardens are placed to achieve a personal interpretation of nature.

In this painting Wu Bin depicts three separate idyllic scenes in a landscape that writhes with its own dynamic energy. Dramatic silhouettes of trees appear against unyielding rock surfaces, and a mountain torrent crashes over rocks. Wu Bin's refined and meticulous brushwork enhances the landscape's bizarre features. S.K.N.

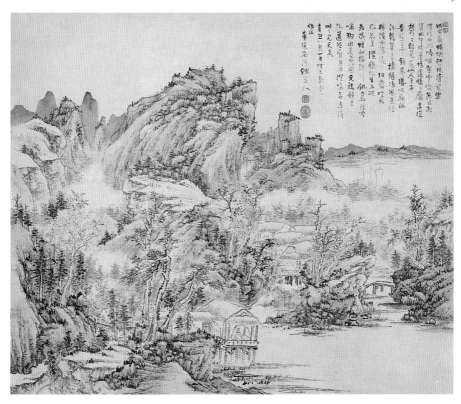

LANDSCAPE, dated 1661

Kuncan (ca. 1610–1674)
China; Qing dynasty
Hanging scroll; ink on paper
H: 39½ in. W: 47 in. (98.7 × 117.5 cm)
The Avery Brundage Collection
B65 D53

The painter Kuncan was interested in religious texts early in life and became a monk in his twenties. After the downfall of the Ming dynasty in 1644, he lived a secluded life, first in the Bao'en Temple in Nanjing, and then in the nearby Yuqi Temple. He remained a hermit, rarely making contact with contemporary Nanjing artists.

Kuncan is known as one of the Four Great Monk Painters of the late Ming and early Qing periods. Inspired by natural scenery and his religious and philosophical ideas, his mature paintings, including this landscape, are characterized by dense and luxurious compositions rendered with an agitated, dry, and ragged brush.

Here, in center foreground, a scholar looks from his cottage out to the river. A path on the right leads from an open space into an enclosed, mountainous area of heavy vegetation and light mist. Sailing boats and mountain ranges fill the background.

The mood is set by Kuncan's inscription on the upper right corner. He alludes to a stale life in the city, and retreats to the hills and rivers, leaving behind the world's passions. He goes on to praise two of his mentors, a writer and a musician "who lived with ink slabs as neighbors and valued only literary works as gems." He turns for solace to the natural life of birds, free from anxiety, and, in an interesting reverse of Western outlook, states that "even if calamities destroy the works of [calligraphers] Zhong and Wang, their bones and flesh [their essential nature] will remain the same." M.L.

l.

FANTASTIC LANDSCAPE,
dated 1645

Fan Qi (1616–ca. 1694)
China; Qing dynasty
Handscroll; ink and colors on paper
H: 12¼ in. L: 161½ in. (31.0 × 409.5 cm)
The Avery Brundage Collection
B66 D19

Fan Qi, a versatile professional artist of Nanjing, worked in a variety of styles and subjects, including figures, flowers, and landscapes. The renowned collector Zhou Lianggong (p. 122) appreciated his work. Fan was later grouped with the so-called Eight Masters of Nanjing, though they had little in common except being active in that city between 1650 and 1695.

In the prosperous and culturally rich Yangzi region, Fan was exposed to many new and foreign ideas. Early in the sixteenth century, the Jesuit missionary Matteo Ricci had come to Nanjing with European paintings and prints, which he shared with Chinese artists and scholars. The works of Fan Qi and

Wu Bin, a generation before him, show signs of their acquaintance with Western painting.

Fan Qi's scroll begins (far right) in a manner similar to Wu Bin's fanciful version of the monumental classical landscapes of the Northern Song (see p. 118). We enter a mysterious world of strange cliffs encircling a misty river valley that offers no easy passage nor any reassuring sense of reality. The only familiar elements, the small huts and two people about to cross a stone bridge, have been forced to the bottom edge of the foreground by the threatening scene looming above them. They do not initiate movement into the painting, but head away from it. This device makes

r.

the eye linger over rich details made dramatic by light washes of green and brown set against areas of white mists and waters.

The next section opens into a panoramic view of a charming riverscape—a tavern in a small village, a secluded country estate, well-kept fields, and the comforting presence of a temple complex.

The scroll ends (left) with a vision as disturbing as its opening. Paths recede and lead nowhere; the river flows into a deep cavern; a house perches precariously on the side of a mountain ridge where all spatial logic has been forsaken. Seemingly unanchored massive cliffs dominate the final scene, a shoreline where fishing boats dock. Fan Qi has deliberately orchestrated the entire composition's eerie, unsettling mood, which he enhanced by the play of flickering light on these unnatural forms.

It is often suggested that the landscapes of seventeenth-century individualists reflect their reactions to the political turmoil of the time. The Manchu invaders made Chinese loyalists to the Ming dynasty uncertain of their positions in the new order. Perhaps Fan Qi's fantastic landscape is his vision of the "Peach Blossom Spring," the Chinese Shangri-la, in which a wandering fisherman passes through a river cavern into a paradise where people dwell in simple harmony, untouched by conflicts of the world outside. S.K.N.

1.

SUMMER MOUNTAINS, MISTY RAIN, dated 1668

Wang Hui (1632–1717)
China; Qing dynasty
Handscroll; ink on paper
H: 17 in. L: 97 in. (43.3 × 245.7 cm)
Gift of the Tang Foundation. Presented to the Asian Art Museum of San Francisco in honor of Jack C. C. Tang's sixtieth birthday, by Nadine, Martin, and Leslie Tang B87 D8

Until 1668 the artist Wang Hui worked under the patronage of Wang Shimin (1592–1680) and Wang Jian (1598–1677), the two eldest of the artists later called the Four Wangs. In that year Wang Hui, until then "comfortable with his poverty," painted this handscroll, his masterpiece to that date, and presented it to the influential connoisseur Zhou Lianggong (1612–72), whom he had met a few years earlier. To seal the outcome, in 1669 Wang Hui solicited an adulatory colophon from Wang Shimin, which records an earlier meeting between Wang Hui and Zhou, and the good feeling it generated.

Zhou was then writing his life's work, the *Tuhualu* (Record of Painting), a compendium of artists' biographies and highly personal criticism. Wang did not underestimate the effect a favorable mention in this work would have on his career. Zhou greatly admired the scroll and called Wang Hui in his book "the greatest artist of the century." He introduced Wang Hui to his wide circle of friends, sought his paintings avidly, and showed them to connoisseurs on his many travels. His patronage eventually catapulted Wang to national promi-

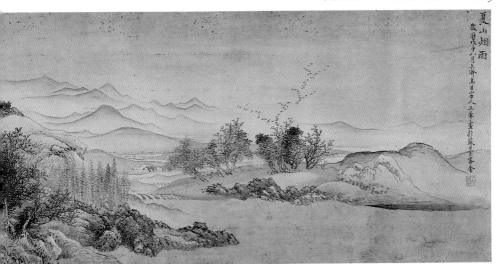

r.

nence. In his old age he was called to serve the Kangxi emperor (r. 1662–1722) and ended his career on a note of highly publicized virtuosity and harmless orthodoxy.

Wang's earlier patrons, Wang Shimin and Wang Jian, had studied under Dong Qichang (1555–1636), the mastermind of Ming orthodox painting theory, with its reliance on formal models over inspiration from nature. Wang Shimin praised Wang Hui's more expansive talent: "He followed the ancient masters naturally." Zhou Lianggong may have admired him for his ability to represent nature in ways both conservative and subtly innovative.

Summer Mountains, Misty Rain depends on Song landscape painting in its monumentally conceived composition, masterful draftsmanship, and engrossing detail, but also introduces much that is new. This work shows Wang's interest in the effect of light on form, its ability to clarify or obscure, and his virtuoso's talent for pictorial rhythms. He begins (right) with a simple flight of birds over an expanse of open water, moves forward rapidly to moody peaks, and concludes gently (far left) with fishermen returning home along a marshy stream.

Wang dated this work in an inscription; his personal seal and those of other collectors and connoisseurs including two belonging to Zhou, as well as Wang Shimin's colophon, also appear at the end of the scroll. P.B.

a.

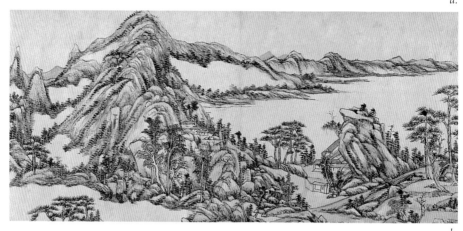

b.

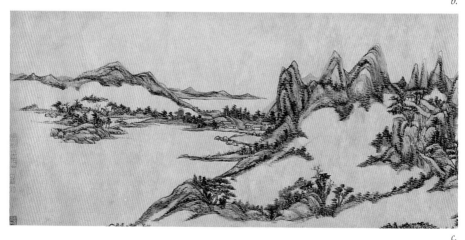

c.

**SPRING MOUNTAINS WITH
PINES AND CLOUDS** (Landscape
in the manner of Huang Gongwang),
dated 1708

Wang Yuanqi (1642–1715)
China; Qing dynasty
Handscroll; ink and colors on paper
H: 17¼ in. L: 107⅞ in. (43.9 × 273.5 cm)
Gift of the Asian Art Museum Foundation
B69 D6

Though Wang Yuanqi never deviated from the orthodox tradition of the scholarly Southern school of landscape painting, he helped redefine it with his personal interpretation of established theories. His mature works represent a new vision and approach to tradition.

Wang was the youngest and most innovative of the Four Wangs (see p. 122). He held several high positions in the Qing government; the Kangxi emperor admired his paintings and appointed him officer in charge of the imperial collections of calligraphy and painting. Thus he would have had ready access to the works of masters.

This handscroll exhibits Wang Yuanqi's late mature style and the peak of imaginative composition and vigorous brushwork. He and his grandfather Wang Shimin (1592–1680) were both influenced by the Yuan artist Huang Gongwang (1269–1354), and the inscription at the start of the scroll (a) acknowledges his debt to this artist and the deliberate, unhurried ways in which he and other ancient masters worked— Wang Yuanqi began this painting in the spring but did not finish it until winter.

Wang summarized his aesthetic theories in the essay *Yuzhang manbi* (Scattered Notes at a Rainy Window). He discusses compositional principles evident in this painting: *kaihe* (spacing interval), *chifu* (rising-falling), and *longmo* (dragon vein). The first two address physical structure and rhythmic flow, but 'dragon vein' may be a term borrowed from Chinese geomancy to describe metaphysical characteristics of both the landscape itself and the reflection of it in an artist's work. For Wang, the flow or unifying force of the dragon vein connects elements "hidden and visible"—the solids and voids carry equal weight.

A strong, rhythmic quality dominates this painting. Echoing lines of the distant peaks, fluctuating shorelines, texture and accent strokes along mountain ridges, and occasional vertical tree trunks define the main lines and set the tempo overall. Repeated shapes with slight variations in size and angles, seen in peaks, boulders, houses, and trees, unify the composition. Solid masses alternate with empty space to establish both a physical and psychological tension. The composition opens and closes (c) with themes of isolation and tranquility, but it culminates in one massive central peak (b). Wang arrived at this apex by piling up rock formations, trees, and texture strokes from the foreground as well as the ascending mountain ranges and distant shoreline. In this work, Wang has observed nature and revitalized the manner of the ancient masters with his own vision.

S.K.N.

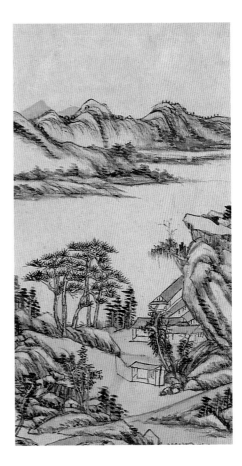

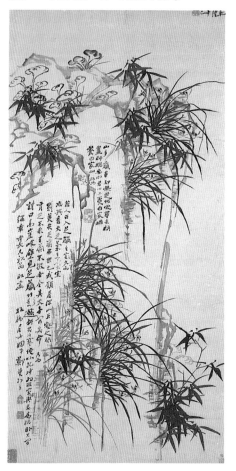

EPIDENDRUMS, BAMBOO, AND FUNGI GROWING ON ROCKS, dated 1761

Zheng Xie (1693–1765)
China; Qing dynasty
Hanging scroll; ink on paper
H: 74⅛ in. W: 36⅝ in. (188.3 × 93.0 cm)
Gift of the Asian Art Museum Foundation
B67 D6

Eighteenth-century Yangzhou, with its rich cultural and economic life, attracted literati and artists who found enthusiastic patrons there. The most talented and innovative were later known as the Eight Eccentrics of Yangzhou. Their eccentricity consisted mainly in their divergence from the orthodox and conservative court style represented by the painters known as the Four Wangs (see p. 122).

Zheng Xie, considered by many the most accomplished of the Eight, was for many years a civil servant. His liberal policies concerning taxation and assistance to the needy incurred the criticism of his superiors. Eventually Zheng, driven out of public office in his sixties, came to Yangzhou to paint professionally. Unlike other Yangzhou eccentrics, he limited his subjects to bamboo, epidendrums, prunus, chrysanthemums, and rocks. His works possess the literary ideal of excellence in painting, calligraphy, and poetry.

Zheng's inscription forms an integral part of this painting. His distinctive and idiosyncratic calligraphy was praised for its echoes of the movement of the leaves and blossoms in this work. The epidendrums and bamboo are rendered in a manner similar to the inscriptions on the cliff, their profusely overlapping forms creating a rich interplay of light and shadow, dense and sparse forms, stiff and supple lines, movement and repose.

Zheng's poetic inscription praises the epidendrums and the fungus of immortality, suggesting that they achieve their greatest virtue when left to grow among cliffs and precipices, in their natural state; it is there that we may best appreciate them and also understand their destiny—and our own.

S.K.N.

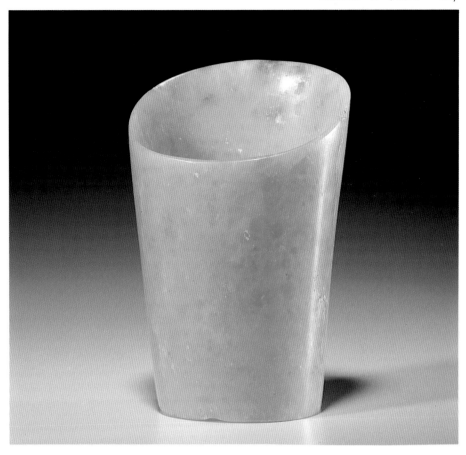

HORSE-HOOF-SHAPED HAIR CLASP OR NECK REST

China, probably from Liaoning province;
Neolithic period, Hongshan culture,
ca. 4th–3rd millennium B.C.
Green jade
H: 6 in. (15.2 cm)
The Avery Brundage Collection
B60 J226

The art of carving jade has roots deep in China's Neolithic period. At least four quite disparate Neolithic cultures buried finely carved jades with their elite dead. This piece is a product of the Hongshan culture and resembles a number of similar pieces all excavated in the northeastern province of Liaoning.

The Hongshan culture, first defined in the 1930s by Japanese archaeologists, was long believed to be a northern derivative of the Yangshao (Painted Pottery) culture. They both produced similarly decorated coil-built ceramics with reddish or buff bodies. But recent discoveries show that the Hongshan people had a distinctive ritual life. One site at Niuheliang, Liaoning province, has a ritual space strewn with broken figurines —hands, elbows and arms, animal parts, and a fierce, nearly life-size clay face of a woman with eyes of inlaid bluish jade. This so-called "goddess-temple" was surrounded by a number of stone cyst burials containing well-preserved skeletal remains and carefully placed grave goods, including intricately carved jades. Two graves at Niuheliang contained horse-hoof-shaped cylinders of jade. Like this example, both are about 20 centimeters long, finely hollowed into wide, slightly flared tubes, and cut at an acute angle at the widest end. The Niuheliang pieces were found tucked under the skulls of the dead, used perhaps as hair clasps or neck rests. Other animal-shaped and abstract jades were placed at the torsos of the dead. P.B.

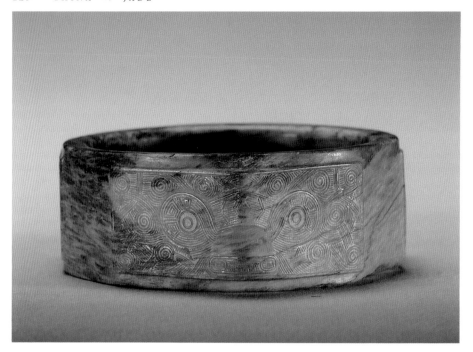

SIX-SIDED TUBE WITH THREE ANIMAL MASKS

China, probably from the Shanghai area;
Neolithic period, Liangzhu culture,
ca. 3rd–2nd millennium B.C.
Jade with incised and polished designs
Diam: 3 in. (7.5 cm)
Gift of Alfred M. Bender B81 J1

The Liangzhu culture, which flourished in the area around Shanghai, used jade more prolifically than any other Neolithic culture in China. Graves of the Liangzhu and its earlier Songze phase (4th millennium B.C.) have yielded thousands of carved jades; single graves sometimes contain hundreds.

Several shapes predominate, especially the *bi* disk, which in the Zhou dynasty came to be regarded as a symbol of heaven, and the *cong* tube, which the Zhou called a symbol of earth. Liangzhu *bi* are often incised with birds, a symbolism that tends to support a link with the heavens. The set form of the Liangzhu *cong*, square outside and round inside, is generally divided into segments decorated with masklike faces. By the Zhou dynasty, the *cong*'s four sides were understood as symbolizing the four cardinal directions, and the *cong* itself had become a symbol of the earth.

This unusual six-sided *cong* tube, with only three finely incised masks, undermines the directional association, but the fantastic animal decoration is typical of Liangzhu craftsmanship. The creatures seem to crouch, their faces resting on protruding, barlike noses and clenched jaws. Their finely articulated bodies, in split representation, wrap around the tube's sides. Although the animal masks of the Shang period suggest a direct relationship to this imagery, excavated jades from Fanshan bearing similar masks overlaid like a shield on the torso of a fierce, glaring human present an intriguing complication.

Liangzhu jades were made from indigenous local stone—tremolite, actinolite, or chrysolite—or agate probably mined near present-day Nanjing. P.B.

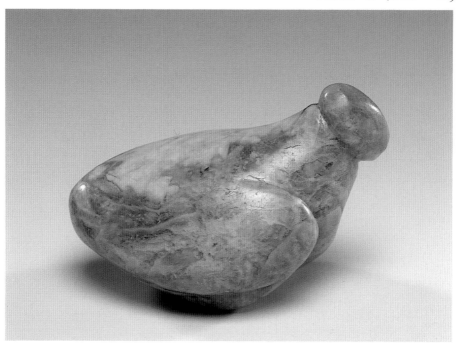

ROOSTING BIRD

China; late Shang dynasty,
Anyang phase, ca. 1300 B.C.
Green nephrite
H: 2 in. L: 3 ⅛ in. (5.0 × 7.8 cm)
The Avery Brundage Collection
B60 J331

This small, smoothly carved bird had
no known precedent in the history of
Chinese art until 1976, when a similar
one of turquoise was found in the un-
disturbed Tomb no. 5, located on the
outskirts of the Shang dynasty ritual
complex at Anyang. The simplicity of
the turquoise bird stood out among 600
other intricately carved jade and stone
ritual objects.

The rich finds and tantalizing evi-
dence of this tomb's original occupant
have spawned a subspecialty in Chinese
archaeology. Only Tomb no. 5 can be
assigned (though not without contro-
versy) to an individual known from
oracle bone inscriptions, and so it alone
can be dated with some precision. Among
the nearly 400 bronze sacrificial vessels
also recovered from this tomb, between
60 and 70 bear inscriptions referring to

Fu Hao, a woman who appears in one
and possibly two contexts in the oracle
bone records. She is most likely the Fu
Hao who lived during the time of King
Wu Ding and was his close associate.

During the Zhou dynasty, *fu* were
women who attended to ritual matters
at court. Some were royal consorts, some
not. Fu Hao held an exceptional position;
the bones record that she led military
campaigns and gave birth at least four
times. She may have been a member
of the Shang royal clan by both birth
and marriage, serving a special ritual,
military, and child-bearing role in the
palace, and thus meriting an extraordi-
nary burial close to the dynastic ritual
compound.

Most Shang jades, even sculptural
pieces, rely on surface decoration ren-
dered on flat planes with painstaking
precision and infinite invention. The
roundness of Fu Hao's bird and this one,
rarely encountered in Shang art, sug-
gests an interest in swelling, organic
form that also resulted in the famous
Brundage rhinoceros (p. 84). P.B.

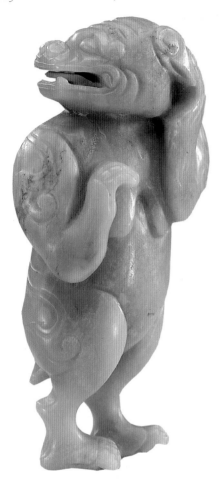

SHE-BEAR

China; Western Han dynasty,
ca. late 2nd century B.C.
Light green russet-veined nephrite
H: 4⅛ in. (10.3 cm)
The Avery Brundage Collection B69 J57

During the Western Han period and in subsequent centuries, the bear became a powerful figure of exorcism and purity. The exorcist who presided over ritual and sacrifice wore a bearskin on his head; by the Eastern Han, his identity had merged in myth and art with Chi-you, the protective and exorcistic ursine god of war. Numerous bears appear in art because of the Han love of hunting and bear-baiting.

This she-bear with turned head and a vaguely surprised expression stands with one forepaw raised to scratch behind her ear, while the other modestly shields a pendulous breast. Her erect pose ties her to a pair of bronze bears from the tomb of Prince Lui Sheng (d. 113 B.C.) of Zhongshan. But Lui Sheng's bears have nearly S-shaped profiles and ride the backs of perched birds. Their raised paws create a flattened surface that must have supported a low table or stand, showing that they were essentially utilitarian rather than autonomous objects like this jade bear.

The artist elaborated each joint of this animal into the curved and hooked volutes that Han artists seem to have been unable to resist. Even her brow ridges and the corners of her mouth curl into fleshy waves. The carver's sophistication and patience is exemplified in the strongly undercut stone, especially in the slightly open mouth, which reveals a panting tongue carved free of support. P.B.

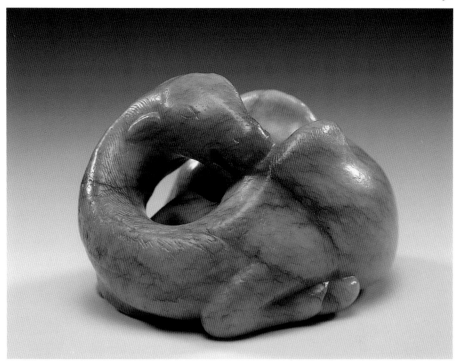

CAMEL

China; Tang dynasty (618–906)
Yellow jade
H: 2⅛ in. L: 3¼ in. (5.3 × 9.4 cm)
The Avery Brundage Collection
B60 J869

Camels were a favorite subject for Chinese artists from at least the sixth century on, when they must have been a common sight in cities and towns along the Chinese end of the Silk Road. In the Tang dynasty, traffic in silk and jade along this Central Asian caravan trail, all carried by two-humped Bactrian camels, reached a peak. Ceramic models and paintings of camels were common in the richly stocked tombs of the period.

Jade camels also appeared frequently in the Tang dynasty. This seated camel, its head turned back to bite or scratch its forehump, is one of a group of similar renderings of camels shown sinuously twisted into a smooth spiral. The carving represents the entire animal, including its padded feet tucked beneath the swelling belly. This Tang jade camel

goes farthest in suppressing surface detail; its final, rhythmic form probably does not vary much from the original jade pebble from which it was carved.

Camels, and recumbent animals in general, were popular in the jade carver's repertory for centuries after the Tang dynasty fell, but those carved immediately afterward are curiously distorted, lacking the nearly perfect blending of natural and abstract values of their predecessors. Tang camels were rediscovered during the Qing dynasty, particularly in the eighteenth century when a craze for antiquity swept the scholarly art world. These later copies are accurate enough in pose, but seem to have hardened and unnatural surfaces.

P.B.

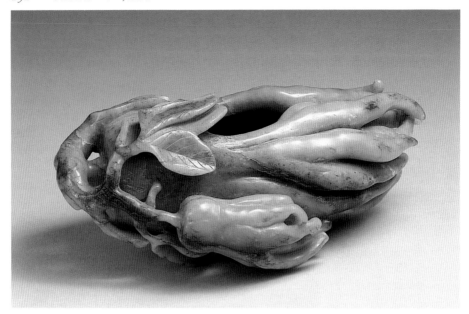

WATER CONTAINER IN THE FORM OF A BUDDHA'S-HAND CITRON

China; Ming dynasty, 15th–17th century
Gray-green and brown jade
H: 3½ in. L: 8 in. (8.7 × 20.0 cm)
The Avery Brundage Collection B60 J9+

The Buddha's-hand citron, a fruit prized for its resemblance to the long-fingered hands of the Buddha, was brought into the home for its sweet scent, which permeates the air, rather than for its flavor. Here it inspired the form of a water receptacle, calling to mind two hands emerging from leafy cuffs and loosely cupped in the Buddhist meditation gesture.

By the Ming dynasty, plants, including flowers of many varieties, had entered the repertory of jade carving as major motifs. The Buddha's-hand citron, the Buddhist lotus, and the Daoist fungus of immortality had symbolic and religious value; others (peony, chrysanthemum, prunus, and pine) conveyed auspicious wishes for wealth, blessings, long life, and success in government—messages based on puns that played on their names. Still others, including the Buddha's-hand citron and lotus, had both religious and secular symbolic meaning. The Buddha's-hand citron, for example, also called to mind the idea of increased wealth because of its resemblance to outstretched hands.

This jade citron exemplifies the almost revolutionary approach taken by Ming jade carvers. Its ample, voluminous forms, the individual tendrils and leaves carved almost completely in the round, and the subtle use of brown inclusions in the stone to heighten the natural effect are typically Ming. As in other media, Ming jade artists, in contrast to their Qing successors, achieved a disarming, off-handed virtuosity, creating masterworks that seem to have evolved effortlessly. P.B.

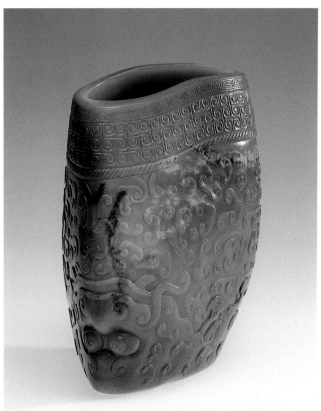

PEBBLE-SHAPED RHYTON

China; Qing dynasty, Qianlong reign
(1736–1795)
Russet-veined greenish nephrite
H: 5½ in. (13.7 cm)
The Avery Brundage Collection
B60 J466

This pebble-shaped rhyton perfectly blends the twin passions for antiquities and natural shapes that fired the imaginations of so many artists during the eighteenth century. The rhyton's decoration makes use of the curves of the river-smoothed jade pebble to suggest a vessel of horn. The piece was probably carved for the Qianlong emperor, whose uninspired poem for it, now inscribed on its base, praises its age and appearance ("It has passed a thousand autumns in a Khotanese river / [Where] watery vapors and variegated earth have soaked into it and not floated away"), its antiquarian elegance and benevolent influence on our taste and our demeanor ("It dissipates vulgarity and teaches us to emulate antiquity"), and its similarity to an archaic Han vessel, a *qiu*.

By the eighteenth century, Khotan in Eastern Turkestan (present-day Xinjiang province) was the major supplier of nephrite to Chinese jade carvers. Qing imperial interest in this distant region, which has always been populated by non-Han peoples, was in part due to the desire to keep the court supplied with jade. Nephrite's soft, waxy surface and subtle colors produced the antiquarian effect so prized by Ming artists and connoisseurs of jade.

The artist has used the stone's calm and rhythmic shape and natural coloration to enrich his playfully contrived design. The cloud scrolls and rolling waves transform, at the base, into a powerful monster mask, and the rice-sprout collar comes from the repertory of Han dynasty art. But their arrangement suggests that the pebble's shape reminded the carver of a horn or tusk; he has oriented the animal head toward the base, to emulate a rhyton of rhinoceros horn. P.B.

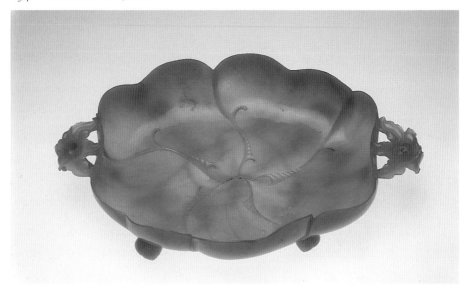

LEAF-SHAPED DISH
China; mid–late Qing dynasty,
ca. late 18th–19th century
Light green jade
L: 10 in. (25.0 cm)
The Avery Brundage Collection B60 J7+

The Manchu rulers of the Qing dynasty maintained active relations with China's Central Asian neighbors, their apparent cordiality symbolized by the flow of tribute to the Manchu court. Unworked jade was an important part of this tribute, for Khotan, an ancient city on the southern Silk Road, was the entrepot where nephrite was gathered, sorted, and sold. In 1758 the Qianlong emperor (r. 1736–95) received the first of many so-called Mughal jades from the Ili Zunghars, Mongols who lived in the region around Yarkand, not far from Khotan. Whether that piece was carved by the Zunghars or imported from Mughal India is not known. Whatever their origin, these jades were greatly admired by Qianlong, who wrote dozens of poems in their praise, and they started a vogue for the so-called Hindustan style among jade carvers in Beijing.

Mughal jades are noted for their soft, natural carving based on the floral motifs acceptable in the Islamic tradition, and for their extraordinary translucence, a quality imparted more by the pure white of the stone than specifically by thinness. Chinese carvers integrated the naturalness and translucence of Mughal design into their work, often adding motifs from the Chinese repertory.

This asymmetrical bowl resembles five overlapping leaves. The motif is carried out inside the dish and also on its underside. Details are extraordinarily soft and delicate; a lustrous, restrained polish heightens the refined effect. The handles, carved in the form of fading blossoms, are purely Chinese, but the curled leaves of the feet are more Mughal in inspiration. P.B.

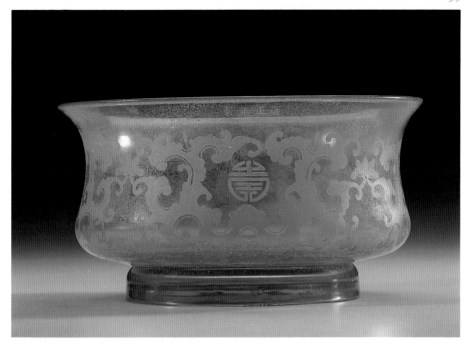

BOWL WITH CLOUDS, LOTUSES, AND "LONG LIFE" CHARACTERS

China, produced at the imperial glass
studios, Beijing; Qing dynasty, Yongzheng
mark and reign (1723–1735)
Pale blue clear glass with wheel-engraved
designs
Diam: 6⅞ in. (17.3 cm)
Gift of Dr. Jules and Hilda Koch B87 M7

Glassmaking in China prospered and
flourished in a kind of golden age during the eighteenth century, a result of
the Manchu rulers' profound interest
in it. The distinctive form of this bowl
for pure water (*qingshuiwan*) is that
of an offering bowl in Buddhist ritual.
Its decorative motifs, the lotus and the
Chinese character for long life (*shou*),
carry the message of the endurance of
the Buddhist faith.

The rough pontil mark is still apparent on this mold-blown bowl. The foot
ring was blown separately and heat-fused in a form and technique used in
contemporary Venetian and Northern
European lowland glass. The foot resembles an inverted shallow dish and
displays a distinct curved contraction
where it joins the bowl. The technical
antecedent is obviously Venetian-style
European glass, documented as having
entered China through the trade port
of Guangzhou (Canton).

Further emulating the highly esteemed Venetian technique of diamond-tip incising, the Chinese glassmaker
decorated this bowl with the wheel-engraving disks used in jade-working
studios; lateral traces of grinding are
readily visible in the decorative band
girdling the bowl.

The bowl has been affected by
'crizzling,' a silvery, powdery surface
decomposition caused by a chemically
unbalanced glass batch that reacts to
relative humidity. This condition can
indicate both authenticity and dating of
early Qing Chinese glass, as it does not
occur after 1740. Before that time, Chinese glassmakers introduced the condition by sometimes using remelted
broken European glass, which contaminated the new batch. C.F.S.

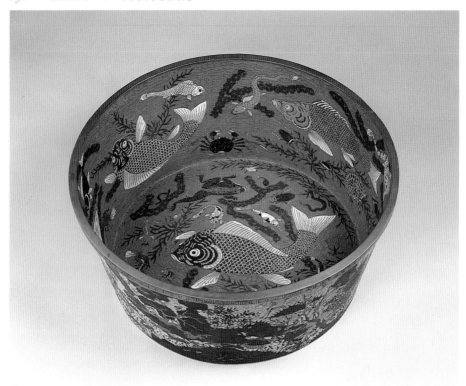

PALACE FISH BOWL

China; Qing dynasty, Qianlong reign
(1736–1795)
Bronze and copper with cloisonné enamels
Diam: 24½ in. (61.9 cm)
The Avery Brundage Collection
B60 M10+

In China, inlaying in metal goes back to the late Shang dynasty, when bits of turquoise were sometimes inlaid in bronze. The Chinese also independently learned to make glass as early as the eleventh and tenth centuries B.C., and used it to inlay bronzes. They continued to produce a limited amount of glass and glass enamel inlay through the Tang dynasty. Enameling technique improved considerably and achieved a new popularity in the early Ming, when Muslim metalworkers from Yunnan province began producing a true cloisonné in the workshops of Beijing.

The high point of Chinese cloisonné came in the Qing dynasty, when the Manchu emperors invited to their courts French Jesuits trained in the art of enameling. This fish bowl and its mate (in the Pierre Uldry collection) were commissioned by the Qianlong emperor. It is alive with fish, eels, frogs, and other water creatures swimming among water weeds on waves of turquoise blue, in an evocation of perfect liberty. The exterior shows a mountain landscape where *lu*, the hundred deer that symbolize wealth and long life, and cranes, companions of immortals, play.

Qianlong ordered many major works in cloisonné. Most were large Buddhist ritual objects intended to astonish and please Tibetan Buddhist dignitaries, including the Dalai and Panchen lamas, but these objects lack the spontaneity and grace of this fish bowl, which apparently was made with nothing in mind but pure enjoyment.

P.B.

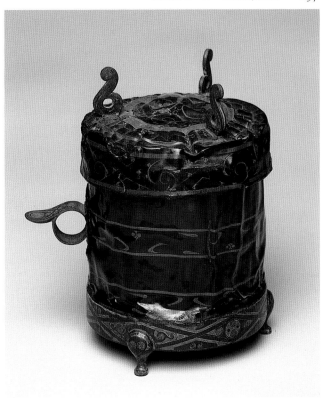

ZUN VESSEL WITH RING HANDLE, dated 278 B.C.

China; Warring States period,
predynastic state of Qin
Black lacquer with red lacquer designs,
and bronze fittings inlaid with silver
H: 7 in. (17.8 cm)
The Avery Brundage Collection
B60 M286

In the early third century B.C., China was divided into dozens of small, contending states. Qin in the northwest and Chu in the south struggled to control the remnants of the Zhou kingdom. This *zun* has an inscription etched with a needle into the underside of its base, establishing it as China's earliest-known dated lacquer. It reveals that in the cyclical "29th year" (278 B.C.), a dowager queen supervised three officials in the making of this vessel, which perhaps was a pawn in the critical game of diplomatic mollification and tribute played out between Qin and Chu.

It is known that this *zun* came from a tomb in Changsha, the Chu capital, and was therefore assumed to be a Chu product, since that kingdom was famous for its sophisticated lacquerwork. But recent advances in the study of early Chinese script reveal that its inscription was written in a style peculiar to the state of Qin before it successfully unified China in 221 A.D. In 278 B.C. Qin was still sending tribute to Chu. Yet the elegant style of the *zun* reflects the fluid decoration typical of Chu lacquer art. It gives us a strong sense of the cultural hegemony Chu continued to exercise over rivals.

The inscription, however, demonstrates Qin's independent role in the evolution of the Chinese language. It is one of the few examples of Qin script remaining from years before Qin Shihuangdi (d. 210 B.C.) accomplished a sweeping standardization of the writing system into the small-seal form. It suggests that even before this reform, the written language was tending toward progressive simplification and the ease of execution that eventually resulted in the development of the clerk and cursive scripts. P.B.

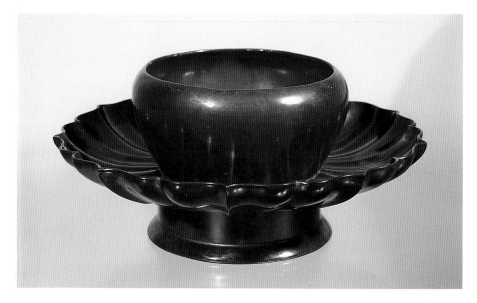

TEABOWL STAND

China; Southern Song period,
13th century
Brown lacquer on wood and fabric
H: 3 ⁵⁄₁₆ in. (8.4 cm)
Gift of the Asian Art Museum Foundation
B76 M3

In style and form, Song monochrome lacquers are closely related to the fine ceramics of the period. The subtle outline and delicate design of this stand reveal the contemporary preference of the scholarly elite for simplicity and understatement. This type of teabowl stand appears in Song paintings illustrating scholarly gatherings and banquets and the tea ceremony.

Textual evidence for tea drinking in China goes back to 1000 B.C. By the Tang dynasty (618–906), tea culture pervaded China. A Tang source attributes the development of this type of stand to a lady's burnt fingers. Needing something on which to support her hot teacup, she placed the cup on a plate and held it in place with wax, then ordered a lacquer craftsman to make a bowl stand.

This bowl stand has the form of a stylized lotus flower, following a Tang and Song tendency to produce vessels in various media in stylized flower forms. X-ray photography reveals the painstaking methods used to shape this stand from paper-thin strips of wood and laminated fabric. Making lacquer was extremely labor intensive, which explains why it was a product affordable only by the elite. Its manufacture was criticized and even restricted at different times as being an extravagant drain on labor and natural resources, but criticism did not curtail the Chinese love for it.

The base of this cup stand has a 2-character inscription in red lacquer, *Ru Zhou*—perhaps the maker's name, or the region of its origin. The lacquer shows no signs of crackle, evidence of its fine craftsmanship. S.K.N.

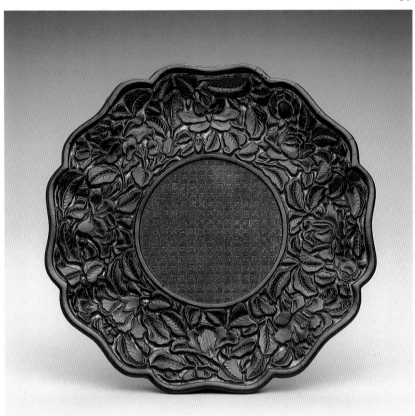

EIGHT-LOBED TRAY

China; late Southern Song–Yuan period,
13th century
Carved brown and red lacquer
Diam: 9 in. (22.5 cm)
The Museum General Acquisitions Fund
B83 M9

This superbly carved dish employs a rare technique, gold foil inlay. It relates to a Tang dynasty technique by which cut designs in gold and silver are inlaid in the surfaces of lacquered vessels. The use of gold leaf as a ground for carved lacquer began in the later Song dynasty and continued into the Yuan. The process was described in classical texts, but not fully understood until more examples, particularly archaeological materials, were recovered.

Gold foil was pressed into the background of this plate and probably made fast with lacquer putty. It glitters in the recesses to accentuate the swirling floral and leaf designs in highly polished, warm brown lacquer. Some carved Song and Yuan pieces exhibit buff-colored backgrounds, perhaps an attempt to imitate

the lustrous effect of the gold ground, but without the expense.

The tray's shape is a stylized eight-petaled flower. The naturalistic, vigorously carved floral motif continues around the rim above and below, with a different flower in the center of each petal or lobe. The flowers include camellia species, gardenias, peonies, hibiscus, chrysanthemum, prunus, pomegranate, and *baoxinghua*, a composite, lotuslike floral motif popular in the Yuan and early Ming dynasties; it is also used on blue-and-white porcelains. The red lacquer diaper pattern of the center is similar to designs found on brocaded textiles. The well-rounded carving and finish make this tray one of the finest surviving examples of late Song and Yuan period carved lacquer.　S.K.N.

RECTANGULAR BOX DECORATED WITH PAINTED LACQUER

China; Ming dynasty, early 17th century
Wood and woven bamboo
H: 4¾ in. L: 19 in. W: 13½ in.
(11.8 × 47.5 × 33.7 cm)
The Avery Brundage Collection
B60 M427

The combination of woven basketry and lacquer painting dates back to at least the fifth century B.C., but the kind of exquisite basketwork represented by this rectangular box with painted scenes was not attained until almost nine centuries later, in the Six Dynasties period (Liu-Song, 420–477 A.D.).

This covered box belongs to a series of seventeenth-century baskets with polychrome painting; they were created as presentation pieces. They reflect the period's exuberant taste and were produced during a fifty-year period when China experienced unsurpassed brilliance and material prosperity in the decorative arts. This sudden burst of creativity occurred during the affluence of the late Ming period (1368–1644),

and was spurred by the collapse of mismanaged imperial workshops, which cast thousands of displaced, skilled craftsmen into private enterprise.

The painting on the box lid is similar to contemporary works on paper and silk. A group of senior officials sits on a terrace receiving reports from a military envoy. Behind them and their attendants is a large painted screen with a black monochrome landscape. Military figures arriving on horseback appear against a brightly painted idyllic river landscape. The scene is framed by borders of lotuses reserved in black against a band of gold. The fine weaving of the basketry appears in a checkered pattern and a twill with connected swastikas.

In China the most prevalent technique of gold painting involves mixing powdered gold directly into the liquid lacquer and applying it with a brush. The polychrome painting is done with a combination of colored lacquers and oil-based paints. S.K.N.

MONEY-SHAPED RELIC WRAPPER

China; late Southern Song-early Ming
dynasty, 13th–14th century
Patchwork silk embroidered in needle-
looping over gilt paper
Diam: 20½ in. (52.1 cm)
Purchase: The Avery Brundage Collection
1988.49

Buddhist relics were traditionally
handled with an exquisite sense of
reverence, which required that they
be wrapped with finely worked silks
and fitted into nested reliquaries. Wrap-
pers might be simple squares of fabric,
or like this coin-shaped one, elaborately
designed in the form of auspicious sym-
bols. Money was often placed with relics
in China as a symbol of good fortune.
Reliquary boxes containing money
and relics wrapped in a money-shaped
wrapper have been found in eleventh-
century pagodas in Shanghai and
nearby Suzhou.

This money-shaped wrapper was
probably made in the last years of the
Song or during the brief Yuan dynasty,
when China was ruled by the descen-
dants of the Mongol conqueror Chinggis
Khan. Its fourteen different silks—plain
weaves, damasks, cords, and brocades—
were all woven during the late thirteenth
and fourteenth centuries, when China's
silk industry burgeoned through in-
creased trade along the Silk Road, and
technical innovations in the drawloom
allowed weavers greater flexibility.

A rare needle-looping technique
decorates this patchwork wrapper. Its
decorations represent flowers of the four
seasons—chrysanthemum, peony, lotus,
and plum. The spiraling loops produce
a knotted, openwork fabric visually re-
sembling but structurally unlike crochet
and attached to the backing only at the
pattern's edges. This allowed the artist
to lay pieces of gilt and silvered paper
behind each flower. The twining stems,
in a pattern akin to the blue-and-white
floral ceramics of late Yuan and early
Ming, are worked in a square chain
stitch and also backed by thin strips
of silver and gilt paper. P.B.

ALTAR VALANCE
China; early Ming dynasty,
ca. early 15th century
Dark-blue silk satin with embroidered silk
and couched gold designs
H: 31 in. W: 68⅛ in. (78.8 × 173.4 cm)
Gift of the Connoisseur's Council, and
Purchase: The Avery Brundage Collection
1990.212

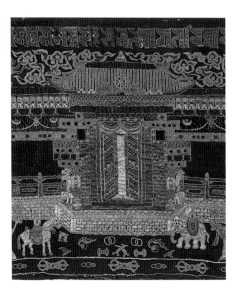

Early in the Yuan dynasty, the Mongol emperors of China and their mentors the Sakyapa lamas of Tibet formalized a patronage relationship that resulted in establishing the Sakya order as overlords of Tibet.

Some Mongol support of Tibetan Buddhism financed woodblock editions of Tibetan scriptures, and Nepalese artists invited to Beijing created a new Sino-Tibetan art. An untold amount of tribute also went to individual lamas and their monasteries.

The first Ming emperor Hongwu (r. 1368–98) strictly regulated activities of the Buddhist clergy, but when the Yongle emperor assumed the throne in 1403, Buddhism returned to imperial

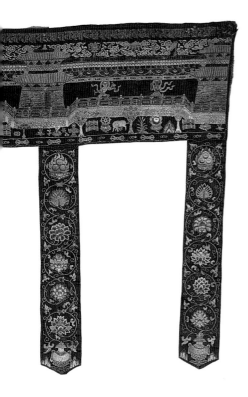

favor. This altar valance was probably part of the traffic in luxurious merchandise that passed over the borders of China and Tibet during the late fourteenth and early fifteenth centuries. It is finely couched in gold and embroidered in a variety of stitches on dark-blue silk satin. In a complex array of images it depicts objects placed on Buddhist altars in Tibet, the Eight Buddhist Treasures, a register of architectural elements (balustrade, towers, and a central, partly opened door) between which sit eight *yogini,* female deities of the senses, and below it a register where the Seven Treasures of the World-ruler alternate with those of Buddhism. Five of the six long pendants are embroidered with jars supporting floral scrolls, and on the third from left, the eight Buddhist emblems appear once more. The door may suggest that the valance represented one ring of a multi-ringed mandala formed by several layers of valances that would have encircled the central deity of the altar. P.B.

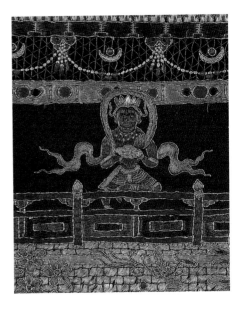

CHAOGUA (lady's court overvest),
dated December 5, 1595

China; Ming dynasty, Wanli reign
(1573–1620)
Silk gauze embroidered in canvas stitch
and satin stitch, and over-embroidered
in silver and gold couching
L: 55 in. (109.2 cm)
Purchase: The Avery Brundage Collection
1990.214

The sleeveless, split overvest (*bijia*), a Yuan dynasty innovation, was first worn by Khubilai Khan's empress Chabi for riding and archery. It was still fashionable in the late Ming dynasty among elegant ladies of the upper classes. The formality of this extraordinary Wanli period padded vest identifies it as a *chaogua*, a court garment. It is cut to fall just below the knees, and is decorated with mountains and waves. Typical of Chinese courtly garments are the large, standing dragons, their paws clutching clouds, that emblazon the vest's front and back panels. The front dragons clutch the jewels they usually pursue; they are surrounded both front and back with large, gold-couched characters reading *shou* (long life). With the swastikas, which mean 'ten thousand,' they combine to form a popular birthday wish for longevity. This symbolism indicates that the garment was intended for such an occasion, and the red Ming dynastic color points to a woman of the imperial family. An inscription embroidered inside the right lapel dates the garment to December 5, 1595, and suggests a likely owner, the Empress Dowager Li, whose fiftieth birthday was two days later.

Li had entered the imperial palace as a servant, where she attracted the favor of the Longqing emperor and bore him a son. Her status as mother of the heir-apparent, who would become the Wanli emperor, and her intelligence and strength brought her the respect of the court and of Longqing's surviving empress-consort. The superb artistry, imperial symbolism, and inscription strongly indicate this vest was intended for Empress Li, the only woman of the period powerful enough to wear it. P.B.

KOREA

After defeating the neighboring king-
doms of Paekche (in 660) and Koguryŏ
(in 668), the Unified Silla Kingdom
(668–935) launched a vigorous policy
of utilizing Buddhism to strengthen the
newly enlarged state. This state devel-
oped as a great Buddhist nation, estab-
lishing contact with China, Japan, India,
and the Middle East.

Unified Silla reached its political
and cultural apex in the eighth century.
During this golden period, Kyŏngju, its
capital, was described as a splendid city
with Buddhist temples as numerous as
the stars of heaven, and pagodas lined
up like flying geese.

Small gold and gilt-bronze Buddha
images have been discovered on Silla
temple sites as well as in pagodas, indi-
cating that these images were pervasive
—large ones for important halls of ma-
jor monasteries, small ones for family
altars, private worship, and as votive
images.

Early Buddha images of the Three
Kingdoms period were related in style
to works from China's Six Dynasties
period (ca. 221–581), with elongated
faces, narrow shoulders, and volumi-
nous robes cascading in the "waterfall
and fish fin" pattern. Images created
during the Unified Silla were inspired
by the Tang international style, with
fuller bodies, rounder faces, and broad
shoulders. Though it follows that style,
this figure has a disproportionately large
head, and a stern facial expression and
"wave pattern" drapery folds over the
legs, characteristics of eighth-century
Korean images. Two prominent knobs
in the upper and lower back indicate
that it was originally equipped with a
mandorla (body halo). This figure prob-
ably represents Amitabha Buddha, who
held the most exalted position during
this period. K.P.K.

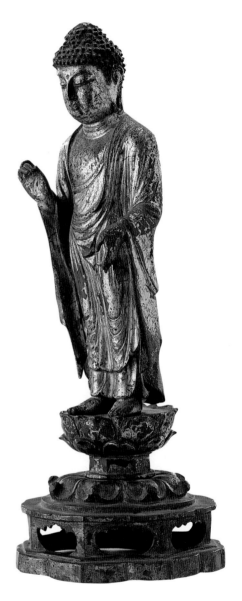

STANDING BUDDHA

Korea; Unified Silla period, 8th century
Gilt bronze
H: 18⅜ in. (47.3 cm)
The Avery Brundage Collection B65 B64

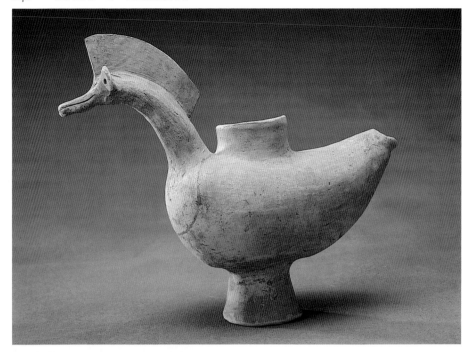

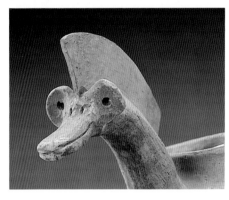

DUCK-SHAPED VESSEL

Korea; Three Kingdoms period, Kaya,
late 3rd–early 4th century
Earthenware
H: 12 in. L: 15 in. (30.0 × 37.5 cm)
The Avery Brundage Collection
B63 P13+

By the fourth century, earthenware in
Korea was apparently made for ritual or
burial purposes, while stoneware served
practical uses such as food storage and
serving. The two groups of early Korean
pottery are distinguished by the color of
the clay body: oxidation-fired reddish
ware and reduction-fired grayish ware.
Because of their relatively low firing
temperatures (800–1000° C), suitable

for making tiles, these oxidation-fired
reddish wares are called *wajil t'ogi*
(tile-quality earthenware).

The most famous of the *wajil t'ogi*
is a group of duck-shaped vessels with
hollow bodies and prominent openings
on the back and tail. No convincing ex-
planation accounts for their use in ritual
or burial practices. The ancient Koreans,
however, interred feathers of large birds
to help the soul of the deceased ascend
to heaven. Ducks, especially, are said to
have been worshiped in the Kaya area,
where all the duck-shaped vessels have
been found, and the Nakdong River, part
of the Kaya region, still attracts them in
large numbers. They must have been an
important food source and may have
symbolized a plentiful food supply for
the deceased in the hereafter.

This vessel and another one very
similar to it in the collection of Yeung-
nam University Museum have expres-
sive faces and alert eyes. The long bill,
with its grin, and the saillike crest add
an air of humor and pomp. The style
of the vessel's stand, which lacks aper-
tures, places this object earlier than
those with perforated stands. K.P.K.

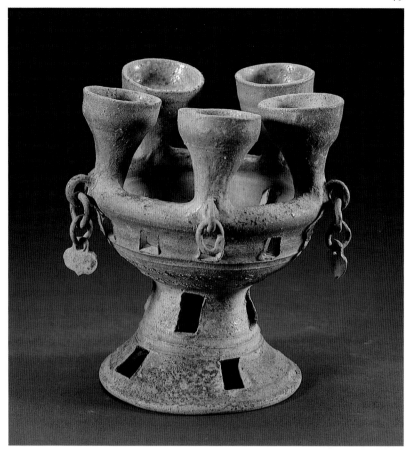

OIL LAMP

Korea; Three Kingdoms period, Silla,
5th–6th century
Stoneware
H: 6½ in. (16.2 cm)
The Avery Brundage Collection B66 P10

During the Three Kingdoms period
(57 B.C.–668 A.D.) from around 300
on, Korean potters built climbing kilns
on slopes or hills. They achieved kiln
temperatures of 1200° C or higher to
produce stoneware that was stronger
than earthenware and impermeable.
An abundance of gray unglazed stone-
ware found in Silla tombs bears witness
to a flourishing industry in the Silla
Kingdom (57 B.C.–668 A.D.).

Stoneware forms include large, glob-
ular, wheel-thrown jars, magnificent tall
pedestals decorated with varying aper-
ture patterns, long-necked jars with bul-
bous bodies, and small, stemmed cups or
bowls with aperture-decorated stands.
They served utilitarian, ceremonial, or
ritual purposes.

This oil lamp might have been cop-
ied from a contemporary metal lamp
and could have been used daily, since it
is perfectly functional. Five small cups
arranged at regular intervals around the
rim of a stemmed cup are connected at
the bottom to the hollow, tubular rim,
allowing a ready flow of oil and demon-
strating the potter's ingenuity. The stand
is decorated in a characteristic manner
with two rows of four staggered open-
ings, and eleven more openings below
the tubular rim. Double rings with a
heart-shaped dangle, reminiscent of
those appearing on famous Silla crowns
and gold rings, ornament the rim and
the stem of each cup.

Most multiple-cup oil lamps do
not have their cups connected to other
parts of the lamp; only two or three
such lamps with connected cups and
additional embellishments exist. This
lamp closely resembles one excavated
from the Gold Bell tomb in Kyŏngju.

K.P.K.

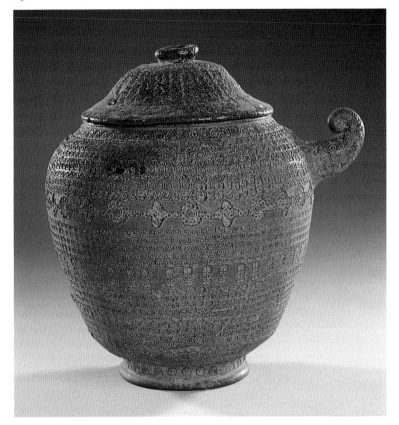

COVERED JAR WITH HANDLE

Korea; Unified Silla period, 8th century
Stoneware with impressed designs and
natural ash glaze
H: 9 in. (22.5 cm)
The Avery Brundage Collection B62 P24

In 527 Silla became the last of the three
kingdoms to adopt Buddhism. By the
time Silla unified the Korean peninsula
by defeating Paekche in 660 and Koguryŏ
in 668, the Buddhist practice of crema-
tion was firmly established, and the
stoneware industry was mainly devoted
to making vessels for practical use and
for cinerary urns.

Korean cinerary urns of the late
seventh century were usually decorated
with bands of incised lines or horizontal
grooves, and occasionally with twisted
dangles. They were placed on a low foot
with apertures, a vestige of earlier Silla
ceramic style. During the eighth century,
cinerary urns were elaborately decorated
with stamped designs that covered the
vessel's entire surface.

In 1975–76, an invaluable group
of 1748 ceramic pieces was recovered
from the Anjap-ji, a man-made pond in
a palace compound. It is believed that
most of this ware was used in the daily
life of the palace. For the most part the
objects are undecorated, allowing us to
assume that vessels completely covered
with stamped designs were for special
use, such as cinerary urns.

This stoneware jar, like other eighth-
century Buddhist cinerary wares, has
stamped motifs of rosettes, concentric
circles, and other floral patterns arranged
in horizontal registers. These floral de-
signs symbolize the dazzling beauty of
Buddha's paradise. The use of stamps
suggests high-volume production and
a great demand for decorated urns. The
natural ash glaze covering part of the lid
and the shoulder enhances the vessel's
beauty. A single handle in the form of a
tightly curled animal's tail adds a sense
of tension and vigor. K.P.K.

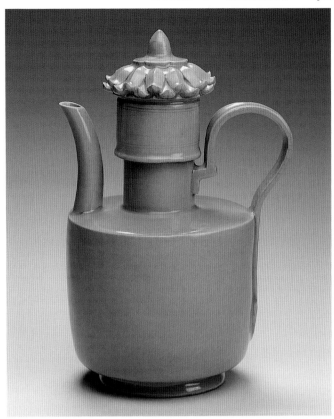

EWER WITH LID

Korea; Koryŏ dynasty, early 12th century
Stoneware with celadon glaze
H: 9⅝ in. (24.2 cm)
The Avery Brundage Collection
B60 P123+

Ceramic technology of the Unified Silla period produced ash-glazed stoneware fired in a reduction atmosphere, and led to the development of Korean celadon-glazed wares. Since 1962, excavations of ancient kiln sites at Inch'ŏn, Yong'in, and Sŏsan have pushed the beginnings of celadon back to the second half of the ninth century. The bluish-green glazes of these wares were inspired by Chinese Yue wares, but techniques of incising, carving, impressing, and molding appear to have been influenced by other Chinese precedents.

Koryŏ celadon reached its height during the first half of the twelfth century. Xu Jing, an astute observer who came to Korea in 1123 with a Chinese mission sent by the Huizong emperor, recorded his favorable impression of the Koryŏ greenish-blue wares the Koreans called "jade-colored" in his *Kaoli dujing* (An Illustrated Account of Koryŏ), in 1124. He was enchanted by unusual forms—an incense burner topped with a lion, wine pots with covers made of a bird sitting on a lotus. The finest Koryŏ celadons were contemporary with the famous Chinese imperial Ru wares made during the early twelfth century, and often rivaled or surpassed them in beauty.

This ewer with a lotus-form cover must once have had a snugly fitting outside bowl. Its form, with a straight shoulder line and crisply looped handle, indicates a metal prototype. In general, celadon forms resembling metal prototypes date earlier, but its elegant form and thin, transparent blue glaze date this ewer to the early twelfth century, when the best celadons were made. In lustre and color the glaze resembles those of the golden age of Koryŏ celadons. K.P.K.

MAEBYŎNG (Prunus vase)

Korea; Koryŏ dynasty, 12th century
Stoneware with iron-painted decoration
under celadon glaze
H: 11¼ in. (28.1 cm)
The Avery Brundage Collection
B60 P17+

Koryŏ celadons with decoration in un-
derglaze iron were first produced in the
tenth century, as evidenced by recent
kiln site excavations. Production of
Koryŏ painted celadons increased and
flourished from the eleventh century
through the thirteenth. Most of these
iron-painted wares took on a yellowish-
brown hue in the oxidizing atmosphere
of local kilns. But a small number were
reduction-fired in major kilns in Kang-
jin and Puan and have the more typical
bluish-green celadon glaze.

Koryŏ iron-painted celadons have
bold, expressively painted decorative
motifs, or a planned and stylized appear-
ance, like this piece. Major motifs are
floral and vegetal—peony, chrysanthe-
mum, lotus, the Tang floral scroll, grass,
willow. The *maebyŏng* was the most

popular of a wide variety of forms.
Though Koryŏ and Chinese Cizhou
wares share a general resemblance,
Koryŏ iron decoration is painted
directly on the clay body, while the
sgraffito of Cizhou wares reveals a
layer of white slip.

Eleven *maebyŏngs* painted in
underglaze iron were retrieved in 1983
from the underwater excavation of
Wando Island, South Chŏlla province.
They offer a valuable clue to dating this
vase. They are similar in shape, with the
same wide foot and swelling shoulder.
Three have a band of painted chrysan-
themum petals on the shoulder, and one
has an identical black band at the base.
The Wando vessels date to the late elev-
enth century, but this vase has a more
advanced decorative scheme of carefully
organized Tang floral scrolls that sweep
in S-curves over its entire surface. Vig-
orous individual brushstrokes, directly
applied to create petals, leaves, and vines,
impart a wonderful sense of energy.

K.P.K.

BOTTLE

Korea; Chosŏn dynasty, 16th century
Punch'ŏng stoneware with underglaze-white slip and iron-painted decoration
H: 12 in. (30.0 cm)
The Avery Brundage Collection B65 P63

Punch'ŏng stoneware and white porcelain formed the two branches of ceramic production at the start of the Chosŏn dynasty (1392–1910). *Punch'ŏng* is an abbreviation of a phrase that means 'white slip decorated grayish-blue stoneware,' but the majority of these wares are light yellow or light brown because of oxidation firing.

Punch'ŏng wares, unlike porcelains, were made for ordinary people, though some were produced on order for various government offices. Also unlike porcelains, they were decorated by inlay, stamping, incising, sgraffito, painting, and with white slip, either brushed on or dipped. Inlay is the earliest of these techniques, indicating that *punch'ŏng* descended from Koryŏ inlaid celadons at the beginning of the Chosŏn dynasty; some are indistinguishable from late Koryŏ inlaid celadon.

Evidence from excavations seems to indicate that underglaze-iron decorated and plain, white-slipped *punch'ŏng* ware originated and matured during the second half of the fifteenth century. The white-slip technique was pursued in the sixteenth century, and *punch'ŏng* ware evolved to assume a whiter, more porcelainlike appearance. The iron-decorated ware never made a comeback after the Japanese invasions of 1592 and 1597.

This pear-shaped bottle belongs to a group of ceramics produced in kilns located in the area of Mount Kyeryong, in South Ch'ungch'ŏng province. The flying-fish motif, symbolizing a courageous spirit, occupies the major portion of the body. Above it are one band of abstract scrolls and another of lotus petals. *Punch'ŏng* wares with expressive designs executed with speed and abandon had an enormous effect on the technique and taste of the modern craft movement, which has an international following. K.P.K.

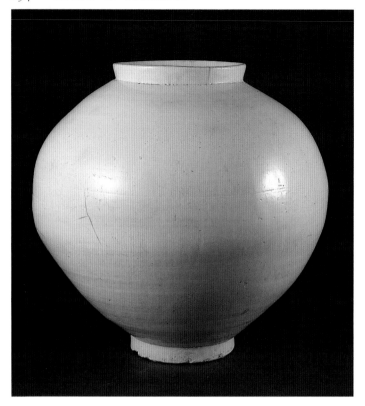

JAR

Korea; Chosŏn dynasty, 17th century
Porcelain
H: 18 in. (45.0 cm)
The Avery Brundage Collection
B60 P110+

The Korean people call themselves *paek'ui minjok*, 'people of the white clothing,' and greatly prefer white ceramic wares. Recent excavations show that white porcelain ware was being made in the tenth century, but it was overshadowed by the more famous Koryŏ celadons. As celadon production declined toward the end of that dynasty, porcelain production advanced, making great progress with the establishment of the Chosŏn dynasty (1392–1910).

From the outset, Chosŏn rulers and scholar-officials (*sadaebu*) made an effort to radically distinguish themselves from their luxury-loving Koryŏ predecessors. The color white, which symbolizes purity, honor, order, and modesty, appealed enormously to Chosŏn scholars steeped in Neo-Confucianism. During this period tremendous manpower and effort went into obtaining the most suitable kaolin to achieve the white hues they desired in ceramic wares.

In 1424 the Korean court sent a set of white tableware to the Chinese Yongle emperor, an indication that Korean potters were producing the finest porcelains by that time. A census of ceramic kilns in 1424–25 counted 139 porcelain kilns directly supervised by the Sasŏn-sŏ, an office charged with preparing and serving food for the king, the court, and for ceremonial banquets. Each year its staff traveled to official kilns to oversee porcelain production, grading their products into three categories according to quality.

The glaze of this large jar has a bluish tint in places. Its body expands in a large globular shape reminiscent of third- and fourth-century stoneware jars with mat or cord patterning. The form is slightly tilted, as if made on an unbalanced wheel, adding a casual and natural touch. K.P.K.

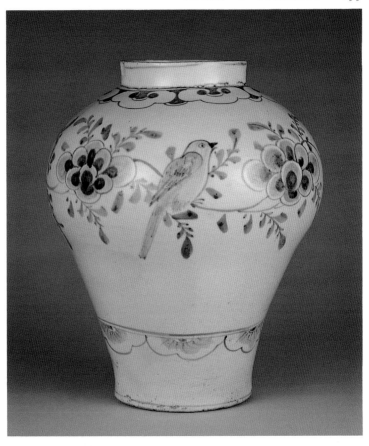

JAR

Korea; Chosŏn dynasty, 18th century
Porcelain with underglaze-cobalt
decoration
H: 15 in. (37.5 cm)
The Avery Brundage Collection
B60 P1793

Though undecorated porcelain or white ware dominated Chosŏn ceramics, decorated porcelain wares were also popular, especially those with underglaze-cobalt designs. In written records, "Mohammedan blue" was first mentioned in 1428 when the Chinese Xuande emperor sent the Chosŏn court a gift of five large and five small blue-decorated porcelains. In 1463 and 1464, a native cobalt ore was discovered at several sites, but it proved unsatisfactory, firing black because of impurities. The pure but costly imported cobalt was preferred for decorating the blue-and-white wares reserved for use by the royal household and gentry (*yangban*). Only in the nineteenth century did commoners freely use underglaze-cobalt decorated porcelain.

This jar form is a typical eighteenth-century piece, with its medium neck, wide mouth, and strong, swelling shoulders. Also typical is the pattern of cloud or magic mushroom, *yŏngji*, decorating the shoulder and lower body, as well as the horizontal lines demarcating the foot, mouth rim, and juncture of shoulder and neck. From the fifteenth century on, the motif of birds on blossoming branches appeared frequently on blue-and-white wares. Early designs tended to crowd the vessel's surface, but in later ones the empty space is deftly manipulated to balance a sparse, simple composition. Brushstrokes executed with speed and spontaneity here suggest the skilled hand of a court painter, who would have traveled to the official Kwangju kilns near Seoul to decorate these porcelains. K.P.K.

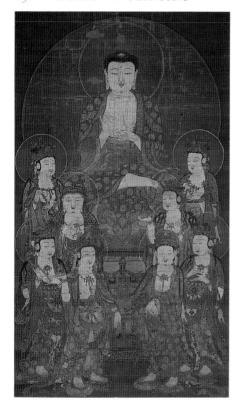

**BUDDHA AMITABHA WITH THE
EIGHT GREAT BODHISATTVAS**

Korea; Koryŏ dynasty, 14th century
Hanging scroll; ink, colors, and gold
on silk
H: 59½ in. W: 34¹⁵/₁₆ in. (148.7 × 87.3 cm)
The Avery Brundage Collection
B72 D38

Painting dominated the vigorous Buddhist arts of the Koryŏ dynasty because it was believed that commissioning paintings in quantity would bring manifold merits to their sponsors. Aristocratic patrons commissioned works for family altars as well as for large and small monastery halls, for either worship or adornment. Buddhist deities such as Amitabha and Avalokiteshvara, who were believed to have the power to help sentient beings in this life as well as in the hereafter, were especially popular subjects.

The Amitabha Buddha was undoubtedly the one most fervently worshiped during and after the Unified Silla period (668–935). As the Buddha of eternal life and boundless light, Amitabha promised all believers rebirth in the Pure Land Paradise over which he presided. Devotees had only to have faith or profess their belief by reciting the phrase *Nammu Amit'a Pul* (homage to the Buddha Amitabha).

Amitabha was represented alone, or flanked by two, four, or eight iconic figures, or by a multitude of bodhisattvas, disciples, and guardian kings. The company of eight figures in this work are bodhisattvas. On Amitabha's left are Avalokiteshvara (Kwanŭm), Manjushri (Munsu), Maitreya (Mirŭk), and Vajrapani (Kŭmgangjang); on his right are Mahasthamaprapta (Taeseji), Samantabhadra (Pohyŏn), Ksititgarbha (Chijang), and Sarvanirvana Viskambin (Chejang'ae). A painting like this one, together with a statue of Amitabha, formed the focus of daily Buddhist worship in halls of Amitabha (Amitajŏn), Amitayus (Muryangsu-jŏn), and Paradise (Kŭknak-jŏn).

K.P.K.

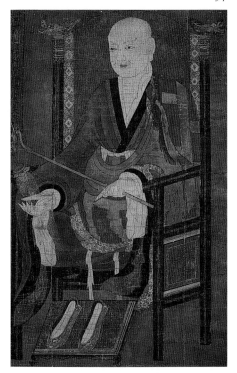

Sŏsan Taesa, educated as a Confucian at the famous Sŏnggyungwan Academy in Seoul, decided in 1534 to become a Sŏn (Japanese: Zen) monk and eventually rose in the monastic hierarchy to become abbot of Pong'ŭn-sa Monastery. In 1556 he resigned his post to pursue meditation and teaching. But when the Japanese invaded Korea in 1592, Sŏsan Taesa, ordered by the king, rallied the monks and fought off the invaders. For his valor he was awarded a long title that honored both his spiritual and military accomplishments.

In 1594 Sŏsan Taesa returned to monastic life. He became famous for his teachings on the importance of meditation for both monks and laymen, and on the unity of the three major teachings of Confucianism, Buddhism, and Daoism.

In this portrait, Sŏsan Taesa's special position in the early Chosŏn Buddhist hierarchy as a great Sŏn teacher is acknowledged by the elegance of his raiment and furnishings. Sitting in the lotus position, he occupies a sumptuous chair decorated with dragon heads and covered by a luxurious red cloth embellished with diamond shapes enclosing a rosette surrounded by stylized wave patterns. He has a dragon-finial flapper, multicolored silk shoes, and the hems of his outer robe are embroidered with delicate floral and cloud patterns. The stylistic features of early Chosŏn dynasty painting are apparent in his face, represented with long, fluid, even lines without shading, and in his robes, depicted by long, sober lines devoid of flourishes. His strong personality is superbly captured in the penetrating eyes and tightly closed mouth. K.P.K.

PORTRAIT OF SŎSAN TAESA, HYUJONG (1520–1604)

Korea; Chosŏn dynasty,
late 16th–17th century
Hanging scroll; ink and colors on silk
H: 43⅞ in. W: 28⅜ in. (111.5 × 72.0 cm)
Purchase: The Avery Brundage Collection
1992.345

Many Korean painters of the nineteenth century were influenced by the famous Kim Chŏnghui (1786–1856), the renowned scholar, artist, and arbiter of taste in painting and calligraphy. Kim's ink paintings of landscapes and the so-called Four Gentlemen themes (flowers and foliage of the four seasons) raised the Korean scholar-amateur school to new heights. His followers painted garden rocks and orchids with long, slender leaves reminiscent of his style. This work by Chŏng Hakgyo follows the scholar-amateur tradition that Kim defined.

Chŏng Hakgyo especially loved to paint strange rocks as well as orchids and bamboos in ink. He was also known for his calligraphy in the seal, clerical, standard, and grass scripts. He had held an official post of magistrate.

In this work, a rectilinear, two-dimensional rock form composed of smaller rectangular and trapezoidal shapes occupies the central position; it is quite unlike the eroded rocks often painted by other scholar-amateur artists. Several orchid leaves and flowers jutting to the left from behind the rock recall those of Kim Chŏnghui. The small dots scattered around the rock's contour have two tails on either side, making them look like insects. The inscription reads:

> People say there is a pavilion
> on the moon,
> But it may just be a shadow
> of mountains and rivers.
> Jagged rocks fill the sea and
> rise above,
> Making the blue clouds proud
> of the soaring peaks.
> *(trans. Dr. Sun-Hak Choy)*

This work was painted in autumn just after the fall of the Chosŏn dynasty on August 29, 1910. In the lower right is a relief seal, which says: "At age 79, in a dream." The latter phrase, *monjung*, is also one of Chŏng's pen names.

ROCK AND ORCHIDS (SŎKNAN), dated 1910

Chŏng Hakgyo (1832–1914)
Korea; Chosŏn dynasty
Hanging scroll; ink on silk
H: 46¾ in. W: 18⅜ in. (118.6 × 46.5 cm)
Gift of Jeanne G. O'Brien in Memory of James E. O'Brien 1993.50

K.P.K.

INLAID BOX

Korea; Chosŏn dynasty,
16th–17th century
Wood with black lacquer and mother-of-pearl and tortoiseshell inlay
H: 8⅛ in. W: 8½ in. L: 13 in.
(24.1 × 21.6 × 32.9 cm)
On loan from the Christensen Fund
BL77 M46a, b

The inlay technique that became virtually synonymous with Koryŏ celadons was first used to decorate metal objects. The earliest surviving object with mother-of-pearl inlay is an eighth-century bronze mirror. From the Three Kingdoms period on (57 B.C.–668 A.D.), a government bureau oversaw the work of lacquer craftsmen and their mother-of-pearl inlay production.

Large numbers of inlaid lacquer boxes were made to hold the Koryŏ court-sponsored Buddhist sutras printed in the eleventh and twelfth centuries. Inlay technique reached its zenith in the early twelfth century; the Koryŏ craftsmen's minutely executed mother-of-pearl designs had no parallel in East Asia.

By the sixteenth century, the luxury and elegance of Koryŏ inlaid lacquer had given way to simple, understated designs of the Chosŏn period, a reflection of the taste of a ruling gentry class steeped in Neo-Confucian philosophy and virtues. Unlike their Koryŏ predecessors, Chosŏn craftsmen created bold and rugged designs with large, thick pieces of mother-of-pearl.

This small lacquer box retains traits of larger Koryŏ sutra boxes, seen in the rectangular shape with its bevel-edged lid and in the surface decoration, which highlights the main area and is surrounded on all sides by a band. The single line of large diamonds at the bottom is a typical simplification of earlier Koryŏ geometric designs. The major motif, similarly simplified, consists of two large lotuses with leaves that look like floating clouds. The large pieces of mother-of-pearl create a bold and fresh effect, reflecting the spirit of sixteenth-century Korean society.

K.P.K.

KUNDIKA

Korea; Koryŏ dynasty, 11th century
Bronze inlaid with silver
H: 14½ in. (36.7 cm)
Gift of Mr. Nam Koong Ryun 1991.147

Many new bronze forms were introduced to Korea through Buddhist liturgy and as altar furnishings—incense burners, bells, drums, *vajras* (thunderbolts), staffs, and miniature pagodas. Most numerous were ritual ewers, *kundikas*. In Korea they were made in a simple bottle form with a long central spout and a filler hole in the shoulder, and later with a cupped filler on the shoulder, like this one. Both types were apparently in use by the eighth century.

Kundikas appear in Buddhist carving and painting over a span of 700 years, from the eighth century into the fourteenth. A relief carving in the famous eighth-century Sŏkkuram grotto shows Indra holding such a vessel; in Koryŏ Buddhist paintings, Avalokiteshvara was often represented holding one, or with one placed near him.

Inlaid scroll and plant designs first appeared on bronze objects in the fifth century. The main field of this *kundika* is ornamented with a willow, a plantain, an unidentified leafy tree, and reeds, all placed along gently curving ground lines. Two birds swim in a pond, and a third flies to join them. Plant, floral, and cloud motifs adorn the lower body, neck, and the disk from which the hexagonal spout rises. The capped filler, which bears a lotus design, springs from the center of a large lotus. Only the foot has a geometric design of close-set, slanting parallels. The width of inlaid lines, leitmotifs, and a somewhat loose compositional scheme all help date this *kundika* to the eleventh century. K.P.K.

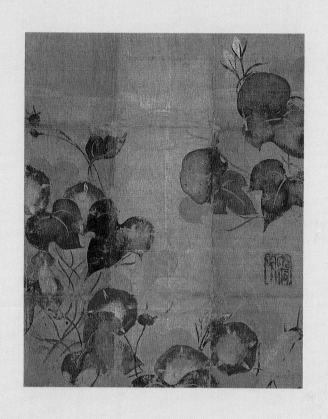

JAPAN

DŌTAKU (ritual bell)

Japan; Ōiwayama, Koshinohara, Yasu-cho,
Shiga prefecture; Yayoi period,
2nd–3rd century
Bronze
H: 24½ in. (61.7 cm)
The Avery Brundage Collection
B60 B14+

By far the most impressive of the
bronzes of prehistoric Japan is the fully
developed *dōtaku,* or bell. Almond-
shaped in section, it has lateral flanges
that merge at the top to form a large,
flat, U-shaped handle. The metal sur-
faces of all *dōtaku* show characteristi-
cally beautiful patination developed
during their long burial.

The square-and-border design on
this *dōtaku* is called *kesadasukimon,*
or priest's surplice pattern. Its wide
handle is decorated with bands of vari-
ous designs. The second band from the
central opening shows a slight three-
dimensional modeling, a reminder of
the earlier thick and functional handle.
Some *dōtaku* have been unearthed with
clappers, but more lack them, perhaps
indicating that the bells, if they were
associated with magic and ritual, became
increasingly nonfunctional.

The more than 400 *dōtaku* known
to date were produced in central Honshu,
Japan's main island, at a time when a
newly organized agricultural society
was gaining importance. All *dōtaku*
have been found in accidental sites—
hillsides, plains, and sometimes deep in
canyons or on mountaintops, removed
from the usual archaeological sites of
burial grounds, dwellings, and middens.
This *dōtaku* was unearthed at such a site
in Ōiwayama.

Traces of woven textile patterns
remain on some excavated *dōtaku,* indi-
cating they had been wrapped in cloth
for burial. Otherwise there is little cir-
cumstantial evidence to reveal whether
these burials were temporary or perma-
nent, despite the obvious significance of
seemingly ceremonial interment. There-
fore studies of the origin, function, and
ownership of *dōtaku* remain only a
series of speculations. Y.K.

MIRROR WITH
MATSUKUIZURU MOTIF

Japan; Heian period, 11th–12th century
Bronze
Diam: 3 ⅛₆ in. (7.9 cm)
The Avery Brundage Collection
B60 B339

The back of this bronze mirror is decorated with a popular Japanese motif, *matsukuizuru*, a flying crane carrying pine needles in its beak. Here two of them are juxtaposed among clusters of pine needles arranged over a thin ridge that seems to frame the birds. A small knob in the center of a chrysanthemum base has a hole to accommodate a silk cord tied as a handle.

Bronze mirrors were introduced to Japan from China during the Kofun period (250–552). Their reflective surfaces were considered near-magical and were treasured by clan chiefs as status symbols. The Japanese soon produced similar mirrors, copying the original Chinese designs and sometimes using molds made directly from the imported prototypes.

The Japanese gradually abandoned Chinese images for simpler designs, a process completed by the Heian period (794–1185). The new designs incorporated more natural subjects, such as birds and flowers, on a much thinner and smaller format—probably a result of preference and a scarcity of raw materials.

In style this mirror resembles some 200 mirrors that were excavated from a Buddhist site on Mount Haguro. During the Heian period, this mountain was the cult site of Shugendo, the Buddhist sect that revered mountains. After reaching the temple atop this extremely steep mountain, devotees threw mirrors into a pond as votive offerings. Those unable to make the rigorous climb looked at their images in their mirrors and then entrusted the mirrors to priests, who delivered them to the temple as offerings.

Y.K.

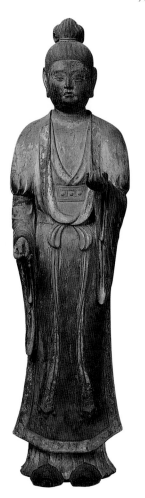
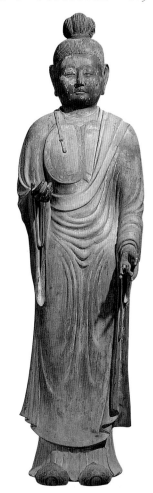

BONTEN AND TAISHAKUTEN

Japan; Nara period, 8th century
Dry lacquer
H. S13 (Bonten): 55¾ in. (141.6 cm)
H. S12 (Taishakuten): 55⅛ in. (140.0 cm)
The Avery Brundage Collection
B65 S12, B65 S13

Bonten and Taishakuten are two power-ful Vedic figures: Brahma, creator of all things, and Indra, the thunder god. In the early development of Indian Bud-dhism, they were adopted from the Hindu pantheon and paired as atten-dants of Buddha Shakyamuni, the his-torical Buddha. Eventually they became the guardians of Buddhism, their duty to oversee the Four Heavenly Kings, or Shitennō, who are guardians of Bud-dhist law. Here Bonten (left) and Taisha-kuten (right) are portrayed as standing noble images. Their long hair is tied in a knot at the top of their heads, and they wear Chinese long-sleeved garments and shoes with upturned toes.

Both figures were made in the time-consuming dry-lacquer technique, by which fabric is soaked in liquid lacquer and applied in layers to a clay core. When the form is built to the desired wall thickness, the clay core is removed. This method of building sculpture was favored in the eighth century for its ad-vantages of light weight and a smooth surface for painting. It lapsed in the ninth century when wood became a major medium for sculpture in Japan.

Very few examples of dry-lacquer images have survived. This Bonten and Taishakuten, originally housed in a hall in the Kōfukuji Temple in Nara, are the only examples in this media in the United States. Y.W.

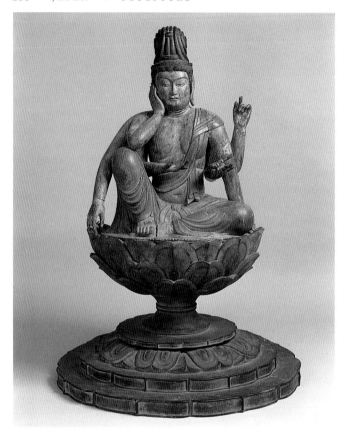

SEATED NYOIRIN KANNON

Japan; early Heian period, ca. 900
Wood with traces of lacquer, pigment,
and gilding
H. (figure): 25⅞ in. (65.7 cm)
Gift of Avery Brundage and George F.
Jewett, Jr. B71 S3

The Nyoirin Kannon, one of the six manifestations of Avalokiteshvara, is worshiped in esoteric Buddhism for realization of long life, safe birth, and avoidance of calamity. His complex iconographical features illustrate his profound benevolence and endless compassion for suffering beings.

Nyoirin Kannon, represented with one face and six arms, is seated in the posture of royal ease with left knee raised. In contrast to his relaxed pose, his face shows deep contemplation. The name 'Nyoirin' derives from two power-ful wish-granting attributes he usually holds: the *nyoirin*, or wheel, and the flaming *nyoihōju*, a jewel. Through their power he grants worshipers wealth and helps them overcome worldly suffering.

He is commonly shown with his first right hand touching his cheek, and the second and third with the jewel and prayer beads. His first left hand rests upon the earth, and the second and third hold a lotus and the wheel. This Nyoirin's attributes are all missing.

The figure's torso is carved from a single block of wood, with limbs carved separately and attached. Even with six arms, the Nyoirin Kannon's upper body retains graceful naturalistic proportions. The high headdress and some hands are replacements. The forbidding facial ex-pression, plumpness, and the deeply carved rolling wave pattern (*hompa*) in the drapery around the legs are promi-nent stylistic characteristics in ninth-century sculptures. Y.W.

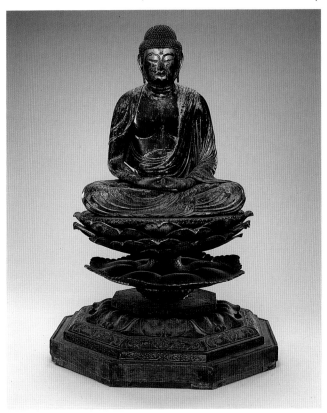

AMIDA BUDDHA

Japan; late Heian period, 12th century
Wood with traces of lacquer, pigment,
and gilding
H. (figure and pedestal): 52½ in.
(133.3 cm)
The Avery Brundage Collection
B60 S10+

Amida, the Buddha of Infinite Light
(Amitabha) and of Infinite Life (Ami-
tayus), is depicted in deep meditation,
seated in the lotus position with legs
crossed and hands in the gesture of
meditation. The elegant, thin robe cov-
ers in a neat pattern both shoulders, the
lower body, and legs. His eyes are half-
closed under gently arched eyebrows.
The head and its large bump (usnisa),
which symbolizes Amida's wisdom, are
covered with regular rows of curls.

Amida, Lord of the Western Para-
dise, is the most benevolent of all forms
of Buddha, who made forty-eight vows
to save all sentient beings. According
to the Pure Land teaching, one could
attain rebirth in the Western Paradise
by merely reciting Amida's name. The
Amida cult, introduced in the seventh
century, became the most influential in
Japanese spiritual life from the twelfth
century on. Aristocrats and court nobles
were especially concerned with the world
after death, and wished to be taken to
Amida's paradise upon departing this
world. Their ardent wish is clearly ex-
pressed in this gentle and serenely exe-
cuted deity.

During the eleventh century the
sculptor Jōchō (?–1057) achieved re-
markable stylistic and technical innova-
tions. He developed a technique whereby
parts of wooden sculptures were carved
separately and joined. This technique
prevented cracks from occurring, as they
might, in time, in works carved from a
single block. It also enabled sculptors to
make and mass-produce large statues.
Jōchō developed a refined, elegant style
that suited the taste of aristocratic pa-
trons, and which became the dominant
canon of the period. This Amida is an
excellent example that was produced
in the tradition of Jōchō. Y.W.

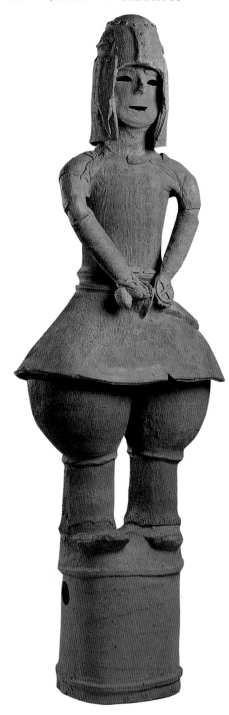

This clay figure represents a fully armed warrior with both hands at his sword. He wears a tunic and puffy pantaloons tied around the knees. His armor includes a helmet and pads to protect the neck, shoulders, and arms. The figure is mounted atop a clay cylinder (*haniwa*); these were placed on the tops and sides of burial mounds in the Kofun period (250–552). *Haniwa* stabilized the soil of the mound. Later they acquired representational forms—rulers, warriors, musicians, birds, animals, boats, and houses. As burial objects, *haniwa* with figures vividly display the high economic and social status of the interred.

The base cylinders and the figures, coil-built of reddish clay, were fired in half-underground kilns at a low temperature. Tubelike arms are awkwardly attached to the shoulders, and details may either be incised or appliquéd. Eyes and mouths were made by cutting openings through the wall.

Beginning in the late Yayoi period (2nd–3rd century), burial mounds were built in the large region from Kyushū to Kantō, and the practice continued well into the mid-sixth century. These great burial mounds, typically of keyhole shape, adorned by *haniwa* and surrounded by a moat, provide the name 'Kofun' (Old Tomb) that designates this period. Agricultural prosperity in the earlier Yayoi period enabled regional leaders to accumulate enough wealth and power to build such tombs.

After the introduction of Buddhism in 552, the use of *haniwa* began to decline as devotees concentrated on establishing Buddhist temples and the works of art that embellish them. Y.W.

STANDING WARRIOR

Japan, Fujioka, Gumma prefecture;
Kofun period, ca. 6th century
Earthenware
H: 47½ in. (120.7 cm)
The Avery Brundage Collection
B60 S204

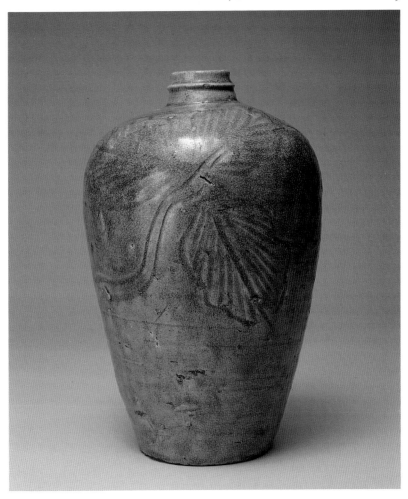

WINE BOTTLE

Japan; Kamakura period, 14th century
Ko Seto ware, glazed stoneware
H: 10⅝ in. (27.0 cm)
Purchase: The Avery Brundage Collection
1991.6

This wine bottle, with its ash glaze of "decayed-leaf" color over an incised, double-leaf pattern, is an excellent example of ware from the Seto kiln complex. Seto, one of the long-celebrated six ancient kilns of Japan, is, with Arita of a later date, one of the most important ceramic production sites in Japan's cultural history. Seto's history is virtually unbroken from medieval into modern times, and its vast production included highly praised tea wares. The term 'Seto' has come to mean ceramics in the Japanese language.

During medieval times, Seto was the only ceramic center producing glazed stoneware that faithfully followed the imported Chinese models desired by the privileged classes. Seto's history is virtually unbroken from medieval into modern times, and its vast production included highly praised tea wares. The term 'Seto' has come to mean ceramics in the Japanese language.

The Chinese refer to this bottle shape as *meiping* (prunus bottle). A narrow band around the straight neck is one of many stylistic features Japanese potters copied directly from Song ceramic ware.

The glaze on this bottle is exceptionally good, amply applied and evenly matured in a well-controlled firing. Many similar bottles excavated from historical sites display noticeable glaze deterioration.

Along with Bizen and Shigaraki wares (p. 170), Seto ware enjoyed early recognition among Japan's tea practitioners, although it was originally used for libations offered on altars and for the formal serving of sake. Y.K.

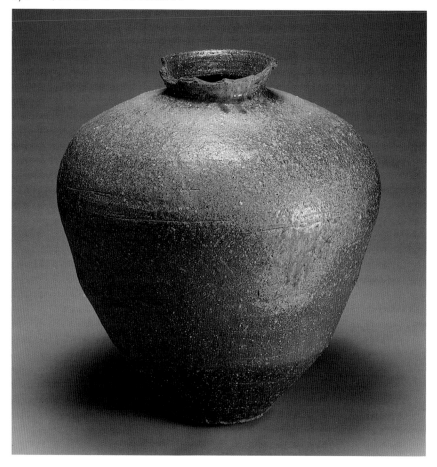

LARGE JAR

Japan; Muromachi period, 15th century
Shigaraki ware, stoneware with natural
glaze
H: 21¼ in. (54.0 cm)
The Avery Brundage Collection B66 P38

Japanese ceramics of the medieval period were mostly unglazed stoneware made primarily for everyday use in agrarian communities. The three basic shapes were the *kame,* a large-mouthed jar, the *tsubo,* a narrow-mouthed jar, and the *suribachi,* a shallow, conical bowl with sharp comb-tooth marks, for grinding food.

This large *tsubo,* a storage jar, was made in Shigaraki, about 30 kilometers southeast of Kyoto, near the sites of earlier ceramic kilns that date back to prehistoric times. Clearly visible on this coil-built jar are the three horizontal bulges where coiling was halted for an interval to allow the clay to dry sufficiently to support the weight of the next level of coils. Since potters did not levigate their local clay (a process allowing coarse particles to settle out of nearly liquified clay), natural impurities such as iron and small feldspar pebbles remained to affect the finished surface.

After being completely sun dried, the pots were fired in simple *anagama* kilns typically dug partly underground on hillsides and vented at the upper end. In the Shigaraki kilns, however, a wall divided the firing chamber lengthwise into two narrow corridors. This construction produced much higher firing temperatures, which created body colors ranging from light orange to dark brown (a result of the iron-rich clay), and a surface spotted with shiny white beads of melted quartz pebbles. A light-green natural ash glaze enhances some areas of this pot's surface. Early tea practitioners prized this glaze characteristic.

Y.K.

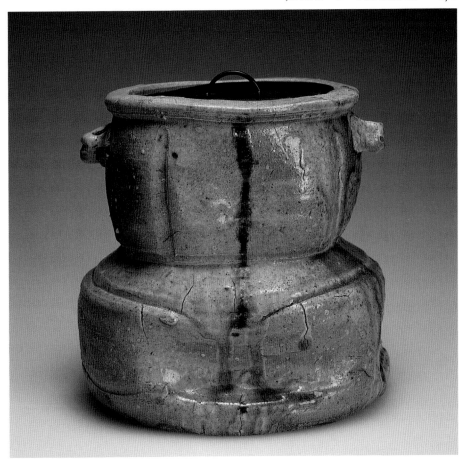

FRESH WATER JAR FOR TEA CEREMONY

Japan; early Edo period, 17th century
Iga ware, glazed stoneware
H: 7¾ in. (19.4 cm)
Gift of the Asian Art Museum Foundation
B68 P4

Potters in Iga, a province next to Shiga-raki (p. 170), produced tea bowls, incense containers, tea-leaf storage jars, fresh water jars, and other utensils for the tea ceremony. Highly treasured in Japan are the fine flower vases and fresh water jars of Iga. Like wares from other ceramic centers of the period, Iga pottery reflects the strong personal taste of tea masters such as Furuta Oribe (1544–1615). A high-ranking samurai, Oribe was one of the principal students of the renowned tea master Sen no Rikyū (1522–91). After his master's death, Oribe radically changed the tea ceremony into a more masculine expression. He had a strong liking for objects with bold colors and forms that occasionally approached distortion.

Many tea wares, like this one, were commissioned by local feudal lords. This water jar was originally wheel thrown. It was further modified to a strong, irregular shape by constricting its waist and pushing the vessel wall inward to form concave areas. Spatula marks around the hip area on the lower section intensify the horizontal movement. Close to the bottom, another spatula mark further accentuates the squatness of the heavy lower half.

The glaze followed the spatula marks, making thick moss-green pools which, along with a line of iron brown that drips halfway down the front, give the piece an arresting presence. The areas of thinner glaze developed warm, iron-brown colors in the oxidizing kiln atmosphere. Y.K.

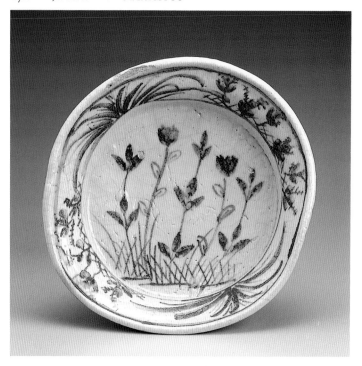

DISH WITH PLANT DESIGN

Japan; Momoyama period, ca. 1600
Shino ware, glazed stoneware
Largest diam: 11 in. (28.0 cm)
The Avery Brundage Collection B66 P37

The glazed pottery from Mino produced during the Momoyama period is among the best in the long history of Japanese ceramics. Mino potters were the first to introduce wares that may be said to represent genuine Japanese taste: Shino and Oribe. This dish with iron-oxide slip decoration under a milky white glaze is among the finest examples of Shino ware.

After a long series of civil wars during the years 1467–1583, Japan was rebuilt by the daimyo, provincial warlords who depended for support on a rapidly rising merchant class in the cities. This interaction created a new urban culture. Shino ware, made of soft, light-colored local clay and covered with a white feldspathic glaze, satisfied the period's new taste for lightness. It established a clear departure from the medieval austerity exemplified by earth-colored stoneware such as Shigaraki (p. 170), Bizen, and Seto (p. 169).

Early Shino wares were fired in an *ōgama*, a single-chambered, much improved version of the earlier hillside *anagama* kiln. The earliest group of Shino, mostly tea bowls and fresh water containers, had a much thicker and less transparent glaze. But around 1590, the new *noborigama*, a multichambered hillside kiln originally from Korea, was introduced from Karatsu, the northern Kyushu potters' community. It completely changed the Mino production pattern. It was much larger and more fuel-efficient, and produced a fully mature glaze suitable for underglaze iron decoration.

Mino wares reached Kyoto and other parts of Japan; merchants specializing in ceramics were well established by the end of the Momoyama period. An urban excavation within the early city limits of Kyoto recently unearthed almost a thousand pieces, suggesting that merchants had been receiving large shipments, perhaps for transport beyond the city. Y.K.

TEA BOWL WITH DRAGON MEDALLIONS

Nonomura Ninsei (fl. mid-17th century)
Japan; Edo period
Glazed stoneware with polychrome
enamel decoration
H: 3½ in. (8.3 cm)
Gift of the Connoisseur's Council and
Bruce and Betty Alberts 1991.230

Ninsei was one of the most fortunate potters ever to have worked in Japan. In a society where tradition kept many potters anonymous, however talented, because of their humble medium, Ninsei is believed to have been one of the first potters to place his seal on his works. Extremely beautiful and technically superb, his works were worthy of the patronage he enjoyed in the highly cultured society of Kyoto.

Ninsei's most famous creations are large—tea-leaf storage jars, and fresh water containers for the tea ceremony. Smaller ones are equally beautiful. His tea bowls and incense containers are esteemed among the many utensils used in the tea ceremony. Many of his tea bowls are inspired by the *gohon-de*, a type of Korean bowl given a slightly more graceful contour in Ninsei's carefully wheel-thrown shapes.

This deep bowl would be used in winter, since it keeps the tea warm longer —a basic concern of a tea host. Its black glaze might remind one of winter; another famous black tea bowl from Seto, now in a private collection in Japan, was named 'Winter Night' by one of its previous owners. Y.K.

PLATE

Japan; early Edo period, 17th century
Kutani ware, porcelain with polychrome
enamel
Diam: 15⅞ in. (40.3 cm)
The Avery Brundage Collection B64 P31

This type of polychrome porcelain is
traditionally believed to have been made
in the small village of Kutani (Nine Val-
ley) on the Japan Sea coast. Produced
under the patronage of the clan head,
Kutani ware has been praised for the
considerable boldness and imagination
of its unique decorative style. The deep
green, rich amber, and sensuous purple
on this large plate are typical of the
wares commonly called green Kutani.

On Kutani ware, the occasional ex-
posure of a nearly pure-white porcelain
body may accent a combination of rich
and dark enamels. Designs using natural
motifs—plants, fruits, sometimes land-
scapes—tend to be quite dramatic. This
plate shows fernlike plants with green
and purple against an amber background

filled with miniature sunburst patterns
and small dots, all painted with black
enamel. The back of the plate is covered
with thin green enamel and decorated
with black plant scrolls. Within the foot,
a double square encloses the character
fuku (happiness).

Kutani ware's production site was a
subject of controversy in Japan as early
as 1938. Between 1970 and 1974, a se-
ries of scientific excavations confirmed
a production date from ca. 1650–1725,
which validated dates found in histori-
cal documents. Sherds collected from
the Kutani kiln, however, showed little
resemblance to ceramics traditionally
accepted as Kutani ware. No sherds of
finished ware were found, an obvious
indication that the excavated kilns had
not been used for firing enamel glazes.
The locations of the sites where Kutani
porcelain was decorated and fired remain
uncertain. Y.K.

JAR

Japan; early Edo period, 17th century
Kakiemon ware, porcelain with
polychrome enamel
H: 10 in. (25.5 cm)
The Avery Brundage Collection
B60 P1206

Kizaemon, a Japanese potter in Arita,
completed a successful firing of the red
enamel that characterizes Kakiemon
ware only after many years of trial and
error. To commemorate this event he
changed his name to Kakiemon, since
the color of the persimmon (*kaki*) was
what he had sought to capture.

This first Kakiemon worked around
the mid-seventeenth century. His de-
scendants up to the present fourteenth
generation have succeeded in creating
what may most truly represent Japanese
taste in polychrome porcelain ware. Their
workshop was located in the Uchiyama
(Inner Mountain) area of Arita, an area
reserved for the production of high-

quality ware. Many fine export pieces
emerged from kilns in this area.

By the end of the 1680s, an espe-
cially beautiful porcelain body, *nigoshide*,
was developed. When this smooth white
clay body was covered with a translu-
cent milklike glaze, it provided porcelain
decorators a perfect ground for refined
painted decoration.

Fine Kakiemon ware always re-
serves a large amount of white space.
This example is decorated with a styl-
ized garden scene in which chrysanthe-
mums, orchids, and violets painted in
light yellow, green, blue, and red blos-
som among fantastic rocks. This jar is
similar to many treasured pieces that
graced the palaces and villas of European
collectors, including royalty and power-
ful merchants, and which inspired Euro-
pean potters at Delft, Meissen, and
Chantilly. Y.K.

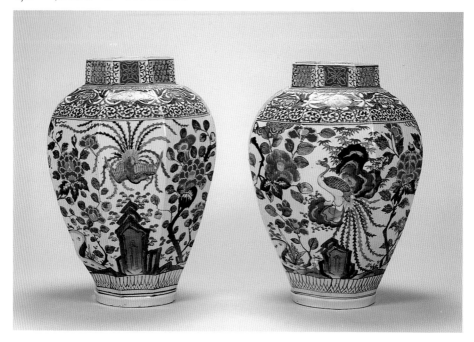

PAIR OF JARS

Japan; Edo period, late 17th century
Imari ware; blue-and-white porcelain
with polychrome enamel decoration
H: 23¾ in. (59.3 cm)
The Avery Brundage Collection
B62 P60, B62 P61

The early history of Japanese porcelain production roughly coincides with the Edo period (1615–1868), when generations of Tokugawa shoguns enjoyed political stability and strong economic growth. The early plain or simply decorated blue-and-white porcelain was mostly produced by the descendants of potters brought back from Korea by Hideyoshi's invading troops (see p. 187). After a large deposit of kaolin clay for porcelain was found in the Arita area, many potters of stoneware turned to this new product, and a remarkable technical advancement in glazing rapidly occurred.

Potters experimented with polychrome decoration, and the famous Kakiemon red enamel (p. 175) was added to the palette by the mid-seventeenth century. Polychrome firing studios spread so rapidly that the provincial government tried repeatedly to regulate them, imposing heavy license fees.

By the last quarter of the seventeenth century, the kilns of Arita were shipping polychrome wares to all parts of Japan and exporting in quantity to European markets. The Dutch East India Company, with permission of the military government (*bakufu*), controlled most of this trade.

By far the most popular wares, with distinctive underglaze blue and polychrome enamel enhanced with gold, were shipped from and named for the port of Imari. The main decorative field of this pair of jars has phoenixes, peonies, camellias, and maples arranged with rocks and water. Stylized peony patterns with the omnipresent underglaze blue plant scrolls appear on their shoulders. Paired jars of this type, some with matching covers, often graced the mantelpieces of many European royal residences. Y.K.

BOTTLE WITH SPLASHES OF GLAZE

Kanjirō Kawai (1880–1966)
Japan; Shōwa period, 1960s
Glazed stoneware
H: 8½ in. (21.5 cm)
Gift of Miss Yoshiko Uchida 1988.58.2

Kanjirō Kawai began his work as a potter by seeking artistic and aesthetic inspiration in the classic works of China and Korea. His extraordinary technical experimentation in clay and glazes gained his early solo shows instant attention in Japanese artistic circles. Kawai's meeting with Sōetsu Yanagi (1889–1961), however, changed his entire life.

In the late 1920s Yanagi, with potters Shōji Hamada (1894–1978) and Bernard Leach (1887–1979), formed a new artistic and highly philosophical movement which they named *mingei* on one of their visits to little-known pottery-making villages. This new movement recognized, assisted, and actively advocated the enduring value of traditional handicrafts.

Following the tradition of village craftsmen, *mingei* potters like Kawai and Hamada did not sign their wares. In the same spirit, Kawai used only a few very basic decorating techniques favored by village potters. Very likely using a large brush, he simply splashed three different glazes on this bottle in a bold manner; he described the process as being "assisted by an invisible power other than myself."

Kawai began writing at an early age and continued to write, publish, and lecture, publicly expressing his undying interest in this *mingei* philosophy. He was a born educator and leader. Yoshiko Uchida, a Japanese-American student of literature, compiled her conversation with him in a small book in English. This bottle was his gift to this young friend. Y.K.

FUGEN BOSATSU
Japan; Kamakura period, 13th century
Hanging scroll; ink and colors on silk
H: 28¼ in. W: 14½ in. (71.5 × 36.8 cm)
The Avery Brundage Collection B66 D2

Fugen Bosatsu, the bodhisattva of benevolence, is Shakyamuni's right-hand attendant. He symbolizes the teaching, meditation, and practice of Buddha and is commonly accompanied by Monju (Manjushri), the bodhisattva of wisdom, who is Shakyamuni's left-hand attendant.

Two important texts, the Lotus Sutra and the *Kan Fugen-kyō*, allude to Fugen. Each states that he will appear to the devotee mounted on an elephant, according to the Lotus Sutra "a white king-elephant with six tusks" (trans. Leon Hurvitz), while the *Kan Fugen-kyō* describes a fabulous, six-tusked, seven-legged beast "as white as snow, the most brilliant of all shades of white, so pure that even crystal and the Himalaya Mountains cannot be compared with it" (trans. Bunno Katō).

This Fugen is a faithful visualization of those descriptions. The white elephant symbolizes divinity. Its six tusks represent the purity of the six sense organs: eyes, ears, nose, tongue, body, and mind. Three of the elephant's seven legs are symbolized by three small lotus pedestals placed near the four legs that are represented.

The swirl of clouds on which the elephant stands suggests that the bodhisattva is descending from paradise to comfort a devotee. The superbly painted faces of both bodhisattva and elephant suggest a Buddhist painting style of the mid to late thirteenth century. Cut gold-leaf *kirikane*, pasted to the surface in perfect precision, forms intricate patterns. *Kirikane* was commonly applied in religious paintings during the Heian period, and artists of later periods continued its use. Y.W.

In esoteric Buddhism, the Five Great Kings (Godai Myōō) are considered to have great magical power to fight against heresy, passion, ignorance, illusion, and other spiritual obstacles. The most popular Myōō in Japan is Fudō, whose name literally means 'The Immovable One.' He is an incarnation of Dainichi Nyorai, who is an idealization of the truth of the universe, from whom all other Buddhas and bodhisattvas were born. Fudō is thought to fight against all evil to protect Buddhist law.

In Fudō paintings, the Yellow, Red, and Blue Fudō are the three basic types of his representation. This painting presents an excellent example of Blue Fudō seated in lotus position and holding his two attributes. A sword in his right hand repels enemies and cleaves the darkness of ignorance, and a rope in his left hand binds evil. He displays well-developed characteristics of Fudō Myōō. His head is turned slightly toward the left, and he makes a ferocious grimace, with crossed eyes and white fangs that protrude from the corners of his mouth. His long hair is gathered in one bundle before his left shoulder. Fudō is adorned with a lotus blossom at the top of his head and a golden necklace, armlets, and bracelets. Swirling flames establish a tremendous sense of movement and power surrounding the immovable Myōō.

This painting was classified in Japan as an Important Art Object and was obtained by the Asian Art Museum through special authorization of the Japanese government. The upper part is extensively damaged from the smoke of burning incense. Y.W.

BLUE FUDŌ MYŌŌ

Japan; Kamakura period, 13th century
Hanging scroll; ink and colors on silk
H: 68⅛ in. W: 42¾ in. (172.5 × 108.7 cm)
The Avery Brundage Collection B70 D2

JINNŌJI ENGI (Legends of the
Founding of Jinnōji Temple)

Japan; Late Kamakura period,
mid-14th century
Hanging scroll; ink, colors,
and gold on paper
H: 13¼ in. W: 21½ in. (33.7 × 54.5 cm)
The Avery Brundage Collection B66 D3

The long, horizontal *emaki* (picture
scroll) with narrative paintings and ac-
companying text developed into a popu-
lar and important art form in Japan. The
story it narrates may be fictional or his-
torical; the latter type often records the
founding of temples or the lives of im-
portant priests.

This small work, now mounted as
a hanging scroll, was originally part of
a set of two narrative scrolls relating the
founding legend of the Jinnōji Temple.
The style indicates that the original
scrolls were produced toward the middle
of the fourteenth century. The first scroll
relates how the famous monk En no
Gyōja (643–?) met in Izumi province
a local deity who asked him to build a
temple there. Gyōja next traveled in
Korea where he encountered the Korean
deity Hōshō Gongen, who agreed to

return to Japan to assist him. With the
help of Emperor Temmu the temple was
built, but then Gyōja was forced into
exile, and in less than a century, the
temple was nearly deserted.

The second scroll deals with Gyōja's
reconstruction of the temple after he re-
turned to Japan from Paekche in Korea
and became known as Kōnin. This seg-
ment, from the beginning of the second
scroll, depicts Kōnin's search for a holy
site and his eventual meeting with a
green bull. Kōnin meditated and then
had a vision of Hōshō Gongen, who
urged him to rebuild the temple. Read-
ing from right to left, it shows Kōnin's
progress as the bull leads him to the di-
lapidated temple.

In this short segment Kōnin appears
four times. Each time he and other char-
acters and landmarks are identified by
small blue cartouches. The repetition of
the central figure assures continuity in
this pictorial narration, as the viewer
literally follows the priest's footsteps
through a continuous landscape. Y.K.

The Ten Oxherding Songs are a series of Zen (Chinese: Chan) allegories explaining the mental discipline needed to attain enlightenment. The allegory of the human mind as an ox proceeds, in these songs, through search and struggle to mastery of the unruly beast. The songs were widely distributed in Song China. Each consists of a prose paragraph of explanation and four verse lines reiterating the same idea.

Catching the Ox is the fourth in the series. Its prose section explains that the herdsman has discovered the elusive ox in a ditch but has difficulty catching him, "for the beautiful wilderness still attracts him. . . . His obstinate heart still asserts itself; his unruly nature is still alive." This painting faithfully depicts the song; beneath a large tree a herdsman battles an ox with all his might, trying to keep the ox's head down so as to mount him.

Japanese Zen monks in the Muromachi period (1392–1573) studied Zen in China and returned with principles of both Zen doctrine and painting, including these ten thematic songs. They introduced Zen ink painting to Japan, whose art until then had been dominated by the colorful *yamato-e* style. In this small composition, the ox and herdsman are depicted in a simple brush technique. The fine, dry lines of the herdsman and the ox's hair create an interesting contrast with the broad, wet brushstrokes of the foliage.

Little is known of the Zen monk-painter Sekkyakushi, whose seal appears at the lower left. He was closely related to the school established by Minchō (1352–1431) of Tōfukuji Temple, in Kyoto. Y.W.

CATCHING THE OX

Sekkyakushi (fl. early 15th century)
Japan; Muromachi period
Hanging scroll; ink on paper
H: 18⅞ in. W: 9⅛ in. (47.8 × 23.2 cm)
Gift of Ney Wolfskill Fund B69 D46

SPLASHED-INK LANDSCAPE

Soga Sōjō (act. 1490–1512?)
Japan; Muromachi period
Hanging scroll; ink on paper
H: 32⅝ in. W: 7⅝ in. (82.8 × 19.3 cm)
Gift and Purchase from the Harry G. C.
Packard Collection Charitable Trust
in honor of Dr. Shūjirō Shimada; The
Avery Brundage Collection 1991.63

The idiom of splashed ink (*haboku*) is one of the most difficult to use, as its success depends on a subtle balance between a carefully calculated composition and a spontaneous and speedy execution. Accidental effects of splashed ink may either greatly enhance the painting's effect, or ruin it. This small painting depicts, in an extremely abbreviated manner, a landscape with mountains, a pavilion, and two human figures. A few ink strokes and washes convey a powerful impression of the painter's action. Few other splashed-ink paintings exhibit the mastery of this one.

The splashed-ink technique originated in China and was brought to Japan by the Zen monks of the Muromachi period (1392–1573) who studied Zen religion and painting in China. Both Chinese and Japanese Zen monks found the spontaneous realization of painting very similar to the sudden enlightenment that was emphasized in Zen practice.

The monk Soga Sōjō was a prolific, well-rounded painter whose subjects ranged from portraits to landscapes, flowers and birds, and legendary figures. He also mastered many techniques, from descriptive brushwork to abstract *haboku*. This painting is documented by the round seal, *Sōjō*, at center bottom, and above, an inscription by Gichiku Shūrin, a talented composer of Chinese poems. He was often sought to inscribe his poems on ink paintings by Zen monk-painters. Shūrin's poem allows us to date this painting between 1503 and 1505. Y.W.

r.

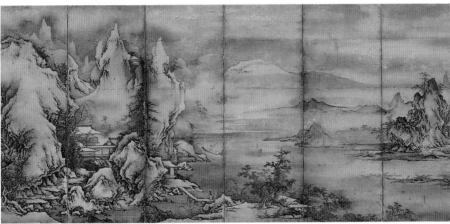

l.

LANDSCAPE OF THE
FOUR SEASONS

Shikibu Terutada (fl. mid-16th century)
Japan; Muromachi period
Pair of 6-panel screens; ink, colors, and
gold on paper
H. (each screen): 60¼ in. W: 127⅝ in.
(153.0 × 324.0 cm)
The Avery Brundage Collection
B60 D48+, B60 D49+

Depicting the four seasons in a continu-
ous composition had become popular in
screen painting by the fifteenth century
in Muromachi period Japan. In this pair
of screens, a spectacular landscape un-
folds before masses of towering moun-
tains and hard-edged rocks composed in
seemingly endless repetitions. Spring
scenery appears at the right of the right-
hand screen, and the seasonal panorama
ends with winter, at the left of the left-
hand screen.

This awe-inspiring landscape is
peopled by human beings humble be-
fore the power of nature, yet enjoying
all its aspects. In early spring, we see a
scholar and his attendant examining
the bare branches of plum trees. In the
summer passage, travelers visit a mist-
covered mountain village where resi-
dents unload cargo from a boat and
spread fish nets to dry. In autumn, a
scholar and two attendants return amid
changing colors to a rustic home in the

mountains, and in winter, another scholar and his lute-bearing attendant cross a bridge to return home to a snow-covered mountain. (The applied gold dust that forms a kind of mist or clouds over the mountains, sky, valleys, and rivers, is a later addition to the paintings.)

The painter Shikibu Terutada had fallen into obscurity by the seventeenth century, and for a long time his seals were incorrectly deciphered as *Ryūkyo*, and misidentified as belonging to Kenkō Shōkei (fl. 1478–1506). Shikibu is now thought to have been a painter active in the mid-sixteenth century in the Kantō area in the eastern region around Kamakura, and connected with the Kenchōji Temple, where he was most likely trained as a Zen monk and painter.

Shikibu also had contact with Kano Gyokuraku and Kōetsu, of the Odawara Kano school, and seems to have learned his superior sense of composition and some techniques from these professionally trained painters. Eventually, however, he grew far beyond their influence. These screens clearly display characteristics of his mature style—an inclination toward fantastic shapes of mountains and rocks formed by numerous pointed peaks and overhangs, obsessive repetitions of angled shapes, and a preoccupation with details in rendering trees, branches, and rocks with numerous dots and strokes. This landscape shows that the Muromachi screen-painting tradition had arrived at a mature phase, when artists like Shikibu could explore style in their own terms.

Y.W.

r.

l.

TARTARS PLAYING POLO AND HUNTING

Attributed to Kano Sōshū (d. 1601)
Japan; Momoyama period,
late 16th century
Pair of 6-panel screens; ink, colors, and
gold on paper
H. (each screen): 65 in. W: 137½ in.
(165.1 × 349.3 cm)
Gift of the Asian Art Museum Foundation
B69 D18a, b

Following Chinese custom, the Japanese referred to the Tartars—Turkic-speaking peoples who had overrun Asia under Mongol leadership in the thirteenth century—as 'northern barbarians,' and to Europeans as 'southern barbarians.' Unlike European foreigners, with whom the Japanese had some first-hand though limited contact, the Tartars had almost no presence in Japan. Curious about so remote a group of people, Japanese artists sought their image of them among works of Chinese art. Japanese paintings

depicting Tartars are far less numerous than works portraying Europeans, yet their artistic quality is consistently high, reflecting the kind of powerful social rank of the original clients for such works.

Against the seemingly continuous landscape of this pair of screens, the nomadic northern Tartars engage in a game of polo, and in a hunt. On the right screen, more than forty players in a fierce polo game take the field, seemingly going in all directions but keeping

their eyes on a single focal point where several fight over the ball. Gate-shaped goals at each end of the playing field are watched by referees.

At the right of the playing field sits a man of high rank within a curtained area beneath a tent; several retainers stand nearby. At left stand a woman and two small children. This static group offers a sharp contrast to the fast-moving polo players.

The hunting scene on the left screen follows the same basic compositional pattern. In the center, mounted hunters race after animals flushed out from surrounding mountains. At the upper right corner, several persons of importance stand within a curtained area before a small hut. Atop a cliff at the opposite end, a group of horsemen surrounds a dignitary under an umbrella held by a boy servant. In each screen, this arrangement of lesser activities juxtaposes the dramatic movement of the main event with quiet watchfulness, providing an interesting contrast that enriches the composition.

Both the polo and hunting scenes appear through stylized gold clouds richly decorated with an embossed small cloud pattern. Here, except for a few tall trees and mountain peaks, the clouds cloak most of the landscape elements. The human activities take place against them. This use of gold clouds is typical for Momoyama to early Edo artists.

These screens have been attributed to Kano Sōshū, a younger brother of Kano Eitoku, an early leading figure among Kano school artists. Kano Sōshū's importance as a painter and leader of the Kano school is well established; a more recent stylistic study even suggests the possibility that Eitoku actually participated in Sōshū's creation of this pair of screens. If both these accomplished brothers had a hand in making these screens, then they represent the best of the Momoyama genre-painting style.

Y.K.

In this stately portrait, the great warlord Toyotomi Hideyoshi (1537–98) is depicted as an imperial regent. He sits on a raised mat in formal attire—headgear, a white robe, loose trousers, and white silk socks. He holds a ceremonial fan in his right hand and clenches his left near a long sword.

The inscription above the ornate architectural structure is by Seishō Shōtai (1548–1607), Hideyoshi's political adviser and the ninety-second abbot of Shōkokuji Temple—the head administrator of all Zen priests in the hierarchy of the five main Zen temples and the ten subsidiary ones. It glorifies Hideyoshi as the greatest hero of the time. Yakuin Zensō, a Tendai sect priest and Hideyoshi's personal physician, commissioned the portrait.

Hideyoshi emerged as a great warlord in the turbulent Momoyama period (1573–1615) and succeeded Oda Nobunaga (1534–84), another powerful figure in the effort to establish national hegemony. His promising future faded after an ill-fated Korean invasion exhausted all his resources. He then fell ill and died in an agony of worry about his young son's future. His successor, Tokugawa Ieyasu (1542–1616) established the Tokugawa *bakufu* (military government), but completely destroyed the house of Toyotomi.

Hideyoshi, a person of legendary stature, is loved even today. He exemplifies an ideal of success. Of humble origin, he was a brilliant strategist who ascended to the imperial regency and the office of minister of state. This painting is an example of a formal portrait type for important persons such as emperors, samurai, and poets. Y.W.

PORTRAIT OF TOYOTOMI HIDEYOSHI, dated 1599

Japan; Momoyama period
Hanging scroll; ink and colors on silk
H: 35¾ in. W: 14⅞ in. (90.7 × 37.8 cm)
Gift and Purchase from the Harry G. C. Packard Collection Charitable Trust in honor of Dr. Shūjirō Shimada; The Avery Brundage Collection 1991.61

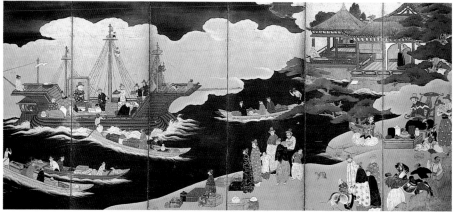

l.

NANBAN SCREENS

Japan; Momoyama period, late 16th–
early 17th century
Pair of 6-panel screens; ink, colors,
and gold on paper
H. (each screen): 58⅛ in. W: 124½ in.
(147.6 × 316.2 cm)
The Avery Brundage Collection
B60 D77+, B60 D78+

The Portuguese were the first Europeans
the Japanese saw face-to-face. In 1543
four shipwrecked Portuguese sailors ar-
rived on the small island of Tanegashima,
south of Kyushu. In 1549 the Jesuit mis-
sionary priest Francis Xavier arrived in
Japan to introduce Christianity, and
Portuguese traders followed him on a
regular basis. These events introduced
firearms to Japan, which changed the
traditional method of Japanese warfare,
replacing mounted warriors and hand-
to-hand combat with musket-bearing
foot soldiers. Strong feudal castles were
then built to withstand firearms. West-
ern culture and arts were introduced,
and traders brought exotic foreign goods
into the country. The Japanese studied
and enjoyed foreign culture until early
in the seventeenth century, when the
Tokugawa shogunate established a policy
of national isolation that endured for
the ensuing 250 years.

Nanban screens usually represent
Portuguese ships arriving in a Japanese
port. Because these vessels arrived via
Southeast Asia, the Japanese called their
crews *nanbanjin,* southern barbarians,
and the ships *nanbansen.*

In this pair of screens, Portuguese
ships, traders, and Christian missionar-
ies are depicted in a typical composi-
tional style for such screens. The left
screen represents the arrival of Portu-
guese ships, most likely at the port of

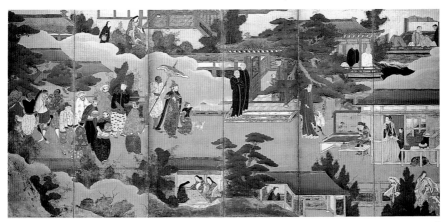

r.

Nagasaki. At upper right is a pavilion to which the painter added the convention of a crucifix, though this structure is not the foreigners' church.

The church is actually part of the building complex depicted in the right screen. (An earlier prototype depicts an altar with a picture of Christ in this part of the composition.) The captain, awaited by black-robed priests, leads a procession to it through town. The painter observed tall foreigners busily engaged in commercial activities, their dogs, and their ships, all meticulously rendered in purely Japanese style. Dramatic waves are patterned in the decorative fashion; gold clouds give the picture a rich glitter and also segregate the spaces in which the activities occur. That these foreign contacts had impact on the Japanese is clearly shown in details—a young man in a house at the far right wears *calsan*, full, big trousers, instead of the Japanese *hakama*, and a white, ruffled collar.

These screens are attributed to an unknown Kano school painter who worked for rich townsmen. They were once held by the Yoshino family of Toyama, whose ancestors had a prosperous shipping business, which suggests that they may have been patrons of this kind of painting. These works are early examples of extant Nanban screens. Y.W.

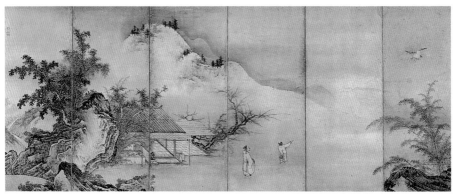

l.

LANDSCAPES WITH TAO YUANMING AND LIN HEJING

Unkoku Tōgan (1547–1618)
Japan; Momoyama period
Pair of 6-panel screens; ink and
colors on paper
H. (each screen): 57⅞ in. W: 140¹⁵⁄₁₆ in.
(147.0 × 358.0 cm)
The Avery Brundage Collection
B60 D73+, B60 D74+

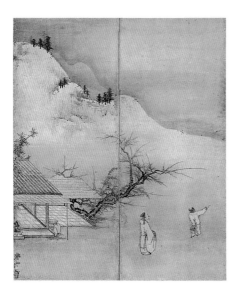

In this pair of screens, two renowned Chinese poets are represented in monumental landscapes. On the far right, Tao Yuanming (365–427), seated in his studio in a bamboo grove, enjoys the view of the mountains. Wine, chrysanthemums, and Mount Nanshan in Shaanxi province, all mentioned in a famous poem of his, became essential pictorial associations with him. In the left screen, Lin Hejing, a famous poet of the Song dynasty (960–1280), looks up to admire his pet crane flying over his garden. Lin was well known for his reclusive life on a mountain near the famous West Lake (see p. 197). He is often associated with plum blossoms and the cranes that he domesticated.

The Japanese love for Chinese literary themes began in the Muromachi period (1392–1573), when Sinophile Japanese Zen monks studied Chinese ink paintings and composed poems in Chinese styles. *Kanga* painting—in the Chinese style, and dealing with Chinese literary themes—endured from this period to the end of the Edo period (1615–1868) and formed one of the two major

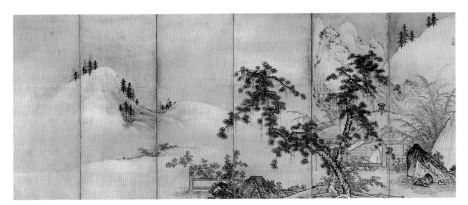

r.

trends in Japanese painting; *yamato-e,* the colorful Japanese painting style depicting Japanese themes, established the other trend.

Born in a samurai family, Tōgan studied Kano school painting and later mastered the celebrated style of Sesshū Tōyō (1420–1506), the towering master of ink painting in the Muromachi period. Tōgan claimed to be the rightful heir to his tradition. His family name, Unkoku, derived from Unkoku-an, Sesshū's studio in Yamaguchi, which he received from his patron Lord Mori as a reward for the splendid works the artist produced for him.

Tōgan succeeded in creating his own style, reflecting the innovative spirit of the Momoyama period. It strikes a balance between the expressive power of somber ink and decorative grandeur by use of patterning of the pictorial elements.

Most of Tōgan's paintings lack both signature and seals. Each of these screens, however, bears a round intaglio seal, *Unkoku,* and a square one, *Tōgan,* confirming they are his works. Y.W.

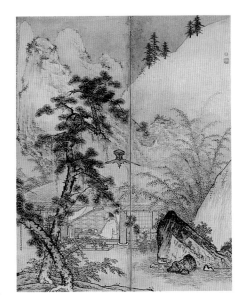

POEMS WRITTEN ON DECORATED PAPER

Honami Kōetsu (1558–1637)
Japan; early Edo period, ca. 1620
Handscroll; ink, gold, and silver on paper
H: 13 in. L: 37⅞ in. (33.0 × 96.4 cm)
Gift of Alice C. Kent B72 D39

Honami Kōetsu was one of the three best calligraphers of the Kanei era (1624–43). He learned the elegant and gentle Shorenin style of calligraphy from Prince Sonchō (1552–1597) and also collected and studied the works of Chinese and Japanese master calligraphers, eventually developing his own unique style. On this scroll Kōetsu inscribed three *waka* poems (a thirty-one syllable form) from *Shin Kokin Wakashū*, in running script. He has arranged bold *manyōgana*, Chinese characters used as phonetic symbols, with extremely thin lines of *hiragana*, the Japanese syllabary of much simplified, cursive-style Chinese characters.

The paper has a gold and silver pattern that was likely printed with actual sprigs of fine leaves. Images are repeated to create the illusion of depth and movement. The reverse is decorated with similarly printed gold and silver butterflies. A rectangular seal, *Kamishi Sōji* (Paper-master Sōji), appears where the sheets are joined.

Shin Kokin Wakashū is an anthology of verses compiled by order of the Retired Emperor Gotoba (1180–1239). The first poem in this section is by Enyu, the sixty-fourth emperor. He requests a blossoming cherry branch from one of his ministers:

Spring days return ever new.
Alas, I am no longer the same.

In the second poem, the minister replies:

Above the fence, flying about,
　only petals.
Why not visit to enjoy a branch?

The third, anonymous poem also reflects on the theme:

At times, thoughts arise, remem-
　bering the imperial visit.
Cherry blossoms.

Y.K.

r.

l.

FLOWERS AND BIRDS OF THE TWELVE MONTHS

Yamamoto Soken (act. 1683–1706)
and unknown calligraphers
Poems by Fujiwara Teika (1167–1241)
Japan; Edo period
Pair of 6-panel screens; ink and colors
on silk
H. (each panel): 44½ in. W: 17⅛ in.
(113.0 × 44.0 cm)
The Avery Brundage Collection
B60 D82+a, b

Fujiwara Teika, foremost poet of the early Kamakura period, composed the poems "Flowers and Birds of the Twelve Months" in 1214. Several hundred years later, in the eighteenth and nineteenth centuries, his poems were taken up by both the newly rich merchants and by the traditional courtiers who had once been the major arbiters of art and culture of Japan. Disenfranchised by Tokugawa Ieyasu (1542–1616; p. 187) when he became the first shogun of Japan's new military government, these courtiers and merchant-scholars nevertheless turned their attention to literature and art, reviving literary and painting traditions of earlier periods. They be-

came interested in Teika's poems, which had come to be considered the epitome of Japanese poetry.

Teika's flower and bird poems are the subjects of this pair of screens. These independent pictures of the twelve months begin with the first month (right panel, right-hand screen) and conclude with the twelfth month (left panel, left screen.) The upper part of each panel contains the name of the month, the specific flower and bird, and two poems; the calligrapher is unknown. These screens represent one of the traditional *yamato-e* themes and styles produced in close connection with courtly culture in Kyoto of the early Edo period.

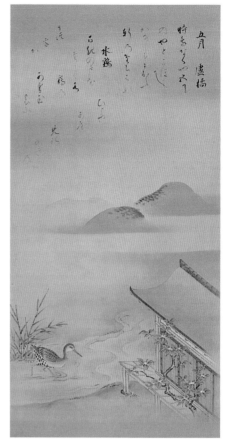

Early attempts to transpose Teika's literary texts and poems into visual form had proved difficult, resulting in hand-scrolls and screens that were more descriptive than expressive. Kano Tan'yū (1602–74), the great master of the Kano school, met this challenge by creating a simple but evocative style. On independent (rather than continuous narrative) panels, he depicted the birds and flowers of each month in dynamic lines and subtle ink washes, hallmark techniques of the Kano style. Yamamoto Soken, a Kano student influenced by the Tosa style, further developed Tan'yū's style by adding to these screens the beautiful colors of the Tosa school.

Soken studied Kano painting under his father, Sotei (fl. late 17th century). He produced many ink paintings for Zen monasteries and later painted for the imperial family and court nobles in the decorative *yamato-e* style of the Tosa school. His refined style greatly influenced the brilliant and talented brothers Ogata Kōrin (p. 195) and Kenzan (1663–1743), of the Rimpa school, who painted the same theme.

The flowers and birds, starting in the first month, are: willow and Japanese nightingale; cherry blossoms and pheasant; wisteria and skylark; deutzia and cuckoo; wild oranges and water rail; pinks and cormorant; patrinia and magpie; bush clover and wild goose; pampas grass and quail; chrysanthemum and crane; loquat and plover; and prunus and mandarin duck. Each of the twelve panels bears the seal *Hokkyō Soken;* the panels for the first and twelfth month bear Soken's signature. Y.W.

```
<li>Bulldogs
<li>Collies
<li>Poodles

</ul>

<h1>May favorite dog</h1>
<p>My favorite dog is Herman, a silly looking mutt with the body o
f a
golden retriever and the legs of a basset hound.
<h3>Mom's favorite dog</h3>
<p>Mom's favorite dog is Sam, a sweet, hairy little sheltie.
Unfortunately, Sam is no longer with us.
</body>
</html>
```

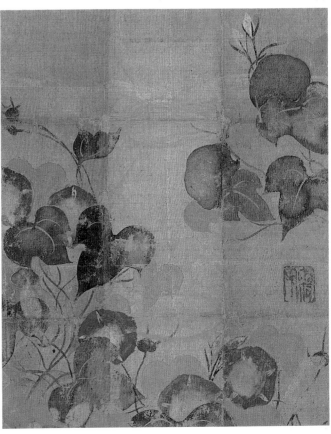

MORNING GLORIES

Ogata Kōrin (1658–1716)
Japan; Edo period
Hanging scroll; ink, colors, and gold
on silk
H: 10½ in. W: 8⅜ in. (26.6 × 21.1 cm)
Gift and Purchase from the Harry G. C.
Packard Collection Charitable Trust in
honor of Dr. Shūjirō Shimada; The Avery
Brundage Collection 1991.79

This small painting was made to wrap
a piece of fragrant wood used for the
incense-appreciation ceremony. The
design of the morning glories is inge-
niously adapted to the function of the
wrapper. Pictorial elements are concen-
trated on the right and left sides. When
the wrapper is folded around the wood,
the blank area of the painting is under-
neath, and the most beautiful parts of
the painting appear on the front. Grace-
ful, arching stems link the clustered
elements on each side of the composi-
tion. The flowers are rendered in a mix-
ture of blue pigment and white ground
shell (gofun), and the broad leaves are
in green or black ink.

Kōdō (incense competition) was an
aristocratic pastime that became popu-
lar in the twelfth century (see p. 205).
Guests would burn the incense they
brought and decide which one was the
best. Commoners took up this pastime
by the latter half of the seventeenth
century.

Ogata Kōrin, son of Ogata Sōken
(1621–87), owner of a prosperous textile
store in Kyoto, was brought up in afflu-
ence. After his father's death the flam-
boyant Kōrin rapidly exhausted his
inheritance, but after becoming poor he
at last took his art seriously and became
one of the most important of Japanese
painters.

Incense wrappers were usually
produced in sets of twelve, one for each
month. Among Kōrin's ten or so extant
wrappers, only this one bears his seal,
Jakumei, which he used in his later
years. Thus, in addition to its artistic
value, this work has a documentary
value as well. Y. W.

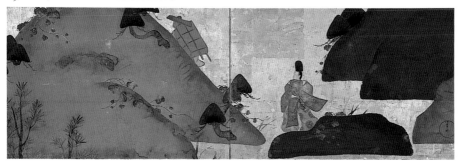

THE PATH THROUGH MOUNT UTSU (Scene from *The Tales of Ise*)

Fukae Roshū (1699–1755)
Japan; Edo period
2-panel screen; ink, colors, and
gold on paper
H: 28½ in. W: 74 in. (61.6 × 182.6 cm)
Purchase: the Connoisseur's Council,
The Museum General Acquisitions Fund,
and Gift of Elizabeth and Allen Michels
B86 D3

The Tales of Ise, a tenth-century poetic narrative about Ariwara no Narihira (ca. 825–80), became a favorite theme of Japanese painters. An esteemed courtier-poet, Narihira became a legendary figure known for numerous love affairs with beautiful women of high social rank. The 125 episodes of the *Tales* unfold around his journey with some companions from the Kansai (western) region of Japan to Kantō (in the east). Each includes one or more poems.

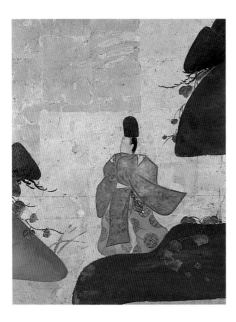

In the seventeenth and eighteenth centuries, well-educated patrons of the arts were particularly interested in *The Tales of Ise* for its classicism and romantic allusion. Rimpa school masters of Kyoto, from Tawaraya Sōtatsu in the seventeenth century to Ogata Kōrin in the eighteenth (p. 195), depicted the *Ise* stories as a continuous narrative in handscrolls, or in single scenes on screens and hanging scrolls.

In this two-panel screen Roshū, a talented follower of Kōrin, depicts a famous scene from the ninth episode, "The Path through Mount Utsu," or simply "Ivy Lane." After a lengthy journey, filled with longing, the lonely Narihira climbs the ivy-grown mountain path and meets a wandering ascetic monk, whom he asks to carry a message to his beloved in Kyoto.

Roshū has transformed the scene into one of the most refined beauty, with much use of color and gold. Empathy for the hero arises entirely from the viewer's prior knowledge of the story, rather than from the scene's literal narrative content.

The young Roshū, son of a powerful officer in the Kyoto mint of the Tokugawa shogunate, was raised in luxury and refined culture. But in 1714 his father was implicated in mismanagement of the mint, and the family was exiled in disgrace. Roshū never recovered from this calamity; little is known of his reclusive life thereafter. Y.W.

r.

l.

THE WEST LAKE

Ike Taiga (1723–1776)
Japan; Edo period
Pair of 6-panel screens; ink on paper
H. (each screen): 67 in. W: 150 in.
(168.9 × 381.0 cm)
Gift of the Asian Art Museum Foundation
B65 D50, B65 D51

The West Lake, in Hangzhou, Zhezhiang province, one of the loveliest districts in China, has long been a source of creative inspiration for Chinese and Japanese poets and artists. Taiga's screens represent twelve famous scenes of the West Lake—its beautiful surrounding mountains and hills, the dikes and bridges that divide the lake, and the temples and pavilions on its shores.

In Japan, from the fourteenth to nineteenth centuries, painters were inspired to depict the West Lake as an earthly paradise. Sesshū Tōyō (1420–1506), the great Zen monk-painter of the Muromachi period (1392–1573), visited China and upon returning to Japan

painted the lake. Interest in and admiration of this scenic spot increased in the Edo period (1615–1868), when Japan, under the isolation policy of the Tokugawa shogunate (see p. 188) was closed to foreigners and its citizens forbidden to leave the country. Nonetheless, intellectuals such as Confucian scholars and literati painters managed to acquire a good (though occasionally inaccurate) understanding of China and its history, literature, poetry, and famous landmarks through imported books. They painted the West Lake and other famous sites from ideas gained from descriptions in books, in actual paintings, and from their imaginations. This approach eventually created simplified depictions that combined the most obvious features of the sites.

For this work, Taiga seems to have relied on Chinese poems and topographical drawings in Chinese geographical books imported to Japan. He depicted twelve famous scenes on the lake, one on each panel, each with a title in four characters. Starting with the right panel of the right screen and going to the left panel of the left screen, these scenes are:

Su Dongpo Causeway in the
 Spring Dawn

Plum-blossom Viewing in the
 West Stream

Viewing Fish in Huagang Pond

Thunder Peak Pagoda at Sunset

East Courtyard and Fragrant
 Breezes

Rainbow after a Storm in the
 Regions of Jade

Autumn Waves in the Zhegiang
 River

Pavilion of the Calm Lake and
 Autumn Moon

Nanping Hill and Resounding Bell

Sunrise at Keling Hill

Viewing Melting Snow from the
 Interrupting Bridge

Spirit Stone and Woodcutters'
 Songs

Y.W.

In the male-dominated feudal society of the Edo period (1615–1868), women had little opportunity to develop their talents, let alone pursue careers. A number of women, however, broke cultural barriers and became successful artists. Ike Gyokuran was the most renowned of these women artists.

Born in Kyoto, Gyokuran was the third generation in a family dominated by women, and was likely raised in a liberal and artistic atmosphere. Her grandmother and mother were proprietresses of Matsuya, a teahouse in the Gion, Kyoto's famous pleasure quarter. Both were talented poets of *waka*, a thirty-one syllable form.

Gyokuran married Ike Taiga (1723–76; p. 197), who was famous for his unconventional life and extraordinary painting talent. He eventually became the most renowned literati painter, and Gyokuran became one of his best pupils. Fame did not bring them wealth, however; they were poor their entire lives, but shared ideals and lived untrammeled by social conventions.

Taiga influenced Gyokuran's repertoire of styles and subjects, and her paintings of bamboos, chrysanthemums, and landscapes, with their broad, relaxed brushstrokes—sometimes long and curvilinear, sometimes short and dotted—display similarities to Taiga's works. Nonetheless she developed her own characteristics—delicacy, beautiful colors, and a fanciful spirit, which appear in this landscape.

The painting depicts a coastal village tucked into a valley among flowering peach trees and green mountains. Details include houses, people, and boats. The village seems a utopian place, perhaps the "landscape of one's heart" so esteemed by literati painters. They tended to exclude human figures from such works to emphasize their abstract and ideal nature, but Gyokuran includes them, making her work unique. Y.W.

SPRING LANDSCAPE

Ike Gyokuran (1727/28–1784)
Japan; Edo period
Hanging scroll; ink and colors on silk
H: 44½ in. W: 19½ in. (113.0 × 49.5 cm)
Gift of the Asian Art Museum Foundation
B76 D3

PLAYING KIN UNDER PINE TREES

Uragami Gyokudō (1745–1820)
Japan; Edo period
Hanging scroll; ink and colors on paper
H: 11¼ in. W: 9¼ in. (28.6 × 23.5)
Gift of Ney Wolfskill Fund B69 D49

Uragami Gyokudō is considered one of the most eccentric of literati painters, for his powerfully appealing, idiosyncratic paintings as well as his unconventional life. He abandoned his prestigious samurai-officer's position after middle age to become a freelance traveling painter whose patrons were rich, educated provincial merchants and farmers. It was a radical and irrevocable decision in the fixed-class society of the Edo period.

Like many other Japanese literati painters at that time, Gyokudō followed the Nanga (Southern painting) style imported fifty years earlier from China. But he broke with traditional painting canons to create an expressive personal style. This small painting displays its derivation.

The composition of mountains and pines is based on the ninth page of the *Wantei Enka-jō* (Album of Paintings of Fog and Mist) by Li Heng, an obscure Chinese painter active in the Qing dynasty in the late seventeenth century. Gyokudō's innovative style is created by formal means and execution, but the conical mountains are animated, as if their inner substance had fermented and bubbled out uncontrollably. Agitated dry and wet brushstrokes quickly contour and texture mountains and trees. Broad, wet horizontal strokes darken sky and water, giving the picture a wintery look. The total effect of restlessness induces a melancholy, almost somber, feeling, which might have mirrored the painter's emotional state.

The painting bears the signature *Gyokudō* and two seals. The square relief seal reads *Kinshi,* and the square intaglio seal reads *Hakuzen Kinshi.*

Gyokudō was educated in Chinese literature and poetry. He taught himself to paint and to play the *kin* (Chinese: *qin*). His artistic name, Gyokudō, derived from the name of a seven-string *kin* he obtained in 1779, Gyokudō Sei'in (Pure Tone of the Jade Hall). Y.W.

Yamamoto Baiitsu worked in the early nineteenth century, when Japanese painting had attained full maturity. He painted awe-inspiring landscapes in monochrome ink as well as many decorative and colorful flower-and-bird paintings. This work displays the artist's best abilities in that genre.

This painting's masterful composition is achieved by formal interplay of natural elements. A sweeping reed stem, curving from the middle of the picture to the upper right edge, establishes a focal point; just below, a lotus leaf gracefully spreads to provide the herons with secluded space. Baiitsu effectively uses opposing movements and contrasting forms. The upward motion of the reeds to the right is balanced by the heads of birds facing left; the tall, narrow reed leaves contrast with the round lotus leaves and egg-shaped bodies of the birds.

The lotus leaves show Baiitsu's flawless execution of *tarashikomi* (literally, 'dipping into'), the so-called boneless washes of color that appear deceptively easy to achieve, but require the painter to foresee results and perfectly control their effect.

Baiitsu studied under a number of local Nagoya painters and while still quite young was befriended by Nakabayashi Chikutō (1776–1853). The two became lifelong companions. They reached an artistic turning point after studying the Chinese literati painting collection of the noted merchant and collector Kamiya Tenyū, also of Nagoya. Both artists committed themselves to the literati, or Nanga (Southern) painting style, and eventually both became famous literati painters. Y.W.

HERONS AND REEDS

Yamamoto Baiitsu (1783–1856)
Japan; Edo period, 19th century
Hanging scroll; ink and colors on silk
H: 53 in. W: 16⅞ in. (134.6 × 42.9 cm)
The Avery Brundage Collection
B65 D14

ELEPHANT AND CHINESE CHILDREN

Nagasawa Rosetsu (1754–1799)
Japan; Edo period
Hanging scroll; ink on paper
H: 46¾ in. W: 12⅛ in. (118.9 × 30.8 cm)
Gift of Martha and William Steen
B80 D1

By the time eccentric painters Nagasawa Rosetsu, Itō Jakuchū, and Soga Shohaku were active in Kyoto in the second half of the eighteenth century, Japanese feudal society was culturally and economically secure enough to tolerate oddity. And though Kyoto lost political power when Tokugawa Ieyasu moved the capital to Edo (modern Tokyo), it nonetheless remained the traditional center where Japanese culture was kept intact. There artists could explore expression beyond ordinary artistic conventions.

Rosetsu had been a low-ranking samurai in service to the Yodo fief, but resigned to study painting under Maruyama Ōkyo (1733–95), founder of the popular Maruyama school. Though a great technician and bold designer, Rosetsu was expelled from the school, perhaps because of his violent nature. He made his living with works for temples and rich provincial merchants.

This painting of an elephant and Chinese children (*karako*) demonstrates how Rosetsu manipulates form, scale, and subject in a bold and witty design. Only the elephant's central area fits into this narrow format. The children perch fearlessly on his vast back, while the animal seems worried, as if concerned he might step on the one at his feet. The elephant is painted in deliberately broad, wavering strokes, while the children are drawn in well-controlled, smooth lines.

In Buddhist art the elephant symbolized selfless benevolence and was often depicted in Japan as the vehicle of Fugen Bosatsu (p. 178), who represents the teaching, meditation, and practices of the Buddha. The elephant became a popular secular subject in the eighteenth century, when a pair was imported from China and the Japanese saw live elephants for the first time.　　　　Y.W.

ALBUM OF LACQUER PAINTINGS, dated 1882

Shibata Zeshin (1807–1891)
Japan; Meiji period,
second half of the 19th century
Album; colored lacquers on paper
H: 8¼ in. W: 7¼ in. (22.6 × 18.0 cm)
The Avery Brundage Collection
B65 D5+

Shibata Zeshin, the painter and print-maker, apprenticed as a lacquer crafts-man in Edo (modern Tokyo) at a time when lacquerers depended on designer-painters to design their works. In 1822, realizing that he could design his own works, Zeshin began the study of paint-ing, first in Edo, then in Kyoto.

Zeshin wished to create in his paint-ings the rich, lustrous surfaces of West-ern oils while retaining traditional Japa-nese subjects. In the 1870s he invented the *urushi-e* technique using colored lacquer for painting. *Urushi* is thick but, unlike oils, neither stable nor resil-ient. It cannot be applied in layers to build color tones, nor can its density be altered like ink. Its colors are limited to green, red, yellow, brown, and black.

This album consists of twenty lac-quer paintings and includes studies of plants, insects, birds, landscapes, and mythological subjects and ritual objects. The sixth page, *Dragonfly on Vine*, dis-plays Zeshin's mastery of this difficult medium as well as his design talent. He balances spaces filled by leaves and fruits with voids; broad leaves are counter-balanced by thin, freely moving veins. Fleshy fruits contrast with the dragon-fly's fragile wings. Gradation of color from black to brown, particularly in the leaves, is done so smoothly that it looks like the traditional technique of *tarashi-komi* (see p. 201).

Zeshin lived and worked in the tran-sitional period when the closed, feudal Japanese society was transformed to an imperial state with an open diplomatic policy. Japanese artists were exposed to a flood of Western influences, and many were adversely affected, but Zeshin was able to maintain self-discipline and ar-tistic integrity to survive this confusing period as a master. Y. W.

COVERED BOX

Signed Yūtokusai Hōgyoku
Japan; late Edo period, 19th century
Lacquer, gold, and silver on wood
H: 3½ in. L: 6¼ in. W: 6 in.
(8.6 × 14.8 × 15.4 cm)
The Avery Brundage Collection
B60 M7+

Many famous artists of the Rimpa school as well as anonymous craftsmen of the period exploited the vast decorative possibilities of ivy. This commonplace plant had literary and romantic associations as early as the ninth century.

The top and sides of the cover that encloses this entire box have an allover naturalistic ivy design which continues up the sides of the container and sprawls into its interior, merging into a continuous organic pattern of great fluidity.

Japanese lacquerwork, with a history of some 7000 years, reached one of its technical heights during the Edo period (1615–1868). The *maki-e* technique of lacquer decoration involves sprinkling silver or gold powders on a painted pattern while the lacquer is still wet. The process is repeated in subsequent coats to produce a finish saturated with metal powder and polished to obtain a soft, glowing effect and a relatively flat appearance. On this superb box, the design embedded in the lacquer surface creates the illusion of depth and layers of leaves. The pattern floats against the black lacquer ground, which is sprinkled with slightly coarser gold flakes. Touches of red indicate an autumnal theme.

The core maker provided a skill essential to the success of lacquerwork. His anonymous contribution is a wooden core so thin that the finished thickness of this box is no more than one-eighth of an inch. Even the craftsman who proudly signed this piece seems to have left no other record of himself. Y.K.

SET OF TWELVE INCENSE CONTAINERS

Lacquered by Hyōsaku Suzuki I (1874–1943); decorated and signed by twelve *maki-e* craftsmen
Japan; Taishō period, 20th century
Lacquer on wood
Diam. (each): 2 in. (4.9 cm)
The Avery Brundage Collection
B60 M295a–l

Kyoto has long been a prestigious center of lacquer production in Japan. Heian period records recognize the specialized skills of the core maker and lacquerer. A third specialist, the decorator (*maki-e shi*), appeared on the scene in the Kamakura period (1185–1334). Their close collaboration has always been a prerequisite for producing fine lacquerware.

These twelve *kōgō*, or incense containers, represent the highest technical and aesthetic achievement in Kyoto lacquers. The lacquerer Hyōsaku Suzuki I engaged twelve *maki-e shi* of Kyoto to decorate these *kōgō*, one for each month of the year. Each artist chose a motif for a specific month. (This theme originated in Kyoto, which enjoys a mild climate and a beautiful landscape of nurturing hills and rivers.) Some of the *kōgō* are discreetly decorated on the inside. Each is kept in its own paulownia wood box within a large storage box. Its lid bears the names of each *maki-e shi*, the month and title of his motif, and Suzuki's signature as lacquerer.

Motifs for January (a silk toy ball), February (sacred jewel of the fox messenger of the Shinto god Inari), and July (leaves wrapped with a strand of silk) commemorate festivals that occur in those months. All the other *kōgō* have seasonal motifs: March, a cascading willow branch; April, falling cherry blossoms; May, a *yukinoshita* (saxifrage) plant; June, the thunder god, representing early summer storms; August, a plump eggplant; September, hares (symbol of moonlight) and waves; October, rice plants and grains representing the harvest; November, maple leaves; and December, bamboo plants.

Y.K.

MONKEY TRYING TO CATCH A GRASSHOPPER

Signed Bazan (act. 1830–1843)
Japan; Edo period, 19th century
Wood
H: 1 in. (2.5 cm)
The Avery Brundage Collection
B70 Y333

RECUMBENT DEER

Signed Okatomo (before 1781)
Japan; Edo period, 18th century
Ivory
H: 1½ in. (3.8 cm)
The Avery Brundage Collection
B70 Y190

MUSHROOM

Attributed to Ichiraku (act. 1781–1788)
Japan; Edo period, late 18th century
Plaited cane
H: 1¹³⁄₁₆ in. (4.6 cm)
The Avery Brundage Collection
B70 Y55

In fine netsuke carvings one can see the result of the Japanese preoccupation with beautifying tools and everyday objects. Normally no larger in size than a large walnut, a typical netsuke was attached to the end of a cord tied to a small personal object, such as an *inrō* (pill case), tobacco pouch, or a set of writing implements (*yatate*). When slipped under a man's obi, the netsuke kept the article suspended at his waist. For this reason a good netsuke should be made of a smooth, durable material, be compact in form and size, and have no sharp edges or protrusions.

The carvers chose a virtually endless variety of subjects. By far the most popular were animals, including the twelve creatures of the Asian zodiac. Human activities were portrayed in great detail and often with humor, sometimes obvious but more often quite subtle. For instance, the piece by Bazan, who specialized in fine wood carving, portrays a monkey as if he were a person trying to catch a grasshopper with a straw hat. But the insect has already escaped and is perching on the other side of the hat.

Two basic materials for netsuke were wood and ivory of various types. A large variety of other natural and man-made materials were also used, sometimes in their found natural form, such as small gourds, nuts, and pebbles.

The fun-loving Edo period populace sought new designs, and a good new piece seemed to attract copiers, as in any other art form. Many skilled carvers signed their pieces, while others, such as Ichiraku, who plaited a series of wonderfully graceful objects, chose never to sign them. Y.K.

KOSODE

Japan; Edo period, 17th century
Ink and silver on silk
L: 54⅛ in. (136.2 cm)
The Avery Brundage Collection
B62 M74

In its simple, straight cut, the *kosode* (literally 'small sleeves') represents the basic traditional style of Japanese garment for both men and women. They were already being worn in the Heian period (794–1185) as under or inner garments by the upper class, who wore elaborate outer garments, and as regular clothing by the working class.

The less sedentary upper class of the Kamakura period came to wear *kosode* more as an everyday outer garment. Thus *kosode* began a long history of development in textiles and in decorative subjects. The blossoming of the *kosode* as an art form occurred during the Momoyama and early Edo periods (late sixteenth to the early eighteenth centuries).

A special group of *kosode* made for the Noh play, a theatrical art that developed during the Muromachi period (1392–1573), is called *noh-kosode*. Normally these garments are made of various richly decorated textiles. These elaborate costumes reflected the gradual sophistication of the life of Noh performers as they enjoyed the approval of society and the personal patronage of its highest-ranking members.

This *kosode* is decorated in black ink on what was once a silver-foiled surface. The mynah-like black birds in various poses may have been block printed. Additional details such as eyes, large beaks, and claws appear to have been hand painted. Y.K.